# From Realism
# to Art Nouveau

*From Realism to Art Nouveau*

# From Realism to Art Nouveau

Laura Lombardi

*From Realism to Art Nouveau*

STERLING

New York / London
www.sterlingpublishing.com

STERLING and the distinctive Sterling logo are registered trademarks of Sterling Publishing Co., Inc.

**Library of Congress Cataloging-in-Publication Data**
Lombardi, Laura.
  [Dal Realismo all'Art nouveau. English]
  From realism to art nouveau / Laura Lombardi ; [English translation by Angela Arnone].
     p. cm.
  Originally published: Dal Realismo all'Art nouveau. Florence : Giunti Editore, c2006.
  Includes bibliographical references and index.
  ISBN 978-1-4027-5926-0
  1.  Art movements. 2.  Art, Modern—19th century. 3.  Art, Modern—20th century.  I. Title.
  N6447.5.L6613 2009
  709.03'4—dc22

                                                                    2008047469

10  9  8  7  6  5  4  3  2  1

This book originally published under the title *Dal Realismo all'Art Nouveau,* written by Laura
Lombardi, first published in *I grandi stili dell'arte*, edited by Gloria Fossi. Pages 704–883.
English translation by Angela Arnone
Managing Editor and Art Consultant: Gloria Fossi
Series Graphic Design: Lorenzo Pacini
Italian Layout: CB Graphic di Christina Baruffi
Iconographical Research: Elisabetta Marchetti
Italian Indexes: Francesca Bianchi

Copyright © 2007 Giunti Editore S.p.A., Florence-Milano
www.giunti.it
Translation copyright © 2009 Sterling Publishing Co., Inc.

Published by Sterling Publishing Co., Inc.
387 Park Avenue South, New York, NY 10016
Distributed in Canada by Sterling Publishing
C/o Canadian Manda Group, 165 Dufferin Street
Toronto, Ontario, Canada M6K 3H6
Distributed in the United Kingdom by GMC Distribution Services
Castle Place, 166 High Street, Lewes, East Sussex, England BN7 1XU
Distributed in Australia by Capricorn Link (Australia) Pty. Ltd.
P.O. Box 704, Windsor, NSW 2756, Australia

Sterling ISBN 978-1-4027-5926-0

© by SIAE 2008: Emile Bernard; Pierre Bonnard; Maurice Denis; George Minne; Alphonse Mucha;
The Munch Museum –The Munch-Ellingsen Group; Edouard Vuillard; Ignacio Zuloaga.

Photograph Credits
© Archivio Giunti, Firenze; Archivi Alinari, Firenze; Corbis; Atlantide, Firenze; Erich Lessing/Contrasto;
Museo di Storia della fotografia Fratelli Alinari, Firenze; Luciano Pedicini Fotografo/Archivio dell'arte,
Napoli; The Bridgeman Art Library/Archivi Alinari, Firenze. Works from Italian State galleries and
museums are reproduced by permission of the Ministry for Cultural Heritage and Activities; cover ©
Erich Lessing/Contrasto
The publisher is prepared to fulfill any legal obligation regarding those images for which a source
could not be found.

For information about custom editions, special sales, premium and corporate purchases, please
contact Sterling Special Sales Department at 800-805-5489 or specialsales@sterlingpublishing.com.

# Realism, Naturalism, and Academia

Realism, Naturalism, and Academia

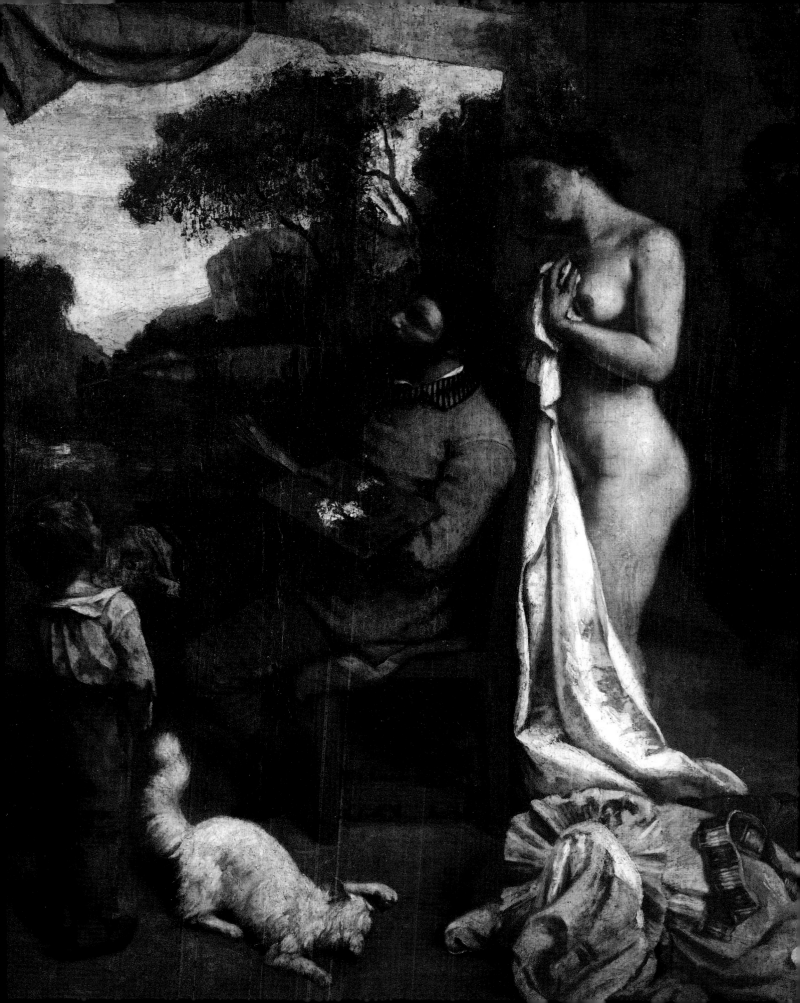

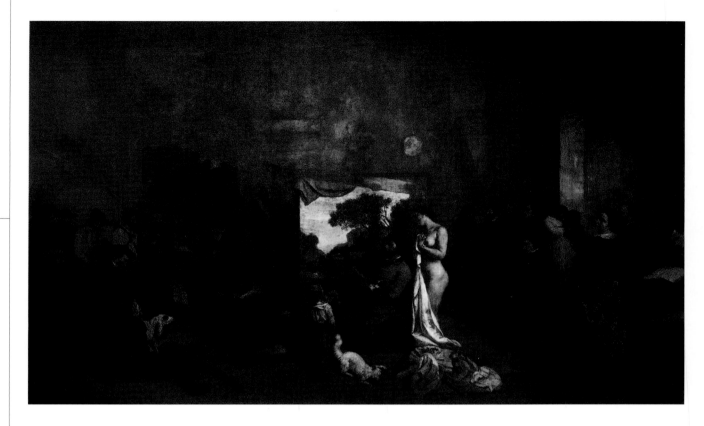

**Gustave Courbet**
*The Painter's Studio*, full
(detail on previous page)
1854–55, oil on canvas.
Paris, Musée d'Orsay.

## The Tenet of Truth in Realism, Naturalism, and Academia

In 1855, the Paris Universal Expo refused to exhibit *The Painter's Studio*, an opus by Courbet, who was already known to the public from the 1850 Salon, when he presented *Burial at Ornans*. In response, the painter decided to exhibit the rejected canvas, along with another forty pieces, in a nearby pavilion he rented with his friend, the collector Alfred Bruyas. The pamphlet that accompanied the show, which was called the "Manifesto of Realism," declared that he simply wanted to seek through knowledge of tradition "the reasoned and independent sentiment of my own individuality. To know in order to do: such has been my thought. To be able to represent the customs, the ideas, the appearance of my own era according to my own valuation; to be not only a painter but a man as well; in short, to create living art." Courbet's initiative simply put the seal on the changes that had occurred all over Europe in the previous decade: in point of fact, the artists of

the Barbizon School (Corot, Rousseau, Daubigny, Troyon, Bonheur) were already aware of the need for a more direct demonstration of the "principle of truth" applied to the landscape, but also to the paintings of Meissonier or of Delaro, who had sought to restore the "truth" of history, applying an order of composition that was no longer defined by Romantic artwork.

These rumblings, combined with intense social events, culminating in the 1848 independence uprisings, brought demands for a new status for painting, what French art critic Jules-Antoine Castagnary described as a "piece of the mirror in which generations behold themselves and each other once again," since the hierarchy of genres imposed by academic diktats had been abolished. Moreover, the philosophy of Positivism that dominated thought and society in those decades, with its profession of absolute faith in science, on one hand withdrew from artists the role of interpreting a leaning toward the absolute that they had played in the Romantic period—a cause of despair for many

**Rosa Bonheur**
*Plowing in the Nivernais*
1849, oil on canvas.
Paris, Musée d'Orsay.

a contemplative spirit—and on the other fueled more active temperaments with a conviction of the "knowability" of the outside world, reproducing faithfully in painting their civic role as witnesses of the era in which they lived, consequent to the principle of sincerity that called upon an artist's sense of ethics. Max Buchon thought that Courbet's works offered a "real synthesis of human life." He actually rejected any expressive lyricism, opting for a thick texture in his painting medium, spread with large sweeps of

**Gustave Courbet**
*The Stonebreakers*
1849, oil on canvas.
Destroyed during World War II, formerly Dresden, Gemäldegalerie.

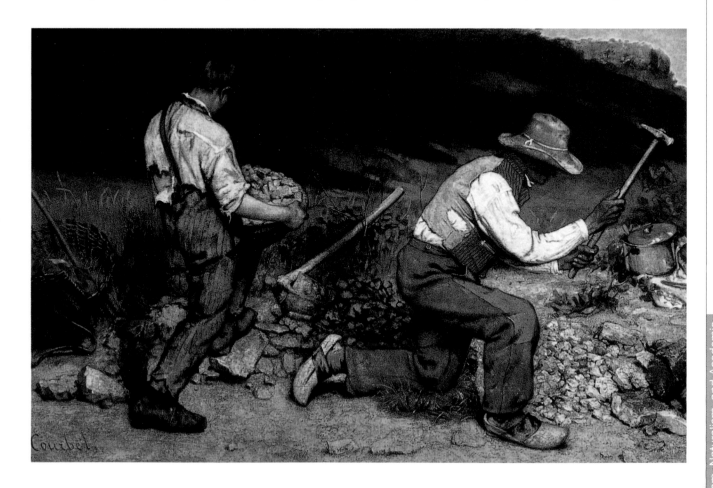

**Gustave Courbet**
*Portrait of Charles Baudelaire*
1848–49, oil on canvas.
Montpellier, Favre
Museum.

the spatula, played on deep or strident shades of color, producing an often deliberately unpleasant effect—provocation with respect to a "finished art"—addressing only the formal values of academic painting. Courbet's reference models are actually found among the old masters of the 1600s, from Spain and Holland (he studied with the critic Thoré-Bürger during the 1848–60 political exile) or France, like the Le Nain brothers, considered the most committed narrators of the humble and their world. His perception was receptive to the many aspects of coeval reality: paintings with poachers or stone-cutters, women at work or girls longing in provoca-tive positions, or the numerous Normandy seascapes, fauna in the woods, works that the philosopher Prud'hon believed to be the tools of humanity in its battle for physical and moral progress, since "in our times we can only find digni-fied human beauty, true beauty in suffering and pain."

The Courbet "phenomenon" echoed around Europe and was widely debated in 1856 and 1857 in the review *Réalisme*, with the artist intervening personally. Not even Baudelaire, a poet of quite different aesthetic leanings, was immune. A supporter of imagination as the queen of all faculties (see also the final chapter in this book), Baudelaire praised the 1855 Universal Expo for the greatness of a then-mature Delacroix and an ageing Ingres (called the "solitary enthusiast" by Théophile Gautier, locked in his exploration of beautiful form dis-connected from the need to convey meaning), acknowledging Courbet's "workman's force" driven by a "wild, enduring purpose" and the merit of "contributing in no small measure to restoring the gusto of simplicity and sincerity."

Nonetheless, Baudelaire also indicated another crucial aspect of the time: the dual face of moder-nity, where the timeless temptations of "ideal loveli-ness" clashed with the discovery of a new form of

beauty, contradictory because it was enclosed not in the eternal, but in the transitory; so it was not a case of painting *d'après nature*—in the Realist directive—insomuch as seeking the new features of changing forms. Although Baudelaire's model was Constantin Guys, a dynamic draftsman ready to embrace the "spirit" of the time's social elite, those thoughts echoed enormously, especially with the generation of artists—Naturalists or Impressionists—active after 1870. A rapport with Nature, founded on the sweeping might of realism (also shown perfectly in the contemporary novels by Honoré de Balzac and George Sand), had already begun to develop during the 1840s, among the artists painting together in the Forest of Fontainebleau. However, they concentrated mainly on landscapes, whereas Jean-François Millet was notable for the "rigorously sincere" interpretation of rural life. The peasants shown in his paintings appear to be "men subjugated by the forces of Nature, but also sovereign with respect to it," "simultaneously martyrs and heroes of eternal work" (A. Michel). In that difficult synthesis of form and meaning, expressed in a deliberately rustic language—although enjoying an analogical relationship with the verses of Virgil or the metopes of the Parthenon whose gessoes decorated his atelier—Millet infused his paintings with a solemn aura, offering realism a different, less provocative, more unruffled meaning than that of Courbet. While the creative disposition of the Realists walked hand in hand with social conscience and sharing of Republican ideals, a feature of French Realism (later extensively pursued right across Europe) was that it was certainly more subdued than the passion shown by Courbet. Then, the predilection for the countryside expressed by many artists at that time actually showed some veiled ambivalence: on one hand, life in the fields led to reflections on social disparities, but on the other, it was the model of primitive purity contrasting with corruption and urban chaos, where industrial progress and heavy

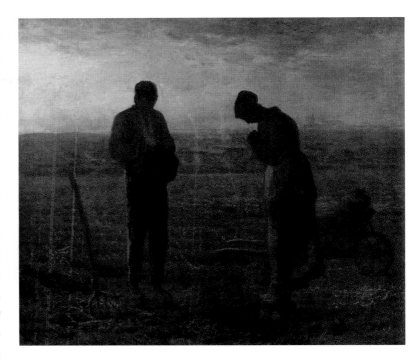

urbanization, light years away from bringing welfare to the masses, compensated by irremediably obfuscating the dream of beauty, making it increasingly difficult to concentrate on the values of poetry and art. At the end of the 1850s, Jules Breton was stimulated by these thoughts and reviewed the language of his master, Millet. Breton country girls trod gracefully and nobly austere, like ancient canephorae,

Jean-François Millet
*Angelus*
1857, oil on canvas.
Paris, Musée d'Orsay.

Jean-François Millet
*Death and the Woodcutter*
1858–59, oil on canvas.
Copenhagen, Ny
Carlsberg Glyptotek.

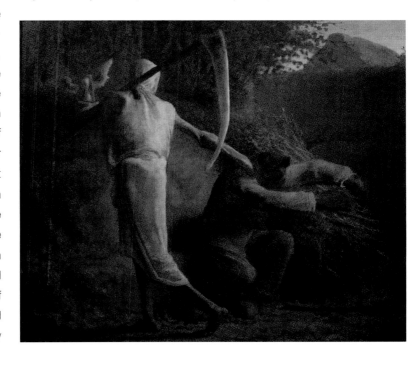

**Jules Breton**
*Calling in the Gleaners*
1859, oil on canvas.
Paris, Musée d'Orsay.

**Thomas Couture**
*The Romans of the Decadence*
1847 (exhibited at the 1847 Salon), oil on canvas.
Paris, Musée d'Orsay.

from *Calling in the Gleaners* (1859, Paris, Musée d'Orsay) to *The Shepherd's Star* (1887), engendering a "naturalism completely infused with poetry," as Zola defined it in his critical tone, seeing its formal poise and more gracious style of narration as a skilled attenuation of Millet's "painted Georgics."

## Profound Changes in the Academies

Historical and religious paintings by artists trained in the academic environment also began to be affected—perhaps less explicitly but with equal penetration and implication—by the need to render

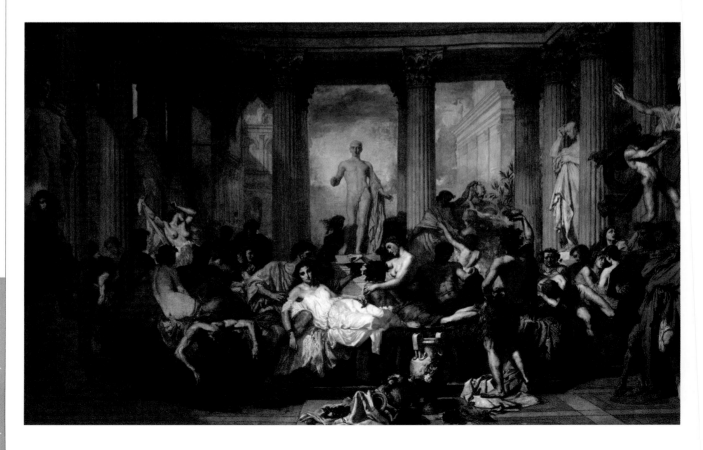

a principle of realism with a more direct approach to objective reality; their works betray the desire to arouse "strong" emotions in the observer, fleeing from the archetypal conventions of the Romantic era, when the expression of joys, passions, and drama was nonetheless compensated in that "prescribed circle" that assured a harmonious bond between humanity and the universe (Carbone). One example of this key change in historical painting is Thomas Couture's large 1847 canvas, *The Romans of the Decadence*, where echoes of Veronese and Tiepolo entwine with a type of trivial pictorial expression and conduct on par with the subject, a banquet inspired by one of Juvenal's satires. Here the plane of communication reveals a physical and emotional solidity that marked the cultural climate of the period, but the fiery, shameless, and provocative spirit of the opus is not so different from Courbet's paintings mentioned earlier. It was precisely in the heart of the academies, places that had retained respect for the traditional masters,

that quite a number of artists experimented with a compromise between the ideals of *l'art pour l'art* (still pursued by Ingres and his atelier) and the language of modern Realism, with varying degrees of success and sensitivity and not always what might have been expected.

So, if Gérôme toned down the reference to the mythical world, evoked with elegant style and anecdotic lilt in the 1846 *Young Greeks Attending a Cock Fight*, Delaunay's *The Plague in Rome* expresses a more austere veil of disquiet. The canvas was begun during his time as an academic pensioner at Villa Medici in Rome in the late 1850s, inspired by an episode of Jacobus de Voragine's *Golden Legend*. Here the tormented scenario, with the beautiful Angel of Death looming out of the deeply gloomy Roman street of the Dark Ages that is strewn with plague victims, has accents that refer to descriptions from novels like the Goncourts' *Madame Gervaisais* or Baudelaire's *Tableaux Parisiens*. Thus, those who still believed in the supreme guidance of

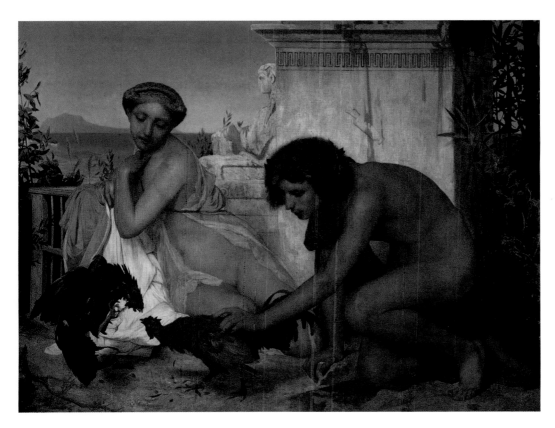

**Jean-Léon Gérôme**
*Young Greeks Attending a Cock Fight*
1846, oil on canvas.
Paris, Musée d'Orsay.

14

**Adolphe William Bouguereau**
*Homer and His Guide*
1874, oil on canvas.
Layton Art Collection,
Milwaukee Art
Museum.

the old masters did so in the awareness of a divide between the contemporary world and the perfection of those models, as Baudelaire reflected in one of his sonnets from *Les Fleurs du Mal*, expressing the discomfort and regret experienced by a modern poet who seeks the original greatness of ancient nudes ("I love the memory of those naked ages . . .") but feels a shadowy chill envelop his soul. This fusion of dreams of antiquity and incumbent modernity can often be felt in the works of Bouguereau, like the 1874 *Homer and His Guide*, where references to the classic tradition do not suffocate the impression of a life sketch. The entire corpus of this brilliant painter is hallmarked with these effects, which he transposed into paintings of different themes—some religious (*Pieta*, *First Mourning*), some mythological (the neo-Titian-style *The Youth of Bacchus*), some genre (*Charity*, *Le Jour des Mort*, or some with numerous shepherdesses)—tinged with the sensitivity that was typical of the academic milieu in the 1860s–1870s.

Not even sculpture was immune to this shift in sensitivity, and in the academies, inspiration derived from antiquity or religious history was a pretext for shrouding a very contemporary disquiet. This can be seen in the works of Jean-Baptiste Carpeaux, where references to Rubens and the Flemish School can be perceived in the tender bodies of the puttos in the *Triumph of Flora* (for the Louvre's Pavillon de Flore), alternating with more tormented forms that echo Michelangelo's style in *Ugolino and his Sons* (page 46), whereas *The Dance*, commissioned from him by the architect Charles Garnier (in 1863 for the Opéra in Paris and presented in 1869), was considered scandalous, labeled as "ignoble Saturnalia," a "moral insult," due to the male nude emerging from the wanton circle of five female figures and giving vitality to the entire relief. Besides, even the most obscure sensuality filtering from the female nudes by the academician Clésinger can be seen to be—over and above the differences of school and approach—the fruit of the same culture that had produced Courbet's

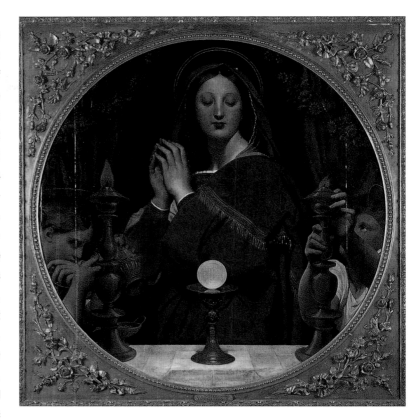

*Les Demoiselles de Village* and, in 1863, Manet's *Olympia*. If Italy in the 1400s was favored by the artists training at the Academy in the 1860s, including Paul Dubois, as the expression of harmonious beauty that was closer to a modern sensibility than that of Greece, critics nonetheless note how often those students sought out the Renaissance for more troubled, fragile, and highly strung models: some works by Donatello or Verrocchio (who inspired Antonin Mercié's 1872 *David*), or Giambologna's intertwined pieces (Falguière, for *Winner of the Cockfight*, 1864), or the style of

**J.A. Dominique Ingres**
*The Virgin of the Host*
1854, oil on canvas.
Paris, Musée d'Orsay.

**Jules-Élie Delaunay**
*The Plague in Rome*
c. 1859–69, oil on canvas.
Paris, Musée d'Orsay.

**Jean-Baptiste Carpeaux**
*The Dance*
1863–69, limestone.
Paris, Musée d'Orsay
(full on page 47).

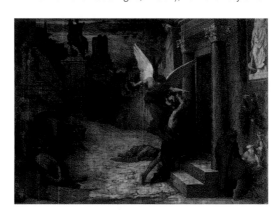

**Edgar Degas**
*The Bellelli Family*
1858–60, oil on canvas.
Paris, Musée d'Orsay.

**Edgar Degas**
*Study of Hands*
c. 1858–60, oil on canvas.
Paris, Musée d'Orsay.

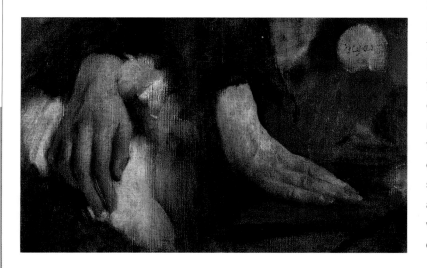

Stefano Maderno (Falguière again, in the sculpture *Tarcisius, Christian Martyr*). So there was a penchant for a modern disquiet channeled into ancient forms.

## The Debut of Degas and Manet

During the years when the ancient face of great cities changed and they became European metropolises—Paris in particular, transformed by the architect Haussmann into a vast building site that appeared "slashed by saber strokes, its veins open" (Zola), unrecognizable to the poets who encountered it

("New palaces, and scaffoldings, and blocks / And suburbs old, are symbols all to me / Whose memories are as heavy as a stone . . . ," wrote Baudelaire)—the exercise undertaken by Giotto or Piero della Francesca, as a support in the quest for a form that responded to the cultural climate of a period of sudden changes, was also of interest to someone who was about to embark on a journey of experimentation, becoming one of the leading players of *nouvelle peinture*: Edgar Degas. The result of his intense reflections, during a trip through Italy that touched Florence, Naples, and Rome, on how to safeguard form from the ravages of time in controlled, essential, and understated style is reflected in works like *The Bellelli Family*, a portrait of his aunt with her husband and daughters, expressing austere realism, yet mindful in the rigorous composition of both the Italian and Nordic 1400s.

It was precisely in the early 1860s that a pictorial trend in contrast to Courbet's excesses and formalist academia began to take shape, and in 1863 Manet showed his *Déjeuner sur l'herbe* at the so-called Salon des Refusés—created by decree by Napoleon III and including works by Pissarro, Fantin-Latour, and Whistler. Manet's canvas, inspired by the rural concerts of sixteenth-century Venetian painting, was considered scandalous, not so much for the female nude, which was common in Realist and academic works, but for the uninhibited presence of two men (Eugène Manet, the painter's brother, and Ferdinand Leenhoff) next to the unclothed woman (Victorine Meurent), moreover in a contemporary context. What further disoriented the members of the jury was the novel spatial construction, in which the perspective was founded not on the drawing but on a sequence of trees and fronds, like a stage's wings, obtained by overlapping colors with fast coats of warm and cool shades in a simultaneous contrast that rendered them brighter and more brilliant. The scandal recurred in 1865, with the showing of *The Mocking of Christ* (an evident homage to the painting of Velázquez) and,

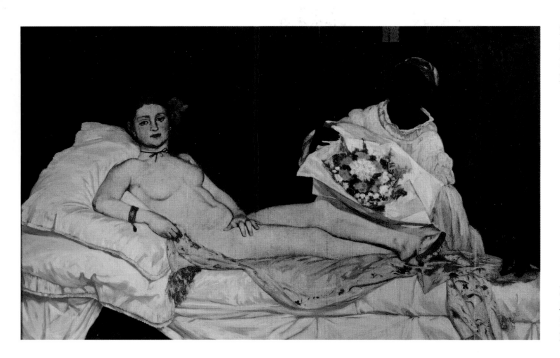

**Édouard Manet**
*Olympia*
1863, oil on canvas.
Paris, Musée d'Orsay.

**Édouard Manet**
*Le déjeuner sur l'herbe*
1863, oil on canvas.
Paris, Musée d'Orsay.

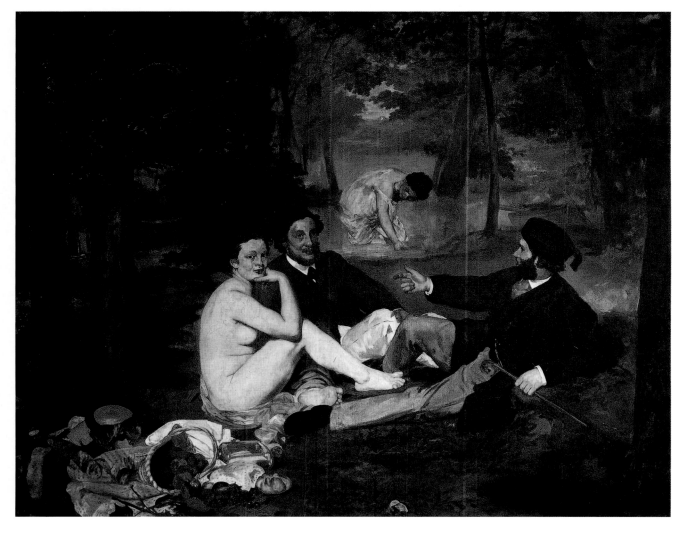

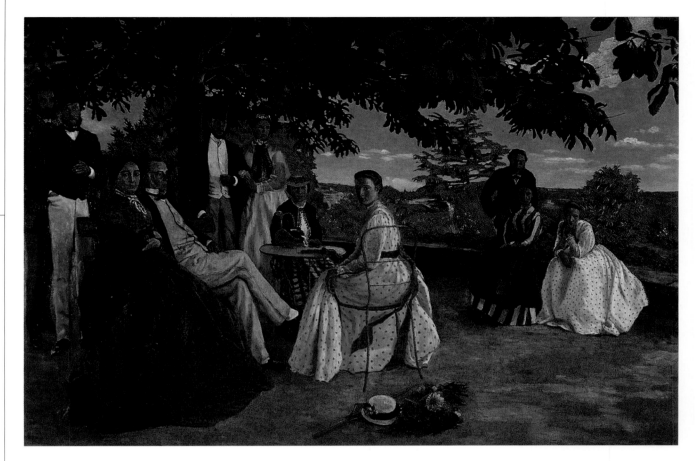

**Jean-Frédéric Bazille**
*Family Reunion*
1867 (exhibited at
the 1868 Salon), oil
on canvas.
Paris, Musée d'Orsay.

above all, by the "immoral" nude, *Olympia*, "a sort of female gorilla, a rubber dummy with black eyes" (Canteloube), "a painting of the Baudelaire school, obviously executed with a student of the Goya school and offspring of the nightmares of Edgar Allan Poe" (Ravenel). Baudelaire, on the other hand, spoke of Manet with enthusiasm: "he will be the painter, the real painter, who will show us how great we are depicted in our ties and shiny leather boots," admiring his "dry temperament, which penetrates in depth." But the warmest supporter of the artist was Zola, pointing out that Manet, "an analyst painter, child of our times"—the times of Positivist research—proceeded "like Nature itself, with bright, broad beams of light," so that he expresses "a corner of nature seen through a temperament." It was actually Zola, in 1868, who defined Jean-Frédéric Bazille and several future Impressionists—Pissarro, Renoir, Monet—as *"naturalistes, actualistes,"* on the "great road to truth and power."

## The Pre-Raphaelite Brotherhood

The concept of "realism" that established itself in Great Britain in the fateful year 1848 was very different, but an equal harbinger of development. This was the year when Hunt, Millais, and Rossetti founded the Pre-Raphaelite Brotherhood, a name referring to the inspiration drawn from the Italian "primitive" painters—those preceding Raphael—indicated as the infallible guide for a "natural" approach. This brotherhood of young British artists—who radically rejected London's industrial face and the idea of progress connected to it—adopted the idea of a secret society (Rossetti was the son of an Italian exile of the Neapolitan Carbonari uprisings in 1820), motivated by the idea of the independent utopia of collective expression, in line with the myth of the artistic community as it existed in the Medieval workshop (like the German Nazarenes in the early 1800s) and the taste for Gothic that spread into British architec-

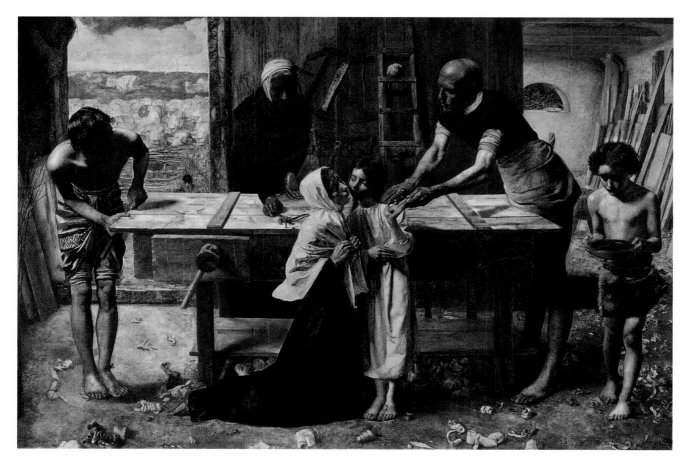

ture in the first half of the century. Proposing a return to the art of the Middle Ages and 1400s, the Pre-Raphaelites exhibited paintings inspired by religious themes or ancient fables at the Royal Academy, arousing the amusement or indignation of Victorian society but the admiration of the critic John Ruskin, also an artist, who underscored the intention of these painters to communicate the knowledge of visible reality, faithfully depicting events, objects, and human emotion. In the 1851 essay "Pre-Raphaelitism," Ruskin elaborated a singular comparison between the Pre-Raphaelites and Turner, based on the ethical rather than stylistic principle of painting as a visible image of truth revealed to humankind through Nature. However, starting from this supposition and heavily encouraged by its rapport with ancient and contemporary Symbolist poetry and literature, the Pre-Raphaelite movement rapidly evolved toward the cult of beauty that characterized all European art, which will be discussed later.

As proof of how the realism pursued by the Pre-Raphaelites did not correspond to the criteria of the time and became irritating precisely for its dogged pictorial register, it is sufficient to recall the tart comment of a writer like Dickens, who, in 1850, defined Millais's *Christ in the House of His Parents* as "ugly, graceless and unpleasant," certainly contrary to the criteria of realism and faithful depiction of society that he expressed in his novels. In 1862, Thoré-Bürger, a tenacious defender of Courbet, accused the Pre-Raphaelites of "excessive realism, a daguerreotype, microscope and stereoscope effect," whereas Delaborde, a *l'art pour l'art* critic, accused these young artists of expressing a "coquettishness disguised as innocence." Nevertheless, in the works by the British artists, the detailed presentation conceals a very intense symbology. In the abovementioned *Christ* by Millais, the work implements and carpenter's workshop furnishings are, in fact, an "inventory" of signs: the

**John Everett Millais**
*Christ in the House of His Parents*
1849–50, oil on canvas.
London, Tate Britain.

**John Everett Millais**
*Autumn Leaves*
1856, oil on canvas.
Manchester City Art
Gallery.

*Bottom right:*
**Ford Madox Brown**
*Work*
1852–65, oil on canvas.
Manchester City Art
Gallery.

*Below:*
**William Holman Hunt**
*The Light of the World*
1854, oil on canvas.
Oxford, Wardens and
Fellows of Keble
College.

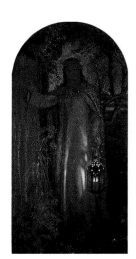

tools on the table and the injury that the small boy shows his mother are meant as a premonition of his destiny; the square is a reference to the divine trinity and the dove; even the wooden planks resting against the wall allude to the construction of a new temple, whereas the wicker basket refers to the switch used for the flagellation. Rossetti's work also was characterized by a fusion of a more domestic style of narrative—with the precise intention of rendering the sacred scene closer to the spectator's sensibility—and the expression of a quite contemporary turmoil, although entrusted to the purity and fragile forms of the 1300s and early 1400s. In *Ecce Ancilla Domini*, what Ruskin defined as a fair, new Virgin is awakened in her austere room by the arrival of a disturbing presence: it is the angel, painted with its back to the viewer, without wings, and not kneeling, in the Paleochristian style. As for Ford Madox Brown's *Work*, started in 1852 and shown in Piccadilly in 1865, the multifaceted interpretation of British Victorian society assumes the tone of a Ruskin-style moral maxim, entrusted to a form remi-

niscent of examples from antiquity, which is also expressed in the actual product: an opus almost two meters in length and arched like a Renaissance altarpiece.

William Holman Hunt was driven by a strong documentarian spirit, and often went to the places of Christ's Passion. If the reading of the works of philosopher Joseph Ernest Renan is not extraneous to this attitude, proposing a completely earthly rereading of the life of Christ in his *Vie de Jésus*— quoting the Scriptures for their mere value as historical testimony in a mainly human story—Hunt's works are nonetheless veiled with an elated, visionary awareness. This can be seen as early as 1854, in Hunt's *The Light of the World*, illustrating the Savior holding a lantern (the meaning of the painting, inspired by a passage from the Book of Revelation, was clarified by Ruskin in a letter to *The Times*), but also in the elaborate composition *Shadow of Death* (1870).

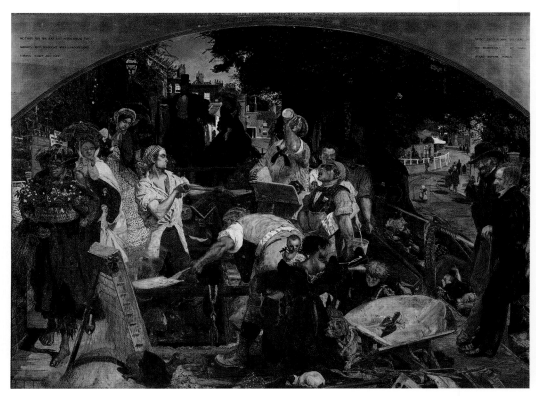

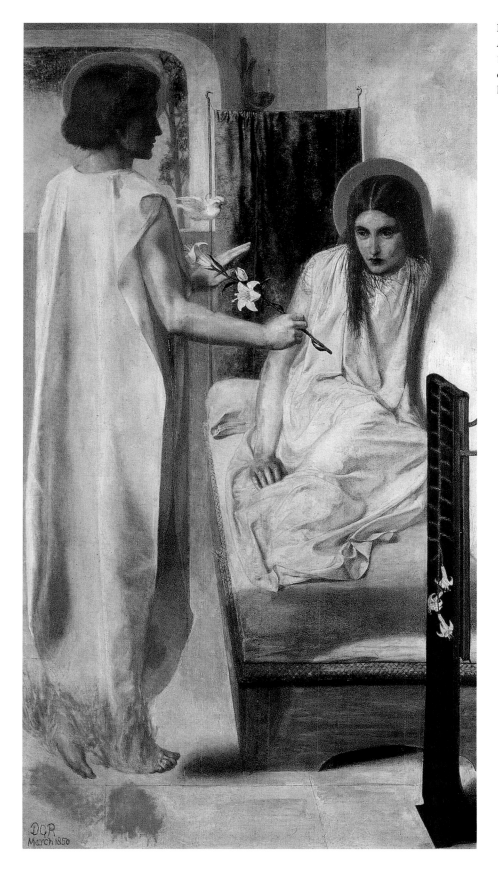

**Dante Gabriele Rossetti**
*Ecce Ancilla Domini*
1850, panel-mounted oil
on canvas.
London, Tate Britain.

**Raffaello Sernesi**
*Ladruncolo di Fichi (Fig Thief)*
c. 1861, cartoon.
Florence, Pitti Palace,
Modern Art Gallery.

**Francesco Saverio Altamura**
*Funeral of Buondelmonte*
1860, oil on canvas.
Rome, National Gallery
of Modern and
Contemporary Art.

# Realism in Italy

The great world exhibitions in London, and even more so those in Paris, became the destination of artists from all over Europe and a valuable chance for comparison. Some of the Italians—De Tivoli, Palizzi—who visited Paris and the 1855 Universal Expo observed, above all, the *Barbizonnier* artists. Others, like Altamura (in Tuscan exile after the Neapolitan uprisings of 1848) and Morelli, were interested in Delaroche's painting, seeking a more authentic method for transposing the historical or religious theme, and depicting, as Morelli did, "figures and things not seen before, just imagined and simultaneously real." Morelli thrived on the philosophies of Francesco De Sanctis and was animated by strong liberal and anti-academic conviction, adopting a style that was founded on crisper tone contrasts and affected many of the Caffè Michelangelo artists, offering important ideas for the birth of the Tuscan "macchia" movement. Toward the mid-1850s, Florence was actually a place where many painters from all of Italy passed through or resided, and, along with Naples and Milan, it became a cradle for creative ferment that often accompanied the republican ideals of those artists, followers of Mazzini and Garibaldi. However, the Tuscan artists—the Macchiaioli, a disparaging term used in 1862 by a *Gazzetta del Popolo* critic, meaning "daubers"—differed from their Lombard

companions, like the Milanese brothers Girolamo and Domenico Induno. They did share an interest in realism, but rejected any anecdotic variation, and relied on a style that contrasted academic rules while accepting and transposing in a completely analogous manner the light and form concepts of ancient tradition. The Macchiaioli's preferred support—especially in the early days—was a wooden panel, sometimes even using cigar box lids, where they tried out the various effects of powerful and contrasting synthesis, which can be seen in the works of Signorini, Banti, Cabianca, and Fattori. The macchia, defined in 1862 by Signorini as an "exaggeration of pictorial chiaroscuro," was intended to oppose the "sacrifice of solidity and relief caused by the excessive transparency of the body as painted by the academicians." The method was also the result of an awareness acquired from optical physiology studies published in reviews, which were read in artistic circles, claiming that painting could never achieve an exact reproduction of real colors.

Nonetheless, after 1860, the paintings that portrayed events from contemporary history linked to the difficult conquest of a unified Italy, with no

**Telemaco Signorini**
*Aspettando*
1867, oil on canvas.

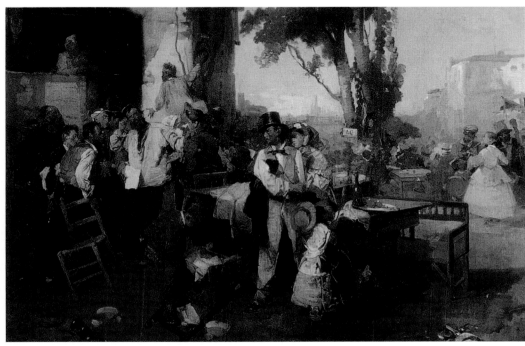

**Domenico Induno**
*News of the Peace of Villafranca*, detail
1861–62, oil on canvas.
Milan, Cariplo Foundation.

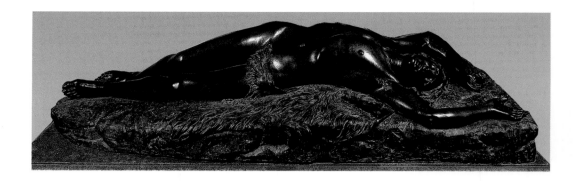

**Giovanni Dupré**
*Dying Abel*
1842, bronze.
Florence, Pitti Palace,
Modern Art Gallery.

rhetorical or celebrative nuances, or scenes of middle-class and peasant interiors or views of landscapes or the Maremma coast, still of a wild, unspoiled loveliness, were affected by a more deliberate investigation of the relationship between form and color; the 1300s and 1400s Italian models were combined with hints gleaned from 1600s Dutch interiors, also much admired in France as in Signorini's *Aspettando (Waiting)* (page 23). The inspiration drawn from the familiar ancient models of sincerity and realism—also suggested by the choice of narrow, horizontal canvases, evoking antique altar pieces—unlike the British Pre-Raphaelites, went no further than analogy, although it was close to the line preferred by Degas in the youthful works mentioned earlier. The Macchiaioli group's experience, supported by critic and patron Diego Martelli, revealed underlying affinities with similar research being developed in Piedmont among the artists of the so-called Rivara School (Pittara and Pastoris), who, like other young Ligurians and Piedmontese (Rayper, Avondo), were following the instructions of

the older Antonio Fontanesi. Methodological and subject choice similarities can also be seen in the painters active in Naples, in the so-called Resina School: De Gregorio, Rossano, De Nittis, and the Tuscan Adriano Cecioni, a sculptor and painter. Nor was sculpture excluded from these changes: if Dupré's *Dying Abel* was seen as too daring when it was shown in Florence in 1842, accused of being a life cast, the arrival of Vela's 1847 *Spartacus* showed that the historical reference was simply a pretext for celebrating the dignity of human toil with accents of realism, which evolved into the bas-relief *The Victims of Labor*.

A similar path from academia to realism was trodden by Cecioni, but he did not abandon tradition: from the 1868 *Suicide*, which aroused debate precisely for its mixing of cultured references, to ancient forms with details of striking realism, such as *Child and Cock* presented at the 1870 Salon, to 1880's *Mother*, where the plebeian woman holding a lively child does retain a classical stance, which was even praised by Giosuè Carducci in one of his poems. Although in works like Signorini's *Towpath* there are also references to Courbet's *The Stonebreakers*, the French lesson penetrated Italy in a more independent, low-key way. This was also the case in other European countries, where the drive for a new language in art was always connected to a specific aspect of local culture, which was consistent, after all, with the criterion of individuality for each artist that Courbet himself claimed.

**Vincenzo Vela**
*The Victims of Labor
(The San Gottardo
Miners)*
1883, bronze.
Rome, National Gallery
of Modern and
Contemporary Art.

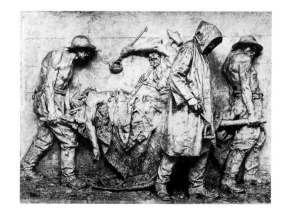

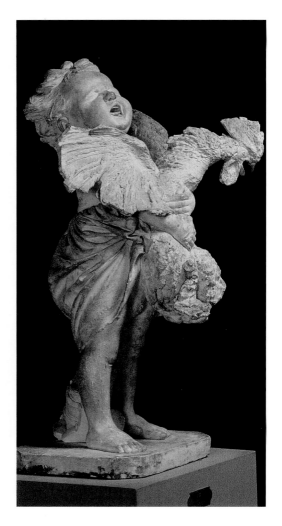

## New Styles of Expression in Germany, Belgium, and Spain

In Germany in the 1840s, Adolf von Menzel began his quest for a more direct way of looking at reality in his painting. He was driven by a sort of "truth neurosis" and investigated with great poetry the spectacles offered by contemporary life and landscape—the walls of monasteries; the wind that filtered into a room, ruffling a curtain; the animation of crowded places, dance halls, workshops, or stations—with disquieting effects of light and brilliance (like the famous *Foundry*), which made the critic Huysmans prefer this style to Monet's Impressionism. On the other hand, the description of life in the fields and middle-class interiors painted by Hans Thoma was austere yet somewhat fantasized, while in the 1860s (before he became a gifted portrait painter for the fashionable circles of Chancellor von Bismarck's united Germany), Franz von Lenbach evoked similar scenes with a more concise style, resembling the studies made by the Italians. Wilhelm Leibl, however, taken to Paris by Courbet, tended to define outlines with wide, flat

**Adriano Cecioni**
*Child and Cock*
c. 1868, bronze.
Florence, Pitti Palace, Modern Art Gallery.

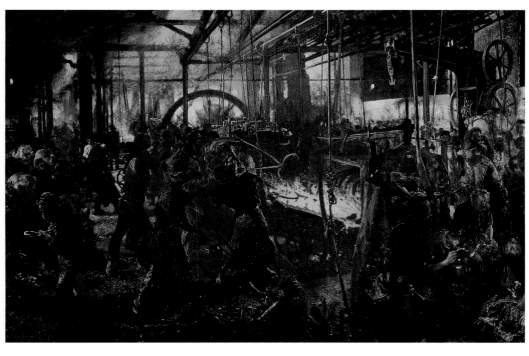

**Adolf von Menzel**
*The Forge*
1872–75, oil on canvas. Berlin, Old National Gallery, Berlin State Museum.

**Franz von Lenbach**
*Self-Portrait with Wife
and Daughters*
1903, oil on canvas.
Munich, State Gallery in
Lenbachhaus.

**José Gallegos y Arnosa**
*Choirboys*
c. 1885–90, oil on canvas.
Madrid, Carmen
Thyssen-Bornemisza
Collection.

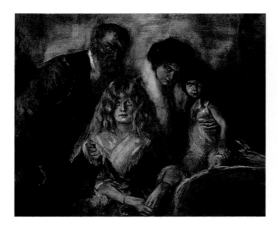

brushstrokes that expressed how he intended the composition, but sometimes combined with a linearity typical of Durer. Courbet and Leibl both exhibited in 1869 in the first contemporary art show organized in Munich's Glaspalast, an event that in a manner of speaking led the city onto the path of privileged location for future international displays. In Belgium, where Courbet had shown *The Stonebreakers* (page 9) in 1851, the Societé Libre des Beaux-Arts was established in 1868. Members of the society included Félicien Rops, Alfred Stevens, and the sculptor Constantin Meunier, who published a manifesto called *L'Art libre* in 1871. The youthful work of Madrid artist Martín Rico and of Francisco Padrilla (*Galician Washerwomen*) was inspired by rural themes, influenced by the Barbizon School; they were students of Madrid's Real Academia de Bellas Artes de San Fernando, like José Gallegos y Arnosa, who later went to Rome, where there was a Spanish Academy of Fine Arts and where many young painters of the *Costumbrismo* persuasion trained. Nonetheless, the most acclaimed were the works of Mariano

**Mariano Fortuny
Carbó**
*The Artist's Children in
the Japanese Salon*
c. 1874, oil on canvas.

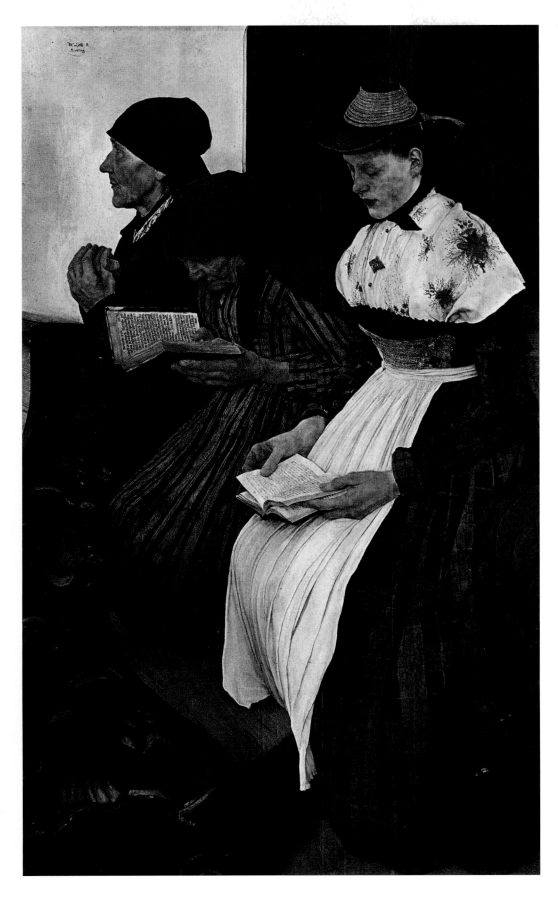

Wilhelm Leibl
*Three Women in Church*
1882, oil on canvas.
Hamburg, Kunsthalle.

**George Clausen**
*The Girl at the Gate*
1889, oil on canvas.
London, Tate Britain.

Fortuny of Cataluña, whose vibrant brushstrokes and palette of dazzling colors drew inspiration from his native regional folklore, from its real life but also from history and legend, with an expressive eclecticism that garnered many enthusiastic followers from all over Europe.

## The Years of Naturalism

Although the definition of "Naturalism" is strictly speaking applicable only to literary works, referring to the novels of Zola, it is often used in the artistic sphere, especially post-1870, to indicate a similar tendency to deal with the objective reality of humanity and landscape, which declared all its might and irrepressibility to the exhausted mettle of the contemporary artist. Following the demise of the illusion that it was possible to offer a thought-out transposition of color and form values parallel to their natural expression, the language preferred was one that could translate the "reality" with the most

**Jules Bastien-Lepage**
*Haymaking*
1877, oil on canvas.
Paris, Musée d'Orsay.

convincing results. Paintings by masters like Bastien-Lepage, Dagnan Bouveret, Lhermitte, Cannicci, Gioli, Tommasi, Bruzzi, Clausen, Walton, La Thangue, and Israëls, to mention but a few, actually deal with subjects of rural life without the proactive aplomb of a Courbet or the measured understatement of Jules Breton's vision, and often translating in gloomier terms the poverty and desolation of a world that was nonetheless dreamed of as a refuge for their tormented spirits.

One famous example is Bastien-Lepage's peasant woman seated in a field in the painting *Haymaking*. She is exhausted by hours of work, certainly not dreaming, but bearing all the signs of her human condition, as do the Abruzzo peasants, "emblems of slavery and brutality" in Teofilo Patini's enormous 1886 painting *Beasts of Burden* (whose terracotta frame, designed by the artist, included heavy chains). The archaic, almost barbaric customs of Abruzzo also inspired Francesco Michetti in his fantastical, visionary developments, where his glance at reality was merely the starting point for drawing the onlooker into the profound, magical alienation of almost primordial scenarios (*La*

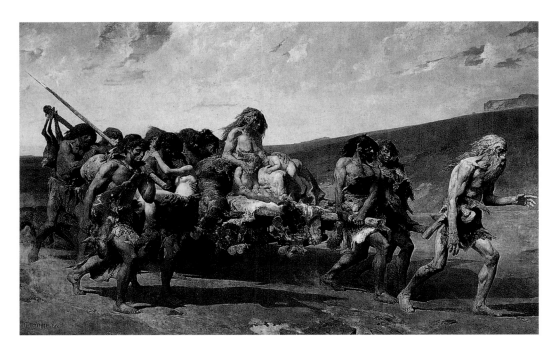

Fernand Cormon
*Cain*
1880 (exhibited at the 1880 Salon), oil on canvas.
Paris, Musée d'Orsay.

*raccolta delle zucche,* or *The Pumpkin Harvest*). The Breton peasants depicted by Charles Cottet in *Au pays de la mer. Douleur,* shown at the Venice Biennale, reveal an inescapable suffering, accepted with resignation, translated into a painting of brooding nuances and almost frozen gestures. Sometimes "adjusted" versions of that dour reality are shown, insisting on detail, with the tiniest graphics prevailing over the narrative core. However, the troubled sensibility of the moment is also reflected in paintings from the academic circles, like Cormon's *Cain* (1880): in addressing a theme dear to nineteenth-century culture, from Byron to Hugo and from Baudelaire to Leconte de Lisle, the artist did not choose the archaic scenario here as an escape from the nausea of the present, but rather to accentuate the oppressive accuracy of the event in the harsh description of the bodies, the emphasis of the naked limbs that comprise the tragic cortege, where the monotones of the earthy grays are animated in points by splashes of blood. Then there are the dreamy readings of the Scriptures produced by Cazin, which have no mystical overtones and, in the 1890s, scenes like the meeting of *Tobias and the Angel* appear with great narrative simplicity in the misty atmosphere of the French fields, with

Francesco Paolo
Michetti
*The Vow*
1883, oil on canvas.
Rome, National Gallery of Modern and Contemporary Art.

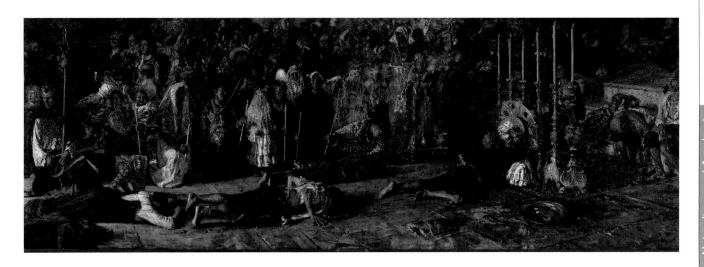

figures appearing as "a concrete emanation of the place" (Bénédite). Fritz von Uhde, who became one of the leading figures in the Munich Secession, narrated the episodes of the life of Christ, setting them in the natural light of the German countryside.

During those same decades, the lesson of *nouvelle peinture*, as Impressionism was called, spread with enormous success, fascinating several diehards of Naturalism, including Max Liebermann, mindful of acknowledging the labors of the "damned of the Earth," but also Zorn or Sorolla, masters of Realism whose encounter with Impressionism was decisive, leading to a variation not only in style but also in subject matter. A skilled combination of influ-

ences drawn from European Realism, in particular from Neapolitan painting, and French Impressionism can be seen in the work of a great interpreter of the Russian spirit, who also played a significant role in the anti-academic movement known as the Peredvizhniki, which means "itinerants": Ilya Repin. A dramatic, concise solemnity dominates both the analytical depiction of rural human and social reality, in his *Religious Procession in the Province of Kursk* (1883), and the flight of the revolutionary, in his 1880 *Unexpected*, paintings in which Repin—who traveled around Italy and France from 1873 to 1876—experimented with light effects reminiscent of the Impressionist *touche*. The landscapes of Isaac

**Ilja E. Repin**
*Unexpected*
1884–88, oil on canvas.
Moscow, Tretyakov
Gallery.

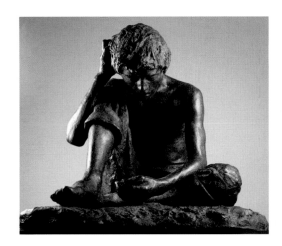

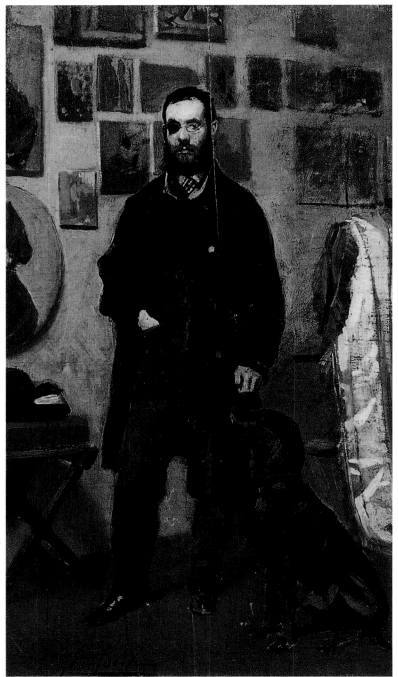

Leviatan are also highly poetical, balanced between realism and echoes of *nouvelle peinture*. While paintings of rural themes might have interested the new middle classes who attended the Paris Salons and the Worlds Fairs, complacent in the knowledge of seeing reflections of the virtues of the work ethic and interested in discovering how many regional customs and habits of unknown districts existed, the same audience liked to see itself in images that celebrated vivacity, frivolity, and the opulence of its social station in paintings both with modern themes and in period dress. The latter were favored for the insuperable ability to trigger a process of identification, since "fashionable ladies and gentlemen, rich bourgeois, could identify themselves in these works. They saw the same fabrics they wore themselves— the carpets they had in their own homes, the luxury in which they lived, and with satin shoes, white hands, bare arms, small feet, pretty heads," as Francesco Netti observed disapprovingly. Therefore, the paintings, sculptures, and artifacts that were the most attentive to features, variety of details, and the ease with which moral or entertainment values could be deciphered were preferred. Refined voices of that taste—and skilled portrait painters, who worked mainly in Paris—included Tissot, Stevens, De Nittis, Raimundo de Madrazo and Ferrara-born Giovanni Boldini. Boldini, after his talented Macchiaioli debut, when his *Portrait of Giuseppe Abbati* opened new vistas in that genre, soon became the undisputed idol of the grandes dames of Parisian and British aristocracy, as can be seen in the next chapter. Leading players among "Neapolitan Bohemians" in the French capital were the sculptors Vincenzo Gemito—excelling in his use of ancient teachings to convey lively gestures and modern expressions—and Antonio Mancini, whose portraits of street urchins and fragile tumblers,

**Giovanni Boldini**
*Portrait of Giuseppe Abbati*
1865, oil on panel.

*Top left:*
**Vincenzo Gemito**
*The Card Player,* c. 1868, bronze-coated gesso. Naples, Capodimonte Museum.

Raimundo de Madrazo
y Garreta
*Un brano preferito*
c. 1880–90, oil on canvas.

Antonio Mancini
*Girl with Yellow
Kerchief*, detail
1876, oil on canvas.

*Facing page:*
Edgar Degas
*The Little Fourteen-
Year-Old Dancer*
c. 1881, polychrome
bronze.
São Paulo, Brazil,
Museum of Art.

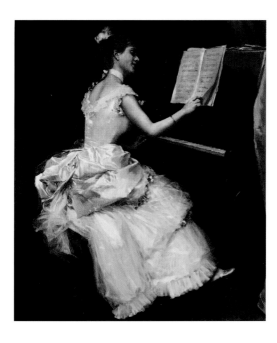

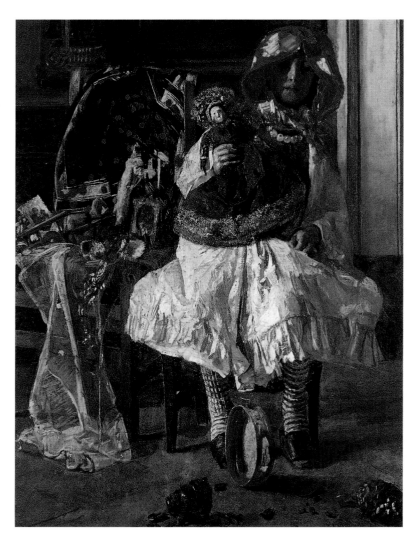

rendered with a vibrant stroke and palette of rich, warm colors, reflect all the existential neurosis of that period, as well as the conscious compromise reached with a demanding, frivolous market, whose preferences had to be learned well, as will be seen later, in the pages dedicated to the merchant Goupil (pages 38-41).

## Degas and His Ballerina

In 1881, a critic commented on the sculpture shown by the now-famous Degas titled *The Little Fourteen-Year-Old Dancer*: "I do not ask that Art always be pretty, but I do not think its role is to show ugliness intentionally. Your *rat de l'Opéra* (as the youngest pupils are still known) resembles a monkey, an Aztec, a fetus." The critic's advice was to put the little statue in an anthropology museum. Degas noted that Maria Von Goethem, who was his model, really did have all the spontaneity of the "street breed," the same trait found in the creatures of Zola's novels, such as *Nana* or *L'Assommoir*, a text that seems to have provided inspiration for the artist's pastels of criminals. The wax ballerina was the product of a culture driven to explore *The Expression of the Emotions in Man and Animals* analyzed by Darwin, who saw vice as a reflection of the environment and also as a hereditary factor, as theorized by the Italian psychiatrist and anthropologist Cesare Lombroso. In that artistic milieu, there was also much interest in the examples of tribal art that were beginning to appear in ethnographic exhibitions. The girl in the tutu therefore made an impression for her "intense realness" (Huysmans), arousing nervousness in the spectator, and in one fell swoop ruined many other experiments in Naturalist sculpture being carried out at the time (artists like Amédée-Jules Dalou, the aforementioned Meunier, and others). Degas's ballerina, swathed like an ancient devotional statue or a tribal

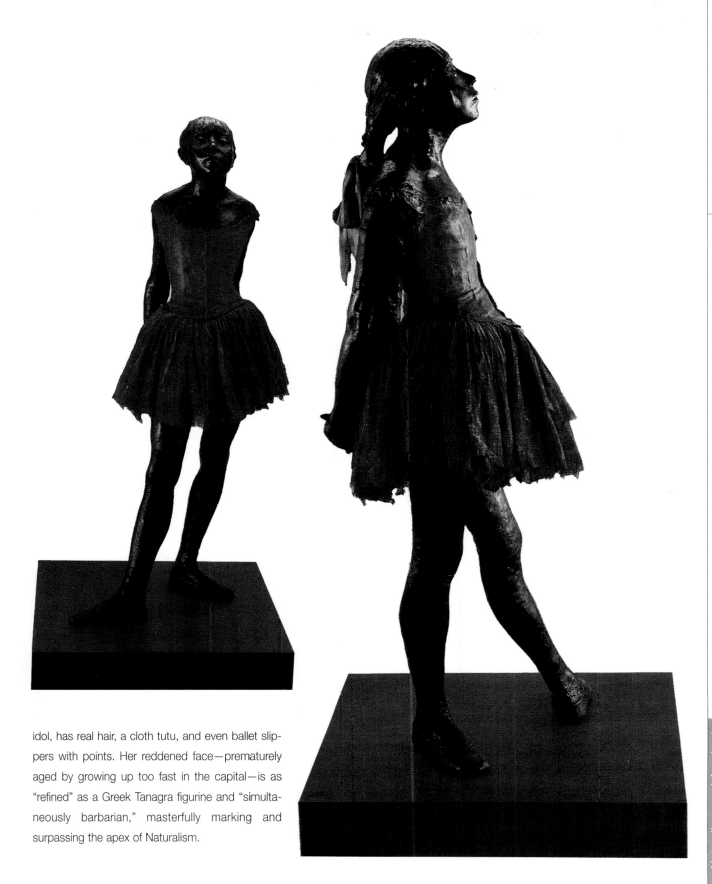

idol, has real hair, a cloth tutu, and even ballet slippers with points. Her reddened face—prematurely aged by growing up too fast in the capital—is as "refined" as a Greek Tanagra figurine and "simultaneously barbarian," masterfully marking and surpassing the apex of Naturalism.

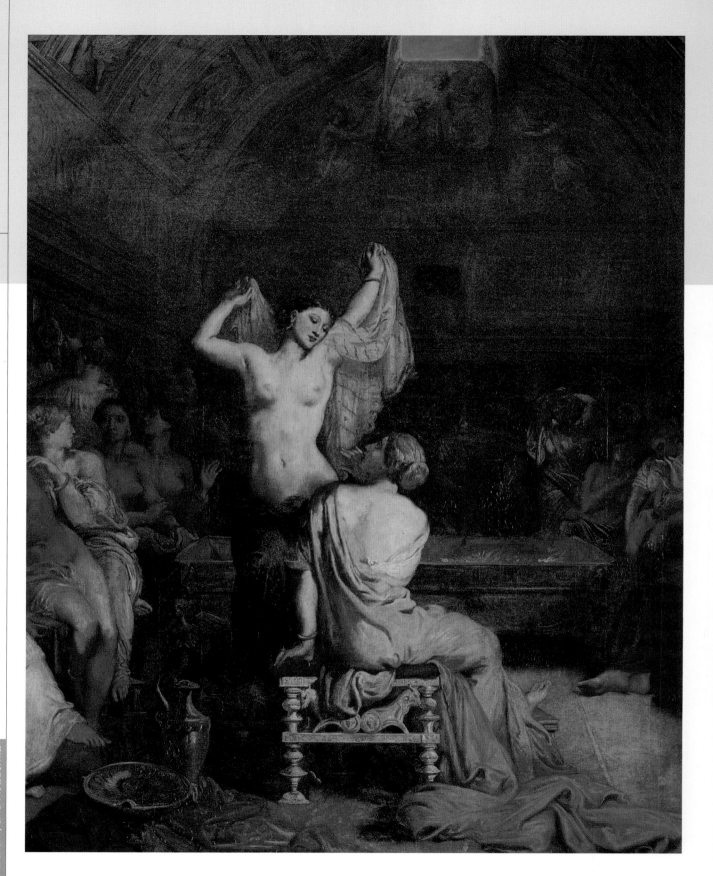

# Hints of the Orient and of Antiquity

The Orient, the legendary point of reference for every century, opened its mysterious doors to Western culture above all in the 1800s. A penchant for that world stimulated the fantasy of artists and literati: even a writer of the caliber of Gustave Flaubert, committed to pragmatism, found inspiration for his *Salammbô*. Nonetheless, during the years of Realism, the Oriental languor of odalisques by Ingres—leader of *l'art pour l'art*—and the passion expressed by Delacroix's whirlwind scenes (*Death of Sardanapalous* and *The Lion Hunt*), the dreams of Gleyre or Vernet, were infiltrated by a type of evocation that was more scrupulous in its reconstructions, as required by the scientific spirit of an era dominated by Positivism,

although this did not diminish poignant nuances and longings that are eloquent descriptors of the sensitivity of that period. If the paintings of Eugène Fromentin or Alfredo Pasini, depicting markets or desert hunting scenes, show an Oriental landscape (as described by the painter Coriolis in the novel *Manette Salomon* by the brothers Goncourt) that is *fin, nuancé, vaporeux, volatilize, et subtil* but permeated by a faint veil of disquiet, those of Gérôme or Henri Regnault offer an Oriental scenario that might lend itself to accepting strong, disturbing themes: abductions, sale of slaves, and beheadings (as in the *Summary Execution Under the Moorish Kings of Grenada*, presented by Regnault at the 1870 Salon). Thus, a sort of fusion occurred, revealing the contradictory cultural climate among the need for truth, realism, and a desire to flee from the daily grind, the

Henri-Alexandre-George Regnault
*Summary Execution Under the Moorish Kings of Grenada*
Opus signed and dated "Tanger 1870," oil on canvas.
Paris, Musée d'Orsay.

*Above and facing page:*
**Théodore Chassériau**
*The Tepidarium*, full and detail
1853, oil on canvas.
Paris, Musée d'Orsay.

**Alberto Pasini**
*The Market of Constantinople*
c. 1880–90, oil on canvas.

dismal, looming city squalor, with the present entwining with the past to evoke unsettling thoughts. Oriental luxuries, the brooding, mysterious superstitions of Egypt and Asia Minor—which were also very much in market demand—were flanked by scenarios of ancient Greece (for instance, Gérôme's *Young Greeks Attending a Cock Fight* on page 13) or Rome and Pompeii, whose civilizations were revived with philological scruple, referring to art no longer characterized by Neoclassicism's renowned pureness and distinctness, but as colorful and alive as archaeological discoveries revealed it to be. Théodore Chassériau's *Tepidarium* (pages 34–35), shown in 1853, was actually inspired by a part of the Pompeii baths that had just been brought to light and mediates an Ingres line and a Delacroix palette, with its disjointed, throbbing brushwork suggesting a senti-

ment of touching nostalgia. In France, the aficionados of these revisitations were numerous and mockingly known by their detractors as *pompiers*, alluding to the ancient helmets that resembled firefighter headgear: Gérôme was in the forefront, with Bouguereau, Papety, Baudry, and others not far behind.

The Gustave Boulanger work shown here also illustrates the extent to which the fashion for antiquity had spread and become a distraction for the well-to-do of the time. Dressed as Roman emperors, they would receive visitors in their metropolitan drawing rooms, where they were replete with reading novels that were quickly translated and distributed in Europe, including Cardinal Wiseman's *Fabiola*—which inspired, among others, the painting with the same title by Siena-born Cesare Maccari—or *The Last Days of Pompeii* by

**Gustave Boulanger**
*Studies for "The Flute Player" and of "Wife of Diomedes," in the hall of Prince Napoleon's Pompeii-style house, Avenue Montaigne*
1861, oil on canvas.
Versailles, National Museum of Versailles.

English writer Bulwer-Lytton, which gave Domenico Morelli ideas for *The Pompeiian Bath*, presented at the 1861 Florence national exhibition, and which had fascinated him precisely for the combination of history and fantasy the novel proposed.

So, not just digressions on the Orient, but also on the ancient worlds of Greece and Rome, were able to arouse similar suggestion where, for instance, the scenarios of imperial corruption could assume the dramatic evidence of daily reality, thanks to the incumbent truth from archeological reconstructions. Examples (not illustrated here) include Giovanni Muzzioli's *Poppea's Revenge*, set in Nero's Domus Aurea, or *The Parasites*, a group by sculptor Achille D'Orsi, shown in Naples in 1877, which invited meditation on the concept of *corruptio optimi pessima* ("the corruption of the best is the worst of all") and where the decadence of an era, translated into an impartial investigation of truth, is seen to be relevant to contemporary moral decline. An aspect that also emerged in the works of the Dutch artist Alma-Tadema moreover combined with a strong visionary and aesthetically inclined component. In a famous canvas of his, dated 1888, Emperor Elagabalus (a name taken by Marcus Aurelius Antoninus) is seated opposite a statue of Dionysius (now in the Vatican), banqueting while he watches the death of his guests suffocated by rose petals: it is said that during the months the painter worked on the canvas, the floor of his studio was strewn with masses of roses brought from the Cote d'Azur.

**Lawrence Alma-Tadema**
*The Roses of Elagabalus*
1888, oil on canvas.

# The Role Played by Art Merchants and the Success of the Goupil "Stable"

In the second half of the 1800s the art-dealer phenomenon acquired a more international dimension than it had enjoyed in preceding centuries. There had always been mediators for collectors (from the time of Isabella d'Este, as early as the 1500s, to the Grand Tour), but the privileged rapport between the artist and the patron had been more important than that tying the artist to the merchant. Now the merchant became the figure who on one hand skillfully directed public tastes, imposing his own artistic choices, and on the other guided the artist toward themes that might be appreciated by rich middle-class clients. In his novel *L'oeuvre*, inspired specifically by the Impressionists, Zola described two types of dealers: one was Père Malgras, a bold talent scout who was quick to make a profit, and the other was the worldly, critical Naudet. This was the backdrop for the establishment and triumph of Maison Goupil, founded by Jules-Adolphe Goupil in 1829, in partnership with the German dealer Henri Rittner, for the trade and printing of etchings and lithographs from ancient and contemporary artworks made by the heliographic process, which ensured true likenesses to the original. Soon the company was also involved in selling the actual works of art, signing up artists with exclusive contracts. Goupil not only had branches in Paris—in Rue Chaptal, on Boulevard Montmartre, and at L'Opéra—but also

**Jean-Léon Gérôme**
*Slave Market*
1866, oil on canvas.
Williamstown (Mass.),
Sterling and Francine
Clark Art Institute.

**Jean-Louis-Ernest Meissonier**
*Young Man Writing*
1852, oil on panel.
Paris, Louvre.

opened in London (1841), New York (1845), Berlin and The Hague (1860), Vienna (1865), and Brussels (1866), with an extended network of points-of-purchase, from Warsaw to Athens but even reaching Havana, Melbourne, and Johannesburg!

Artists under contract to Goupil, converted to "girlies and parrots" (as Martelli commented acidly about De Nittis), were almost all disciples of Meissonnier or Gérôme, and even though they came from different countries—from France to Italy, from Hungary to Holland and Spain—they all focused on the choice of highbrow subjects that met public expectations. One of the most prolific artists of the "stable," excelling in Oriental and neo-1700s themes, was Mariano Fortuny: a Spanish artist who died in 1874, but who still launched an outright style, *Fortunismo*, imitated not just by Spanish artists (Madrazo, Zamaicos, Villegas, Ríco, Cortazo) but all over Europe. Fortuny's works revived the splendor and light of 1700s paintings, translated with swift, splintered brushstrokes into a seductive, colorful force. The critic Francesco Netti mocked Fortuny's imitators and their "delirium of gowns with trains, lace, embroidery and pretentious fabrics," pointing out: "Then came needless unbending movements, reasonless strange lines....We left the Academy of nude heroes and stumbled into the Academy of clothed squires." Boldini—who praised Goupil's ability to "make artists sparkle beyond all belief"—introduced dynamic stances to neo-1700s subjects, so that the sentiments and passions depicted were comparable to those of contemporary Parisian high society. But the identification of the middle classes in

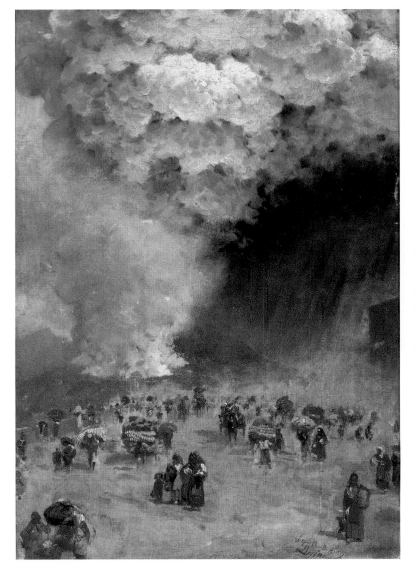

**Giovanni Boldini**
*Due signore col pappagallo*
c. 1873, oil on canvas.

**Giuseppe De Nittis**
*Rain of Ashes*
1870, oil on canvas.
Florence, Pitti Palace,
Modern Art Gallery.

the customs of a closer century—and even reflected in literature, in particular the works of Jules and Edmond de Goncourt—was flanked by the interest in exotic worlds, also likely to stimulate the onlooker to an identification process. The trips made by Gérôme and Albert Goupil (who were brothers-in-law) to southern Italy explain the presence in the "stable" of the large group of artists that included sculptor Vincenzo Gemito and painters Antonio Mancini, Edoardo Dalbono, and Francesco Paolo Michetti, whose subjects inspired by popular life and the folklore of religious feasts were much appreciated by the attitude of the period, which delighted in the "authentic feel" of humble figures. Morelli, however, for whom Goupil made direct sale of works like *The Madonna of the Golden Stairs* and *The Temptation of Saint Anthony*, did not succumb to

the dealer's charms and refused to give him exclusive rights of sale. Less "commercial" paintings were supported by dealers like Théo van Gogh, brother of Vincent, and Durand-Ruel. The latter founded and personally financed (in 1869) the *Revue Internationale de L'Art et de La Curiosité* and supported the Impressionists right from the start, opening galleries in London, Brussels, and New York, where an 1886 exhibition confirmed the success of Impressionism in the United States. In Italy the painting of the so-called Scapigliatura, then that of the Divisionists (Previati, Segantini, Morbelli, and others), was circulated mainly by two brothers, Alberto and Vittore Grubicy, who signed Segantini and Longoni under contract in 1878 and in 1888 took part in the Italian art exhibits in London.

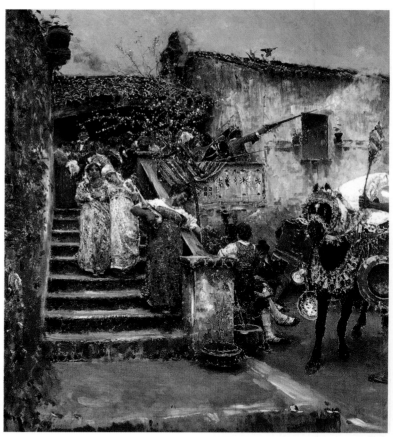

**José García Ramos**
*A Spanish Courtship*
Oil on canvas.
Madrid, Collécion
Carmen Thyssen-
Bornemisza.

**Francesco Paolo
Michetti**
*Wedding in Abruzzo*
1876, oil on canvas.

**Domenico Morelli**
*The Temptation of Saint
Anthony*
1878, oil on canvas.
Rome, National Gallery
of Modern Art.

**Mariano Fortuny**
*The Vicarage*
1870, oil on canvas.
Madrid, Museum of
Modern Art.

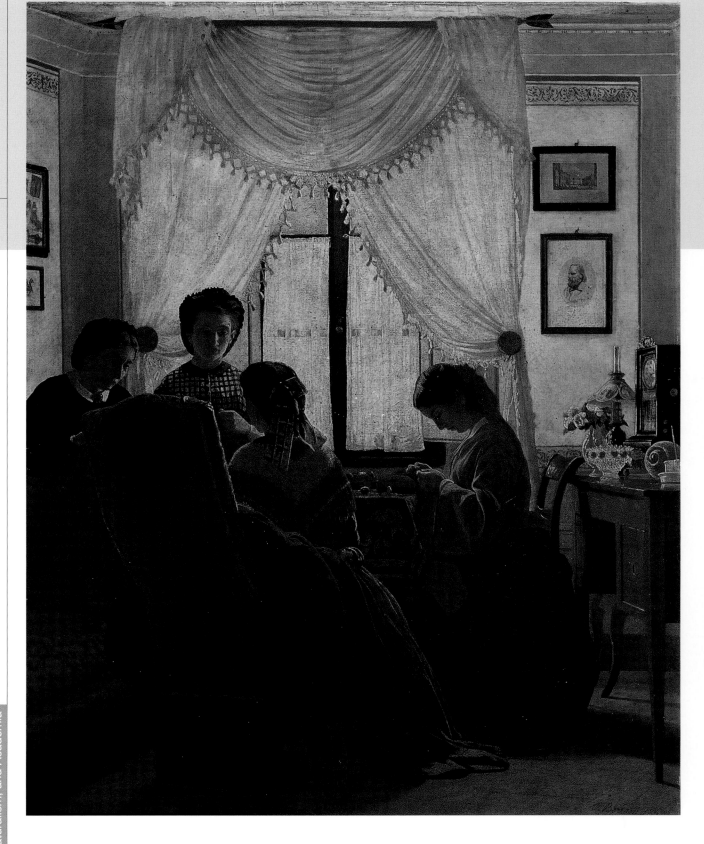

# Lifestyles

In 1863, at a crucial moment in Italian history, Odoardo Borrani depicted the patriotic fervor of several young women intent on sewing red shirts for Garibaldi's army. The furnishings in the drawing room where the scene is set are still Biedermeier, in a Tuscany that had been governed by Lorraine until just a few years earlier. Hence, the discreet elegance of the Empire furniture is matched by the objects: the decorated lamp with bright turquoise touches, the glass fruit bowl next to the huge shell, and the drapes hanging from a wood and metal arrow. Even though sobriety remained, especially in the provinces—confirmed by similar descriptions of interiors in novels of the time, including Flaubert's *Madame Bovary*—the big cities were converting quickly. The upper and middle classes, the latter playing an increasingly significant role, sought more lavish comforts for their homes, suitable for frivolous society gossip, playing instruments such as the harpsichord, or a furtive boudoir rendezvous. Moreover, salons and world exhibitions were crowded with people who were starting to discover that art was a form of social redemption. Flaubert commented on this when he visited one Universal Expo and was overwhelmed by the number of artworks, not necessarily of good quality—objects being made haphazardly and on an industrial scale, in less noble materials—but on the surface very eye-catching: "So many people who, a century ago, would

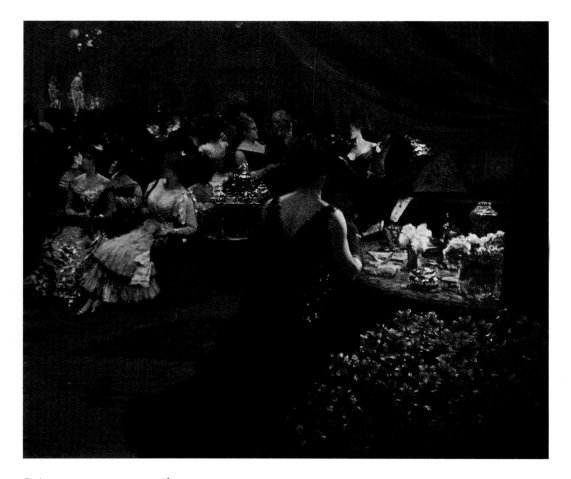

*Facing page:*
**Odoardo Borrani**
*The Seamstresses of Red Shirts*
1863, oil on canvas. Montecatini, private collection.

*Above:*
**Giuseppe De Nittis**
*The Salon of Princess Mathilde*
1883, oil on canvas.

have lived without fine arts, now need *small* music, *small* statuettes, *small* literature!"

Yet the desire to corroborate a status quo through the purchase of paintings, sculptures, furniture, and knickknacks was sustained by art dealers, who cannily forecast how tastes would evolve, from the French 1700s revival, a vehicle for the painting of iconographies for pleasure, to a penchant for the Orient. An accomplished eclecticism can be seen in the mélange of styles found in homes and in the studios of fashionable artists. One example is Tissot, who in *Hide and Seek* (c. 1877) depicted his drawing room in Grove End Road, in London's St. John's Wood, with children playing and a woman lost in her reading: here the furnishings reveal a definite taste for the exotic, with Persian carpets and tiger skins, and other pelts thrown over the armchairs, as well as painted screens and an oil lamp assembled in a porcelain vase on a Chinese table. These lavish items are offset, however, by the plain white holland blinds at the window, with a winter garden visible outside. In a coeval painting, Mihály Munkácsy, a wealthy Hungarian artist living in Paris, showed antique, exotic fabrics and many palms amid period furnishings, from a Henri II cabinet to a Louis XIII armchair, inspired by the French Renaissance. This exuberance contrasts with the simplicity of Nordic homes at the turn of the century, whose furnishings and atmospheres were depicted by the Swedish artist Carl Larsson in his moving testimonies of the interior of his own country dwelling, where he lived with his wife Karin: an exquisite, refined, and joyous marriage of the openness of Art Nouveau and the popular taste for local crafts.

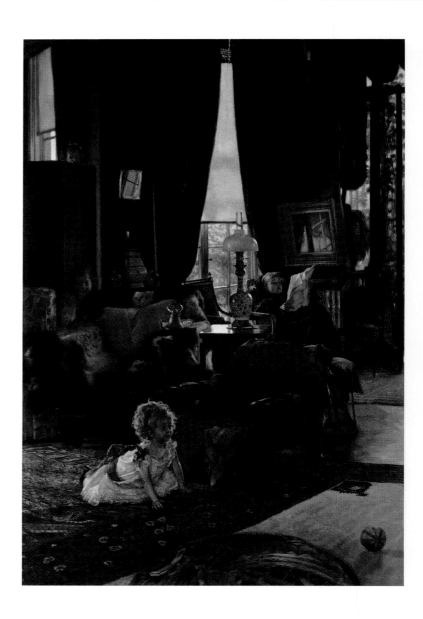

**James-Jacques-Joseph Tissot**
*Hide and Seek*
c. 1877, oil on panel.
Washington, National
Gallery.

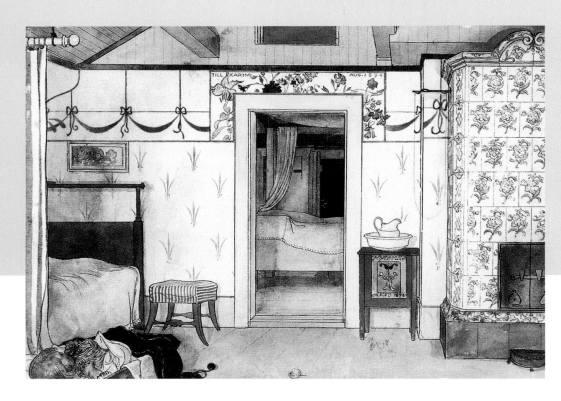

**Carl Larsson**
*Brita's Forty Winks*,
from the Ett Hem series
1894, watercolor.

**Mihály Lieb Munkácsy**
*Paris Interior*
1877, oil on canvas.
Budapest, Hungarian
National Gallery.

Realism, Naturalism, and Academia

# Jean-Baptiste Carpeaux

(b. Valenciennes 1827, d. Paris 1875)

After studying at the École des Beaux-Arts under Théodore Duret and François Rude, Carpeaux won the Prix de Rome in 1854. While staying at Villa Medici, he designed and sculpted *Ugolino and His Sons*, from which he later cast the bronze shown here. Princess Mathilde (cousin to Napoleon III) introduced Carpeaux to the imperial family, and he became their preferred artist. In 1865, Carpeaux sculpted a portrait of the young prince (*The Imperial Prince and His Dog Nero*), to whom he also taught drawing, and produced portraits of other members of the court. The artist was highly sought-after in Second Empire Paris; between 1863 and 1866, he decorated the Pavillon de Flore facade on the Seine with allegorical groups (*Imperial France Protecting Agriculture and Science* and *The Triumph of Flora*). Carpeaux achieved great fame with *The Dance* (1863–69); he repeated this work's compositional arrangement in *The Four Parts of the World* (1869–72, Jardin del'Observatoire).

**Jean-Baptiste Carpeaux**
***Self-Portrait as Henry IV***
1870, oil on canvas.
Versailles, National Museum of
Versailles.

Jean-Baptiste Carpeaux
***Ugolino and His Sons***
1862, bronze.
Paris, Musée d'Orsay.

For this work, executed during his years of study in Rome, Carpeaux chose Canticle XXXIII of *Inferno* (Archbishop Ubaldini imprisoned Ugolino della Gherardesca, the tyrant of Pisa, with his sons and grandsons in a tower without food; he eventually devoured them, then perished himself), which he illustrates with a homage to Michelangelo's *Last Judgment*. The bronze glimmers in the light, and its partial, refined disharmony contradicts the canons of Romantic sculpture, where the pathos of affections lies in the criterion of reality and not actual "truth."

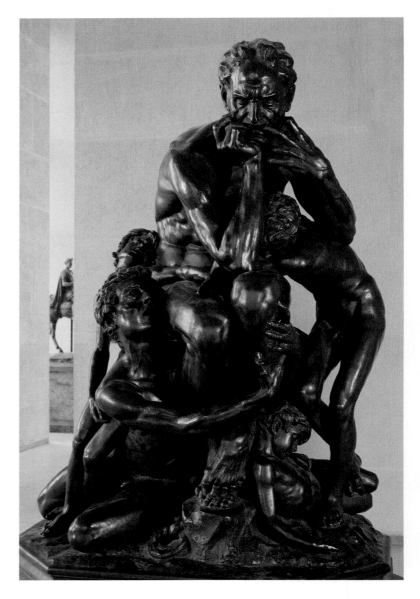

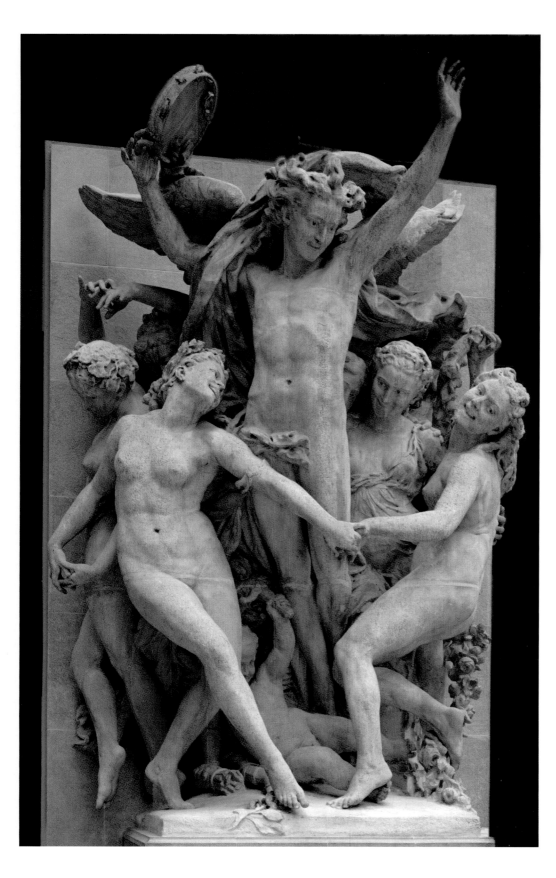

**Jean-Baptiste Carpeaux**
*The Dance*
1863–69, limestone.
Paris, Musée d'Orsay.

# Gustave Courbet
## (b. Ornans 1819, d. Vevey 1877)

Courbet was born in the region of Franche-Comté, and he later painted the area's places, customs, and traditions. From 1840, he resided in Paris, where he attended the Père Lapin and Père Suisse academies, and worked in the studios of Steuben and Hesse. Courbet also traveled to Amsterdam, as he greatly admired sixteenth- and seventeenth-century Dutch paintings. He exhibited *Self-Portrait with Black Dog* at the 1844 Salon, but in about February 1848, at the time of the revolution, his style shifted toward Realism. The revolution inspired paintings like *The Stonebreakers* (1849; see page 9), which led to the creation of the Pavilion of Realism in 1855. During the last ten years of his life, he focused on sea paintings, hunting scenes, and studies of animals. Courbet also acted as delegate for Fine Arts under the Paris Commune. He was later imprisoned, and after fleeing to La Tour-de-Peilz (Vevey, Switzerland), he was fined in 1874 for his part in destroying the Vendôme Column. He died a month after all of his works had been put up for auction.

**Gustave Courbet**
*Self-Portrait with Pipe*
1848–49, oil on canvas.
Montpellier, Fabre Museum.

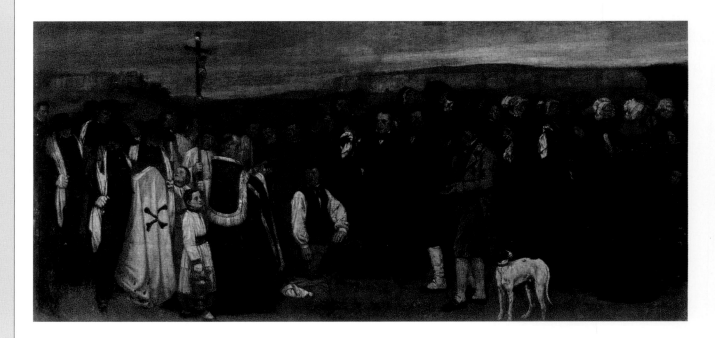

**Gustave Courbet**
*Funeral at Ornans*
1848–50, oil on canvas.
Paris, Musée d'Orsay.

In this large-scale painting, the composed depiction of a country funeral replaces a more elevated academic subject, and its impact is that of a chapter of modern history. The canvas aroused outrage in both critics and the public ("How can anyone paint such ugly people?"), and Jules Champfleury wrote to George Sand that it was the "first canon shot" in the subversion of art. Then Paul Mantz described it as the "pillars of Hercules of Realism," a limit beyond which it was impossible to proceed without risking the decline of painting. Delacroix, however, came to its defense and declared parts of it to be "superb": the figures of the priests, the altar boys, the holy water urn, and the despairing women.

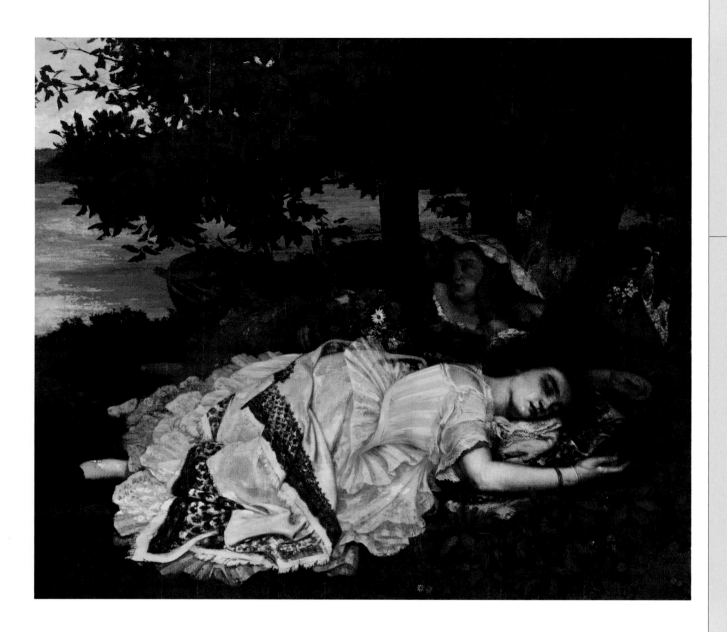

**Gustave Courbet**
*Young Ladies on the Bank of the Seine*
1856, oil on canvas.
Paris, Musée du Petit Palais.

For the philosopher Prud'hon, the young ladies—
sprawled in intensely languid and flirtatious poses,
whom the artist renders in all their physical appeal—
represent a ferocious criticism of the decadent
bourgeoisie.

**Silvestro Lega**
*Self-Portrait*
1856–60, oil on panel.
Florence, Uffizi Gallery.

# Silvestro Lega
(b. Modigliana, Forlì 1826, d. Florence 1895)

Lega moved to Florence in 1843 and studied under Enrico Pollastrini and Antonio Ciseri at the Accademia di Belle Arti, as well as with the Purist Luigi Mussini. In 1852, he exhibited *David Placating Saul* at the Accademia's Triennale. From 1860, he became a guest of the Batelli family in the Piagentina countryside, where he executed the first studies marking his changeover to the Macchiaioli movement. In 1861, he participated in the First National Exhibition with *Ambush of the Italian Bersaglieri* and *Return of the Italian Bersaglieri*. Lega's presence in Piagentina attracted other artists to the area (Borrani, Abbati, Signorini, and Sernesi), but after Virginia Batelli's death in 1870, he went to Romagna. After years of misery and economic hardship, Lega returned to Florence in 1880 to be near his close friends. From 1886, he often visited the Gabbro countryside, continuing to paint enthusiastically despite serious eyesight problems.

**Silvestro Lega**
*The Folk Song*
1867, oil on canvas.
Florence, Pitti Palace, Modern Art Gallery.

The canvas shows Lega's expressive mastery in overlapping variety in Nature and the formal unity of Tuscan 1400s painters, elevating an everyday subject (Virginia Batelli playing the piano while younger friends and pupils, Maria and Isolina Settimelli, sing a folk song or *stornello*, probably of a patriotic nature) to the solemn dimension of an ancient altarpiece. An equilibrium between emotion and intellectual speculation is indeed created in that severe monumental synthesis, as Lega uses the geometries and crystal-clear light of a Piero della Francesca to express his private considerations on affections and on the magic, but fleeting, deferral of particular moments, disengaged for an instant from the passage of time. In this aspect, the purist training that Lega received from Luigi Mussini (a follower of French artists like Ingres and Flandrin) plays its part and is similar to that of Degas. Lega's research can actually be compared to that of the French artist's work in Florence, when he composed his *Bellelli Family* (see page 16). There are hints of a mission shared with artists of different milieus and nationalities, nonetheless seeking the key to modern realism by reference to the teachings of fourteenth- to seventeenth-century masters.

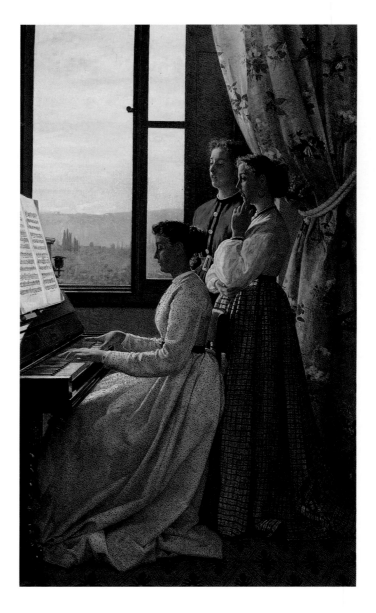

# Franz von Lenbach
(b. Schrobenhausen 1836, d. Munich 1904)

As a student at the Academy of Fine Arts in Munich, Lenbach took courses with Karl Theodor Piloty in 1857 and studied *en plein air* with Johann Baptist Hofner. He traveled to Italy in 1858, and in 1863 he met Anselm Feuerbach, Hans von Marées, and Böcklin in Rome; in 1865, he went to Florence. Lenbach won a medal at the Paris Universal Expo in 1867. After a trip to Morocco in 1868, he settled in Vienna, where his friend and fellow painter Hans Makart lived. In Vienna he became an acclaimed portrait artist and won a prize for *Emperor William I* (1873). In 1876, Lenbach moved to Munich, and in 1878 he painted the first of many portraits of Bismarck; he gained widespread recognition in this city as well. Lenbach was given an aristocratic title in 1882 and assumed such official duties as the creation of the Bayerisches Nationalmuseum. In 1886, he acquired an estate in Munich and designed a Florentine-style villa with architect Von Seidl.

**Franz von Lenbach**
*Self-Portrait*, detail
1895, oil on cardboard.
Munich, State Gallery in
Lenbachhaus.

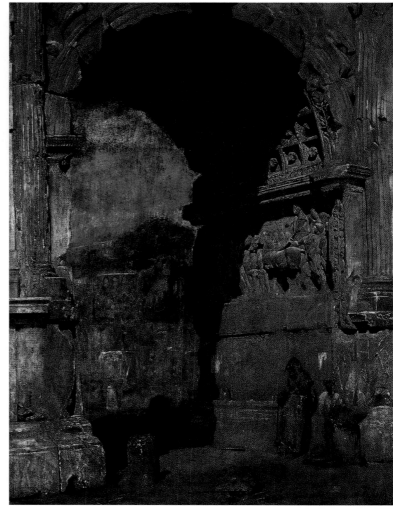

*Above:*
**Franz von Lenbach**
*Young Shepherd*
1860, oil on canvas.
Munich, Bayerische
Staatsgemälde
Sammlungen, Schack
Galerie.

*Right:*
**Franz von Lenbach**
*The Arch of Titus*
Opus signed and dated
"Rom 1858," oil on
canvas.
Munich, State Gallery in
Lenbachhaus.

"Nature was the word on the flag I flew when I arrived in Rome, and guided by this course, I made my studies on the Arch of Titus." The painting translates a mood balancing between eternity and decay.

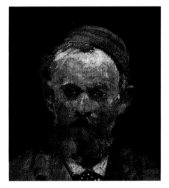

# Édouard Manet
(b. Paris 1832, d. 1883)

After a trip to Rio de Janeiro as a young man in 1849, Manet obtained his father's permission to join Thomas Couture's atelier in Paris, where he stayed until 1856. In 1852, he visited Holland and possibly Prague, Vienna, and Munich. In 1853, Manet met Delacroix and also traveled to Italy; he returned to Italy in 1857. That same year, he met Fantin-Latour while copying Venetian paintings at the Louvre. In 1861, he exhibited *Portrait of Monsieur and Madame Auguste Manet* at the Salon along with *The Spanish Guitarist* (New York, Metropolitan Museum of Art), which received an honorable mention. In 1863, Manet exhibited *Déjeuner sur l'herbe* at the Salon des Refusés, and in 1865 he unveiled the

**Édouard Manet**
*Self-portrait with Skull Cap*, detail
1878, oil on canvas.
Tokyo, Bridgestone Museum
of Art.

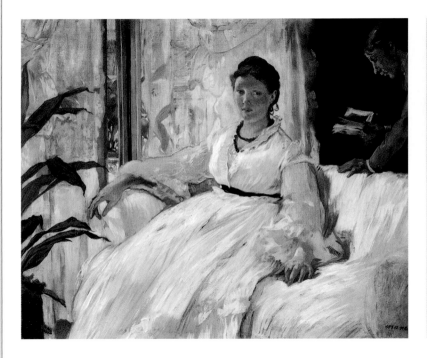

**Édouard Manet**
*Reading*
1865, oil on canvas.
Paris, Musée d'Orsay.

The painting dwells on the harmony of very pale shades, from the white of the curtains and the dress to the complexion of Suzanne, the artist's wife. The figure of Léon Koella, her son, was added later.

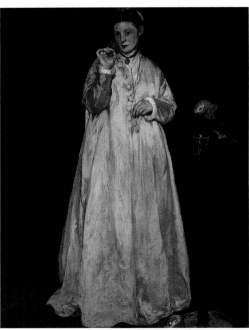

**Édouard Manet**
*Young Lady in 1866 (Woman with a Parrot)*
1866, oil on canvas.
New York, Metropolitan Museum of Art.

Émile Zola praised the young woman's "charm," a mix of grace and severity, but the work was attacked by official critics as lacking harmony.

famous and "scandalous" *Olympia*. Manet met Émile Zola in 1866, and during that same year his painting *The Fifer* was rejected by the Salon. In 1867, Manet arranged his own personal exhibit (as Courbet had done previously) near the Universal Expo with the following invitation: "Do not come to see perfect works, but to see sincere works"; in 1878 he again organized his own exhibit, with the motto "Either in thousands or alone." In 1870, Manet enlisted in the military to fight against the Prussian siege. The following year, he published a manifesto supporting the creation of a federation of artists in the *Journal Officiel*. In 1872, the art dealer Durand-Ruel, who had acquired twenty-four of Manet's paintings, exhibited fourteen of them at the Society of French Artists in London; that same year, Manet returned to Holland. It was during that time that he began to suffer from depression. In 1873, Manet met Mallarmé; he later worked with the poet by illustrating the translation of Edgar Allan Poe's *The Raven* (1875) and Mallarmé's *Afternoon of a Faun* (1876). Manet exhibited various works at the Salon and had frequent contact with the Impressionists, yet while he supported these artists, he did not exhibit with them. In 1881, he won a prize at the Salon and was awarded the Legion of Honor.

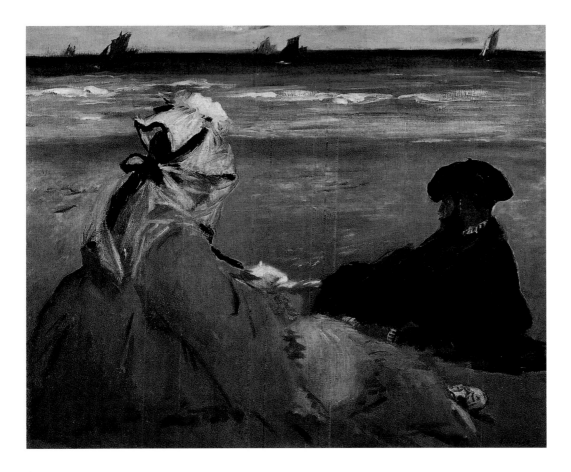

**Édouard Manet**
*On the Beach*
1873, oil on canvas.
Paris, Musée d'Orsay.

The canvas, probably painted from life (there are traces of sand on the canvas), portrays Suzanne Manet and Eugène, the painter's brother (who shortly after married the artist Berthe Morisot), on the Normandy beach of Berck-sur-Mer. The high horizon and the formal, chromatic sectioning suggesting two-dimensional effects make it the most Japanese of Manet's works.

# Adolf von Menzel
(b. Breslau 1815, d. Berlin 1905)

Menzel started out as an illustrator in his father's lithography studio, then studied at the Königliche Akademie der Künste, where he became a professor in 1865. Although his early works were in the Biedermeier style (*The Balcony Room*, 1845), he later turned to Realism and finally, in the late 1870s, focused on industrial scenes. He participated in the 1848 revolutions (referred to in *Victims of the March Revolution in Berlin Lying in State*). Menzel traveled to Vienna and Prague (1852), Paris (1855), and Dresden (1857). In 1867, he returned to Paris, where he exhibited *The Coronation of King William I* in 1868. He also became interested in *plein air* paintings (*Afternoon in the Tuileries Gardens*). In 1884, a retrospective exhibition was held at the National Gallery in Berlin, followed by exhibits in Paris (1885) and London (1903); in 1899, he participated in the Paris Universal Expo against Bismarck's wishes. Faithful to the motto *Nulla dies sine linea* ("no day without a line"), Menzel also took up photography in his later years.

**Adolf von Menzel**
*Self-Portrait*
1882, pencil.

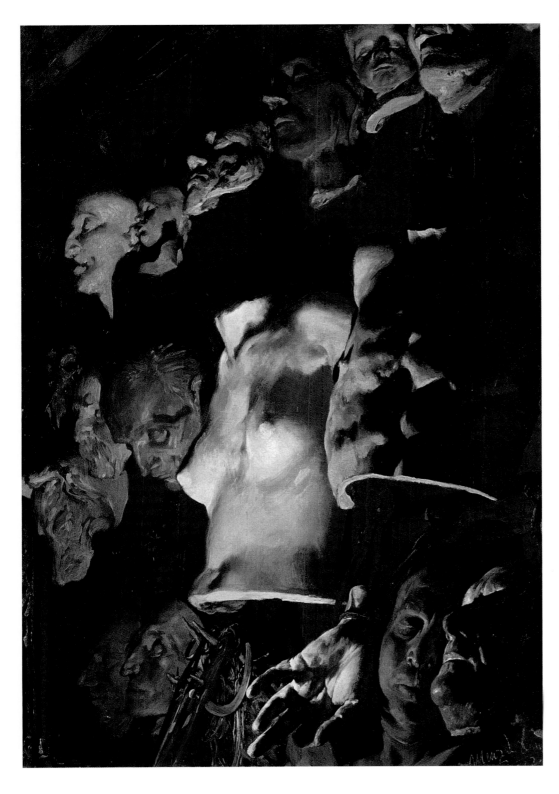

**Adolf von Menzel**
*Studio Wall*
1872, oil on canvas.
Hamburg, Kunsthalle.

In this Realist still life,
but with transforming
light effects and visionary
accents, Menzel expresses
the aesthetics and poetry
of the fragment, as
opposed to academic
values, also seen in an
1852 work, now in the
State Museum of Berlin.
Theater-style light
illumination seems to
render life to the
inanimate plaster models,
which include masks of
Dante and Schiller, side
by side near the
compasses, as well as that
of Wagner on the far
right, the Venus de Milo,
and a bust of Laocoon.

*Facing page:*
**Adolf von Menzel**
*Menzel's Sister Emilie,
Sleeping*
1848, oil on paper
mounted on canvas.
Hamburg, Kunsthalle.

# John Everett Millais
(b. Southampton 1829, d. London 1896)

After completing his studies at the Royal Academy and producing the first examples of his brilliance as an academic painter, Millais met W.H. Hunt; together with Rossetti, they founded the Pre-Raphaelite Brotherhood in 1848. At the age of nineteen, Millais exhibited *Isabella*, an expression of the group's ideals. Paintings with religious, literary (*Ophelia*), and contemporary (*The Return of the Dove to the Ark*, 1851) subjects then followed. In 1853, just when the group was about to dissolve, he was elected to the Royal Academy. Millais fell out with Ruskin in 1855, and married Ruskin's ex-wife. He painted *The Black Brunswicker*, a contemporary reinterpretation of a theme Millais had dealt with during his youth in *The Huguenot*. From that point, Millais painted with fewer minute details and less precision, applying the paint more freely. He became a renowned portrait artist and participated in the 1878 Paris Expo; he was elected president of the Royal Academy not long before his death.

**William Holman Hunt**
*Portrait of John Everett Millais*
1853, pencil.

**John Everett Millais**
*The Blind Girl*
1854–56, oil on canvas.
Birmingham,
Birmingham City
Museums and Art
Gallery.

The realism of the image conceals a profound meditation on human destiny: the cloying tone the scene might have risked is redeemed by the poetry with which the blind girl raises her eyes to the rainbow-furrowed sky. She feels the blades of grass and the flowers, and she perceives the odors distinctly, enhanced by recent rain, while her friend hugs her and a butterfly, symbolizing the soul, alights on her shoulder.

*Facing page:*
**Domenico Morelli**
*Christian Martyrs*
1855, oil on canvas.
Naples, Capodimonte
Museum.

The painting depicts the bodies of Martyrs Justina and Cyprian transported during the night by angels from the Roman amphitheatre to the catacombs and, despite its small size, is handled in such a way that it manifests great evocative power. Echoes of seventeenth-century Ribera- and Stanzione-type Naturalism are united with the brilliant, lively application of color (with patriotic references), in the style of Delaroche, revealing the artist's skill in merging the imaginative dimension with reality. The opus was praised by critics of the time for its arrangement of light, with a chink of twilight that adds solemnity and truth to the scene.

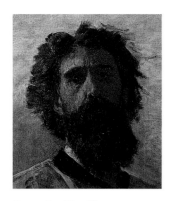

**Domenico Morelli**
*Self-Portrait*, detail
1896, oil on canvas.
Florence, Uffizi Gallery.

# Domenico Morelli
(b. Naples 1823, d. 1901)

Morelli was educated at the Accademia in Naples, but soon incorporated the Realist aspirations that characterized Gigante's and Palizzi's works. After the 1848 Florence uprisings, where he also met Pasquale Villari, Morelli traveled to Paris to visit the Universal Expo. In Florence, Morelli joined artists who met at the Caffè Michelangelo, and in 1861 he exhibited seven works in the First National Exhibition (including *Count Lara*, *The Iconoclasts*, and *The Pompeian Bath*). He became an internationally successful artist, in part due to assistance from the dealer Vonwiller, and was involved in reforming the Naples Institute of Fine Arts, establishing the Arts and Industries Museum (dedicated to applied arts), and being a philanthropist. During his later years, Morelli's work took a more mystical turn; he was the only Italian chosen to illustrate the *Amsterdam Bible*, along with other famous artists including Gérôme, Puvis de Chavannes, Leighton, and Alma-Tadema.

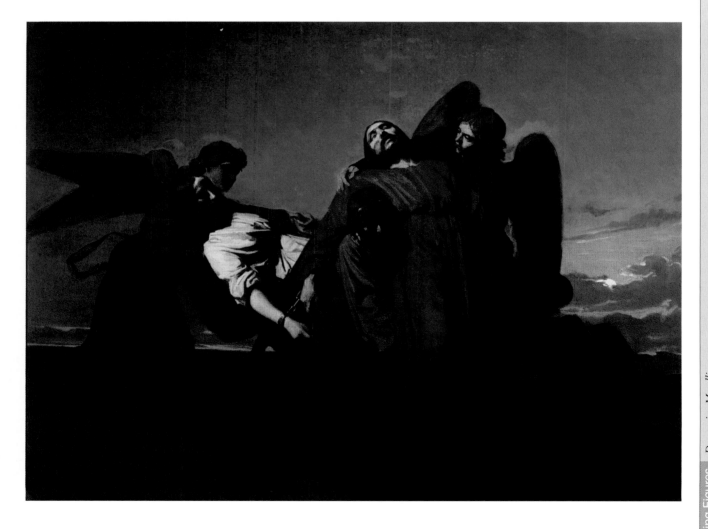

**Charles Lutwidge Dodgson
(Lewis Carroll)**
*Dante Gabriele Rossetti on
October 6, 1863*
1863, album imprint.

# Dante Gabriele Rossetti
(b. London 1828, d. Birchington-on-sea 1882)

The son of an Italian political exile and Dante Alighieri scholar (from whose writings he derived political interpretations, as well as the ideologies of ancient mysterious initiation cults), Rossetti composed his first poems before the age of twenty. He found the academic atmosphere in London to be stifling and did not complete his studies. In 1848, Rossetti founded the Pre-Raphaelite Brotherhood with Hunt and Millais. When the group began to dissolve in 1853, he lost interest in Naturalism and preferred the themes of Dante Aligheri, Shakespeare, and Browning. In 1857, Rossetti, Burne-Jones, and Morris painted the murals in the Oxford Union, which was the culmination of his Medieval-inspired works. From 1859, Rossetti devoted himself almost entirely to female portraits, emphasizing both human and spiritual beauty—from *Bocca Baciata* to *La Pia de Tolomei* (1868–80). The model was William Morris's wife Jan, following the suicide of Rossetti's wife, Lizzy.

**Dante Gabriele Rossetti**
*The Wedding of Saint
George and the Princess
Sabra*
1857, watercolor.

*Facing page:*
**Dante Gabriele Rossetti**
*Beata Beatrix*
c. 1863, oil on canvas.
London, Tate Britain.

The spirituality of Dante Aligheri's philosophy inspired the artist not only to write poetry on the joint themes of life and death, but also to produce paintings and drawings with Beatrice as the protagonist, including Dante's *Dream at the Time of the Death of Beatrice* (1871) and *The Blessed Damozel* (1875–81). This oil painting precedes the two latter and was inspired by the death of his wife Lizzy (Elisabeth Siddal) in 1862, which Rossetti likened to that of Beatrice, as Dante described in the *Vita Nuova*, imagining the departure of his beloved to the Kingdom of Heaven. The poppy, brought by a vermilion dove to the woman's lap, alludes to laudanum, the cause of Lizzy's death, whereas the sundial in the background marks the time of death of Dante's Beatrice (at nine), and the figure of Dante is seen among the streets of Florence. While the dominating colors of the green robe and vermilion dove are symbols—as a critic of the time observed, of hope and discouragement, life and death—the radiating light effect may derive from Rossetti's interest in Julia M. Cameron's early photographic technique.

# From Impressionism
# to Neo-Impressionism

*From Impressionism to Neo-Impressionism*

**Claude Monet**
*Impression, Sunrise*
Opus signed and dated
1872, oil on canvas.
Paris, Musée Marmottan.

*Previous page:*
**Claude Monet**
*Water Lilies*, detail
1908, oil on canvas.

## Nouvelle Peinture

In 1876, art critic Edmond Duranty wrote an essay on a subject he defined as *nouvelle peinture*, identifying the traits and artists of a group supported by art dealer Paul Durand-Ruel. Two years before, in Paris, these artists had founded an anonymous society of painters, sculptors, and engravers and had exhibited in the photographer Gaspard-Félix Tournachon's (called "Nadar"), atelier on April 15, 1874. The title of Monet's *Impression, Sunrise* led to the group subsequently being called Impressionists (the first was Louis Leroy in the journal *Le Charivari*) by both their admirers and their detractors. Their paintings emphasized the *netteté*

*de la sensation première*, as the critic Burty noted, commenting on the works the day after the inauguration of the show. These paintings included Cézanne's *The House of the Hanged Man* (page 69), Pissarro's *White Frost*, Claude Monet's important *Déjeuner sur l'herbe* (cut into pieces), Renoir's *The Theater Box*, and Berthe Morisot's *The Cradle*. The following year, these same artists confirmed their union with a public sale at the Hôtel Drouot and later organized exhibitions in 1876, 1877, 1879, 1881, 1882, and finally in 1886. Although Impressionist aesthetics were introduced to the public in 1874, the leading players of *nouvelle peinture* were often well-known painters who had been active for over a decade, as mentioned in the

**Eugène Boudin**
*The Beach at Trouville*
Opus signed and dated
1865, oil on panel.
Paris, Musée d'Orsay.

preceding chapter. These artists were intent on pursuing a movement that initially had many parallels to Realism, as the scandal surrounding Manet's *Olympia* demonstrated. This painting was acquired in 1890 by the Musée du Luxembourg (which also had academy paintings), thanks to fundraising led by Monet. During Monet's years of training in the academic painter Gleyre's atelier, he met Renoir, Sisley, and Bazille. Monet and Bazille experimented together in the Forest of Fontainebleau with this new form of painting; the former was also encouraged to paint "people, trees, light, in the outdoors, as they are" by Eugène Boudin, whose sea paintings of the Normandy coast were held in great esteem by Baudelaire, for they captured the most elusive sensations, successfully expressing the "date, hour and wind" in the clouds and waves. Monet's work *Femmes au Jardin*, exhibited at the 1867 Salon, attracted the attention of Zola, who commented, "You would have to love your own period truly to dare attempt such a *tour de force*, with fabrics split in two by shade and sunlight." Followers of *nouvelle peinture* often met at the Café Guerbois (11, Grande-rue de Batignolles, today Avenue de Clichy) or just outside Paris at the

Marlotte tavern at Chailly in Bougival, and after 1870 they chose the Café de la Nouvelle Athènes in Place Pigalle as their headquarters.

The year 1870 was a crucial one in the equilibrium of European history. During this period, Positivism fell prey to crisis, no longer offering certainties or barriers against the turbulence that had so far been kept in check by exploration of form. These painters, although inspired by "realist"

**Édouard Manet**
*Portrait of Stéphane Mallarmé*
1876, oil on canvas.
Paris, Musée d'Orsay.

**Claude Monet**
*Women in the Garden*
1866–67, oil on canvas.
Paris, Musée d'Orsay.

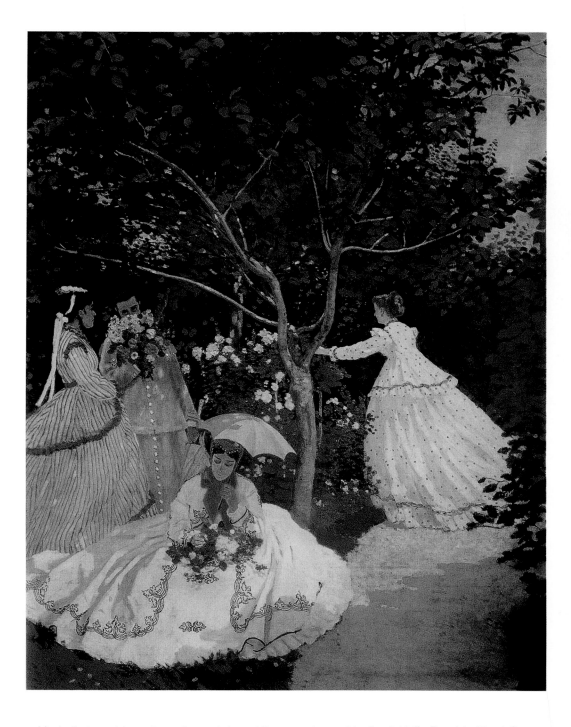

subjects that provide such an eloquent view of the period's middle-class society, chose to focus on a quest in which the principle of "truth" was less important than the pictorial expression pursued through new versification, the same used in poetry, as in Verlaine's *Art poétique*: "De la musique avant toute chose/Et pour cela préfère l'impair" ("Music first and foremost. In your verse/choose these

meters odd of syllable"). Renoir's friend George Rivière noted that their interest lay in "dealing with a subject for its tones and not for the subject itself." Aided by the arrival of new pigments and paint in tubes, which could be used anywhere and under any conditions, the *nouvelle peinture* followers developed a "system of colorist vibration comprising small areas of separate colors and of

**Gustave Caillebotte**
*The Parquet Planers*
1875, oil on canvas.
Paris, Musée d'Orsay.

**Alfred Sisley**
*Flood at Port-Marly*
Opus signed and dated
1876, oil on canvas.
Paris, Musée d'Orsay.

mixed and unbroken tones," based on subjective visual experience and the colors and harmony of the whole, a concept of Romantic origins. Although significantly influenced by the works of Turner and Constable, the Impressionist landscape was a presence to be taken in its immediacy, based on the recognition of the extent to which strong light decolorizes tones. Duranty noted that "due to its brightness, the sun reflected by objects tends to bring them to that luminous unity that incorporates prismatic rays into the single, color-less whole that is light."

A similar interest in the degradation of the tones that define depth and volume as they combine to create different hues gave rise to the law of simulta-neous color contrast studied by Eugène Chevreul in 1839. Although these theories were not used for scientific applications, they were used by Neo-Impressionist artists. Nonetheless, the essence of things, perceived in the split second and the under-pinning to Impressionist research, was also the

discovery of the timelessness of what is ephemeral and what is permanent in the elusive. In fact, *nouvelle peinture* was one of many reactions expressed by artists during the second half of the nineteenth century to the rapid changes in a society that had attempted to relegate art to the role of "documentation," when for centuries it had acted as a guide for the conscience. While Pissarro recom-mended "working with small strokes . . . before the sensations disappear," the writer Jules Laforgue, in presenting an Impressionist exhibition in Berlin in 1883, analyzed the paintings as a product of evolving perception, substituting the "invincible illu-sions" of "aesthetics" (design, perspective, indoor studio lighting) with the "forms obtained not by the design of the contours but solely through the vibra-tions and contrasts of colors," arranged in the painting without obeying the laws of perspective. In this manner, the rational perspective still present in the *plein air* Barbizon School paintings made way for the two-dimensionality and varying perspectives of

**Claude Monet**
*Water Lilies*
1916–23, oil on canvas.
Paris, Musée de
l'Orangerie.

Japanese prints—by Utamaro, Hiroshige, and other artists—circulating in large numbers at that time. Laforgue considered the Impressionist eye to be "the most advanced eye in human evolution, that which thus far has grasped and rendered the most complicated and unexplored combinations of nuances," because "it sees the reality of the forms in the living atmosphere, disassembled, refracted, reflected by beings and things in never-ending variations"; he also noted that the "three methods based on dead languages" were replaced by "the true living line, without geometric form, constructed with thousands of irregular strokes that, from a distance, create life." In contrast to its progenitor, Realism, Impressionism avoids the precise rendering of details, preferring a handling that reflects our visual experience in assimilating external stimuli, which always differs according to the sensitivity of the artist who depicts it. In fact, a single painting can incorporate different perceptual moments, from excitement at the discovery of the

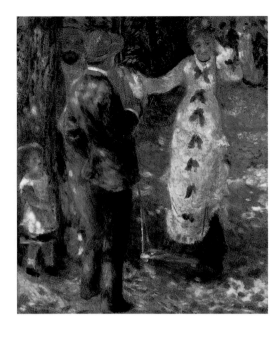

**Pierre-Auguste Renoir**
*The Swing*
Opus signed and dated 1876, oil on canvas. Paris, Musée d'Orsay.

natural sight to the keenest concentration and finally to a decreasing of this keenness due to restless weariness.

This interest in perceptual phenomena led Monet, who Guy de Maupassant defined as a

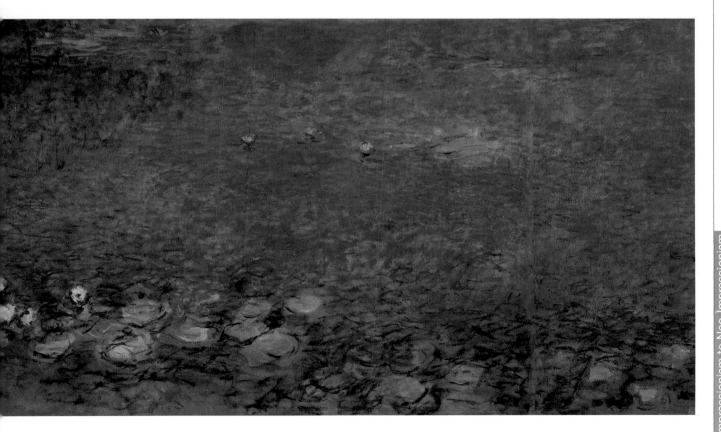

**Claude Monet**
*La Grenouillère*
1869, oil on canvas.
New York, Metropolitan
Museum of Art.

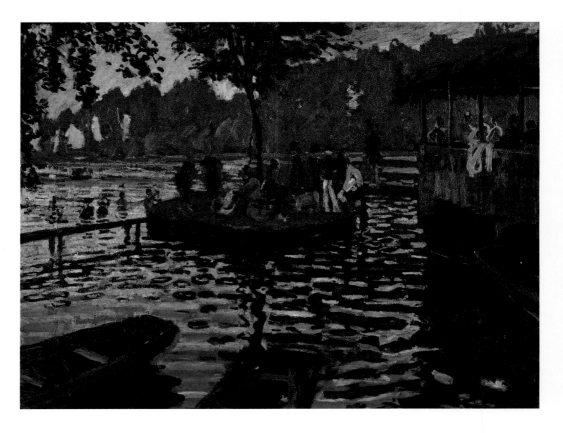

**Pierre-Auguste Renoir**
*La Grenouillère*
1869, oil on canvas.
Stockholm,
Nationalmuseet.

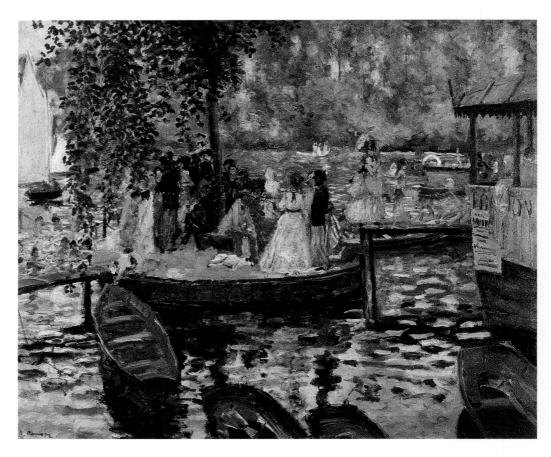

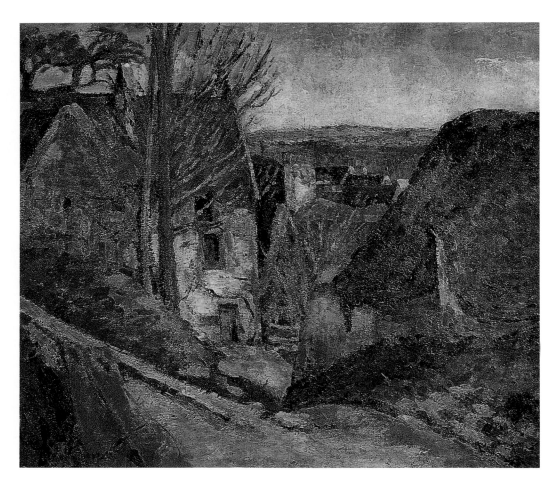

Paul Cézanne
*The Hanged Man's
House*
1873, oil on canvas.
Paris, Musée d'Orsay.

69

"seeker of the intangible, fleeting conditions of outdoor life," to concentrate on the image of the moving train, enhancing the ephemeral, intimate character of the view with the elusiveness and rapid shading of the figures and landscape, or to depict the same subject several times at different hours of the day, as he did with Rouen and Westminster cathedrals, haystacks, and finally the water lilies in the pools of his Giverny garden. Kandinsky, the future father of lyric abstractionism, would later say that when he saw the *Haystack* paintings in 1889 on a visit to Paris during his youth, he understood for the first time what a *painting* truly was: a work in which the subject, an element that until that point was thought to be indispensible, lost all relevance. From the early 1870s, Monet was the artist in the group least interested in the subject to be painted, and he therefore evolved explorations that were extremely *l'art pour l'art* (although not directed toward the perfection of form). Renoir, on the other hand, used Impressionist techniques to portray the charm of the spectacle of outdoor life: country or city dances, leisure activities in gardens (*The Swing*, page 67), and gatherings in dance halls or in the rowing clubs along the Seine near Bougival. In fact, a comparison of the same subject painted by Monet and by Renoir, *La Grenouillère*, shows that although the effect of a dazzling mosaic of colors is common to both works, the perspective chosen by Renoir is closer and more focused on the figures, while that of Monet seems more removed and abstract, observing the play of water on the section of the shallow river ("the frog pool"). Laforgue noted how there were "no longer isolated melodies" in Impressionist paintings because "the whole is a symphony that is living and changing, like the 'forest voices' in Wagner's theories . . . like Unconsciousness, the law of the world and the great melodic voice,

**Edgar Degas**
*The Rape*
1868–69, oil on canvas.
Philadelphia, Museum of
Art.

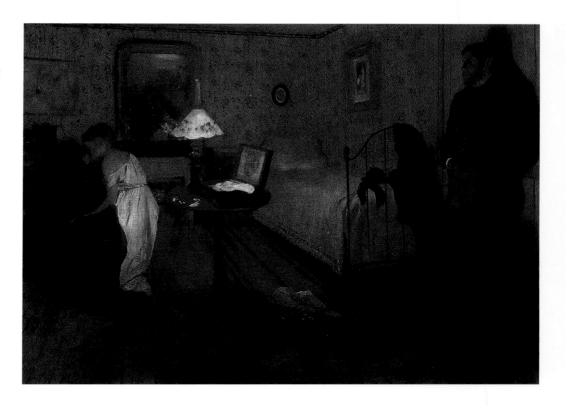

resulting from the symphony of consciousness of races and individuals. This is the principle of the *plein air* Impressionist." The reference to Wagner's music (which, as will be shown later

**Berthe Morisot**
*Summer (Young Woman
by a Window)*
1878, oil on canvas.
Montpellier, Fabre
Museum.

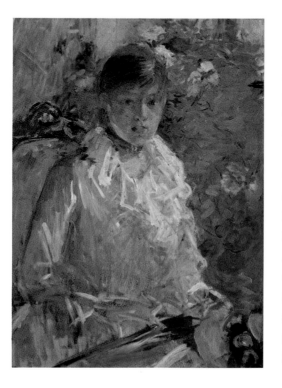

(pages 127-128), was continual in Symbolism, with artists inspired by his fantastic imagination and the stage devices in his works) was apparent in the very nature of the Impressionist technique; the nonintegrated form and the broken and unresolved brushstroke, particularly after 1880, became eloquent expressions of the anxious sensibilities of the time, echoing the tones and leitmotifs in Wagner's symphonies. Fantin-Latour also dedicated a series of paintings and engravings to Wagner's works, as will be seen in the following chapter.

One characteristic of Impressionist painting was the very striking combination of an emphasis on the materials used, which were dense, paint-laden impastos (which would later appeal to European Informalist artists in the 1940s and American Abstract Expressionists, who were captivated by Monet's later works, exhibited in New York in 1953), with an ineffable lightness and extremely subtle modulations. At the end of the century, similar modulations characterized the music of Debussy, a composer who was closely connected

**Henri Fantin-Latour**
*Still Life—The*
*Engagement*
1869, oil on canvas.
Grenoble, Musée des
Beaux-Arts.

71

with Symbolism. However, it was precisely the Impressionists' need for perception, centrality, and totality that merged with their emotions on confronting infinite light modulations, resulting in a subtle sense of the inadequacy of the artists' tools for representing the natural scene before them. This was the obsession of Claude Lantier, the protagonist of Zola's novel *L'oeuvre*, which narrates many events involving the Impressionists, starting with the scandal surrounding Manet's *Déjeuner sur l'herbe* at the 1863 Salon des Refusés, discussed in the previous chapter. This Realist writer, who had praised Manet in the 1860s, could no longer share in the evolution of his paintings and considered Impressionist theories unresolved ("these are all precursors," wrote Zola in *Voltaire*; "the genius has not yet been conceived . . . they appear incomplete, illogical, exaggerated, powerless"). Cézanne was convinced he recognized himself in Claude, a brilliant, innovative artist incapable of fulfilling his own turbulent aspirations, and broke off all relations with the writer. Degas had a unique role in the panorama of Impressionist painting, untiringly experimenting with different techniques, including oils, pastels,

Peter Severin Kroyer
*Hip! Hip! Hurrah!*
*Artists' Party at Skagen*
1881–82, oil on canvas.
Göteborg,
Konstmuseum.

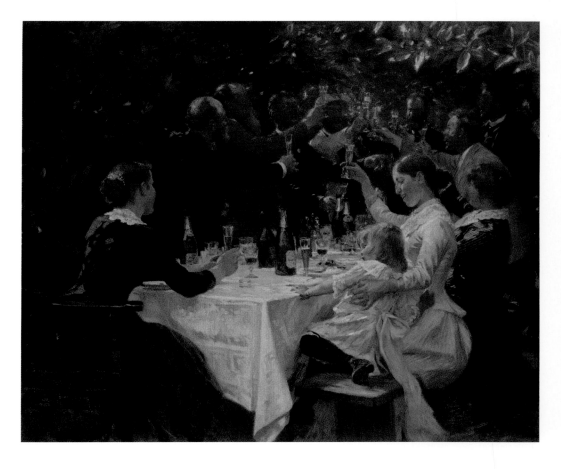

and sculpture. He was also the most daring in revolutionizing perspective and in portraying Parisian life with great pictorial confidence, including horse races, risqué interior scenes, ballerinas at the rehearsal bar, or onstage at L'Opéra, continuing to use a compositional framework reminiscent of Ingres, even in less noble subjects like women ironing or washing in tubs.

Valentin A. Serov
*Girl with Peaches*
*(Portrait of Vera*
*Mamontova)*
1887, oil on canvas.
Moscow, Tretyakov
Gallery.

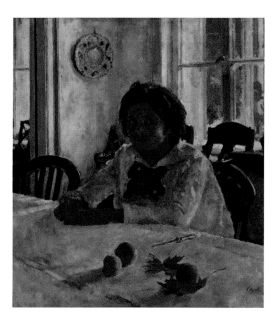

## The Echo of Impressionism

The success of Impressionism soon spread throughout Europe, and also across the ocean, thanks to the exhibition organized by Durand-Ruel in his New York art gallery in 1886. Many artists traveled to Paris (an essential stage in their artistic training) and, drawn to the new form of artistic expression, changed their austere, realistic style. In fact, even while Impressionism in France was fading and being replaced by Neo-Impressionism, Synthetism, and paintings by the Nabis, there were Russian, Scandinavian, English, German, and Spanish artists at the Venice Biennale (the important international artistic event inaugurated in 1895) who

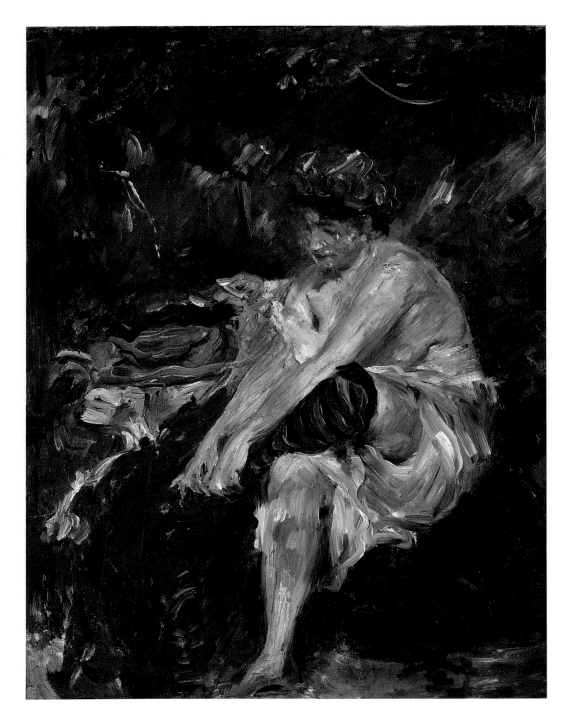

**Lovis Corinth**
*After the Swim*
1906, oil on canvas.
Hamburg, Kunsthalle.

73

exhibited works strongly inspired by Impressionism and brimming with ever-increasing vigor. Thus, even themes inspired by rural life or national customs and traditions were rendered with rapid brushstrokes and bathed in light: the women walking on the beach with their white skirts fluttering in the intense midday sun or intent on their outdoor work in paintings by the Spaniard Joaquím Sorolla y Bastida; the quiet, pensive girls or folk-dancing peasants portrayed by the Russian Valentin Serov; female nudes painted by the Swedish artist Zorn and the German Corinth; the crowds in luxuriant gardens by another German artist, Max Liebermann; and the laughing villagers portrayed by Russian artist

**Max Liebermann**
*Country Tavern at Brunnenburg*
1893, oil on canvas.
Paris, Musée d'Orsay.

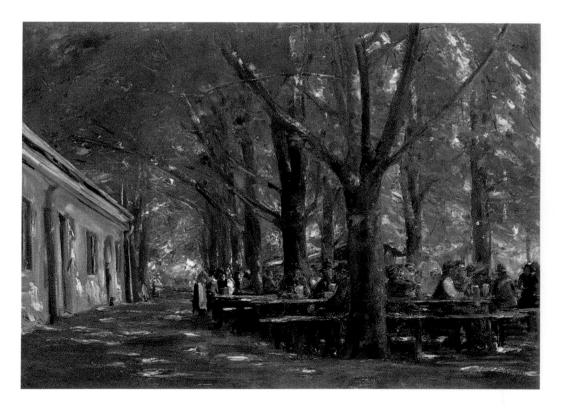

**Giovanni Boldini**
*Highway of Combes-la-Ville*
1873, oil on canvas.
Philadelphia, Museum of Art.

*Facing page:*
**Anders Zorn**
*In Wikström's Studio*
1889, oil on canvas.
Mora, Zorn Museum.

Maliavine at the turn of the new century. A careful study of Impressionism also reveals the presence of a few Italians in Paris, from the 1870s: Zandomeneghi, De Nittis, and Boldini. These artists found valuable inspiration for *plein air* paintings, which continued to be in demand and appreciated by the upper middleclass and the aristocracy and valued by dealers like Goupil. Diego Martelli, the

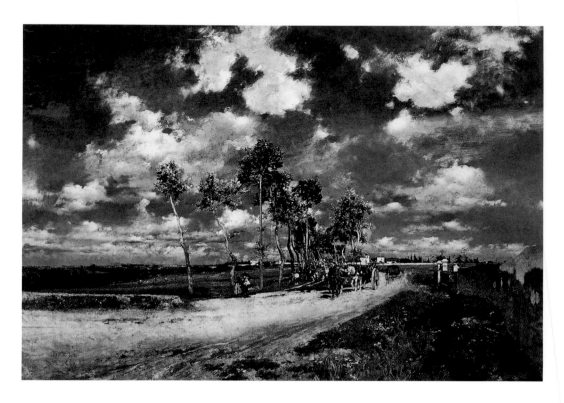

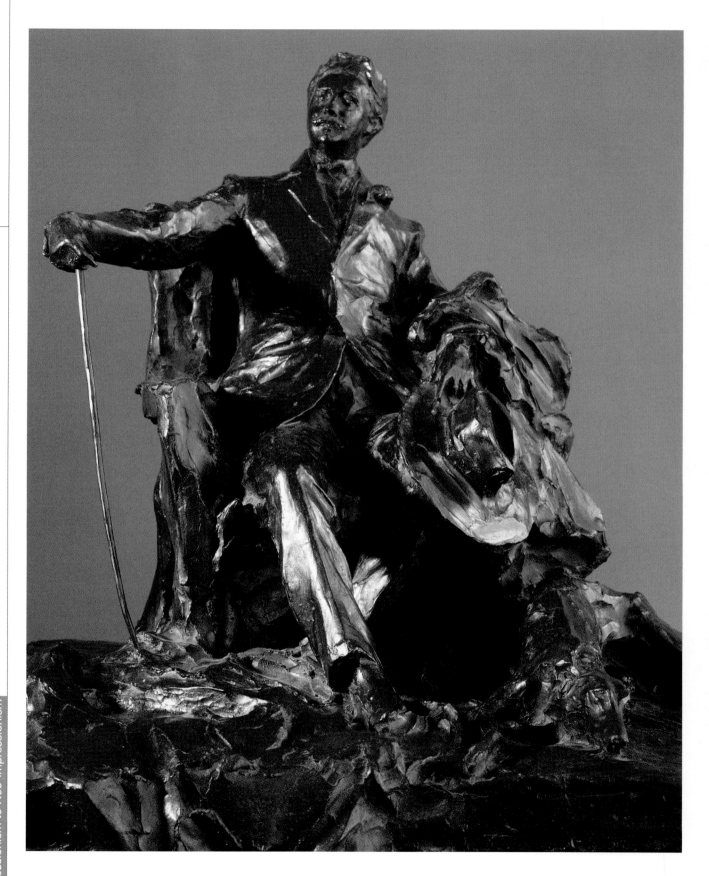

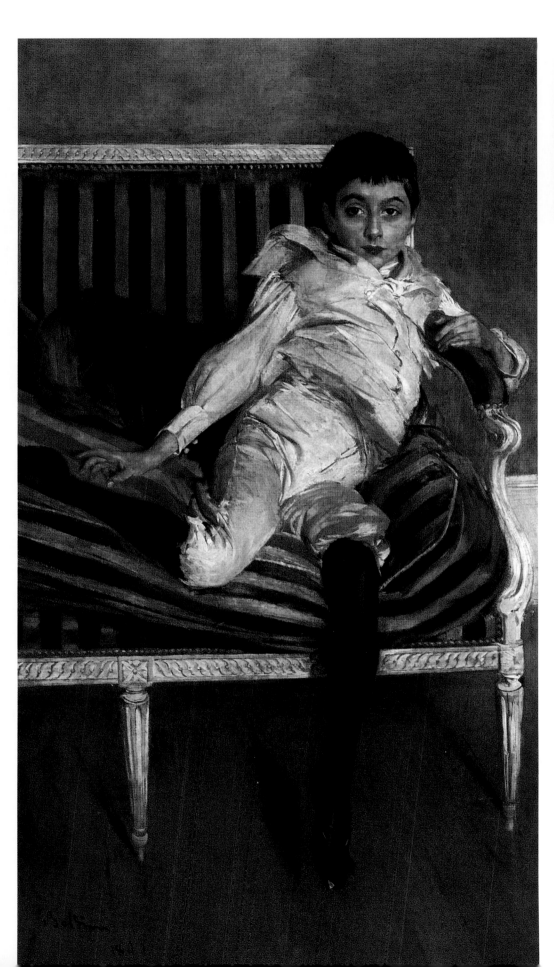

*Above:*
**Luigi Conconi**
*Portrait of Primo Levi*
c. 1880, oil on canvas.
Milan, Gallery of
Modern Art.

*Left:*
**Giovanni Boldini**
*Portrait of the Young
Subercaseuse*
1891, oil on canvas.
Ferrara, Museo Giovanni
Boldini.

*Facing page:*
**Paolo Troubetzkoy**
*Robert de Montesquiou,*
detail
1907, bronze.
Paris, Musée d'Orsay.

**William Merritt Chase**
*Hall at Shinnecock*
1892, crayon on canvas.
Terra Foundation for the
Arts, Daniel J. Terra
Collection (Chicago,
Terra Museum of
American Art).

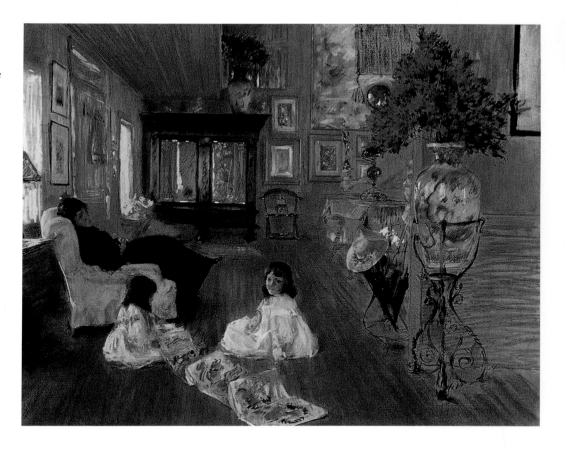

**James Abbott McNeill
Whistler**
*Nocturne in Black and
Gold: The Falling
Rocket,* detail
1875, oil on panel.
Detroit, Detroit Institute
of Arts.

patron and mentor of the Macchiaioli group, also went to Paris, where he had his portrait painted by Degas. However, his interest in some aspects of Impressionism was not adopted by the Tuscans (aside from Signorini), who identified more with the lines of Realism and never abandoned a firm compositional structure. The term *Impressionists* is often used to refer to the Lombard Scapigliatura, including Cremona, Ranzoni, Mosé Bianchi, and Conconi, although their paintings, influenced by the fluidity of the hazy, vague style of Giovanni Carnovali ("il Piccio"), lacked the *à plat* effect typical of the French paintings and, if anything, were reminiscent of the brushwork of the Venetian eighteenth century or of artists like Magnasco from Genoa. In addition, Paolo Troubetszkoy's sculptures disdain the formal, echoing the neurotic, excited sensibilities of the Scapigliatura. In portraits above all, these sensibilities can be felt as a sort of glimmer—a secret force, tenderness, or tension of the subject in the continuous variation of atmosphere and flow of time. Manet's interpretation of Spanish paintings by Velázquez and Goya, and later the refined exoticism and different spatial composition of Japanese art adopted by the Impressionists, attracted mainly artists coming from the United States, including

John Singer Sargent and the younger William Merritt Chase. Even Whistler was inspired by Manet's suggestions but soon turned to depictions of urban or rural landscapes, reminiscent of Turner and showing strong parallels with Monet's later art, with increasingly rarefied, two-dimensional prospects and evident symbolic quality, also suggested by the close parallels with Japanese art and with music, which is always mentioned in the titles of his works (*Arrangement in Grey and Black* and *Portrait of the Artist's Mother* in 1871, *Nocturne in Black and Gold* in 1875, *Nocturne: Blue and Gold—Old Battersea Bridge* in 1877).

The term *Impressionism* applied to sculpture arouses some controversy, since its relevance to plastic arts seems contradictory, given that the movement was founded on contrasting colors and on their application *à plat*. As mentioned in the previous chapter, Degas was the only Impressionist sculptor, and although Auguste Rodin's works are frequently referred to as "Impressionist," he has been included in the final chapter because of the evident Symbolist sensibilities in his work. The Italian artist Medardo Rosso was a friend of Rodin, until they argued violently. Rosso's works were often modeled in wax and have flowing, indefinite qualities in the form that, when interacting with light, create effects that suggest pictorial techniques being applied to sculpture. In the meantime, Cézanne continued to evolve independently and was taken as a model by early twentieth-century avant-garde artists. From his earliest works (like *The House of the Hanged Man*, shown, as already mentioned, at the famous 1874 exhibition), Cézanne manifested a greater attraction toward structural values. In *Bathers at Rest* (exhibited in 1877 at his last public event before his solo show organized by Vollard in 1895), the dense, compact thickness of the paint, as well as the arrangement of staggered blocks of color forming meadows and water, raise the silhouettes in a manner resembling a bas-relief, which reminded the critic George Rivière of the "broad and essential [movements] in ancient sculpture." In fact, in

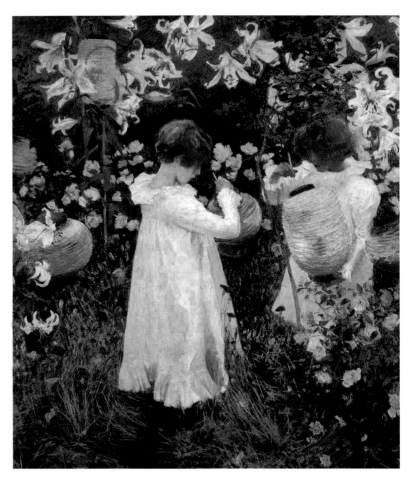

the atmosphere of a strong primitivism revival that characterized art at the end of the century (ranging from Nietzsche's archaic and Dionysian Greece to Oceanic and African art imported from the colonies), ancient culture was valued not for its formal elegance, but for echoing an archetypal knowledge able to capture essential reality. Cézanne executed landscapes, figures, and still lifes that distorted the illusionistic principles of chromatic values, linear structure, and spatial order, subordinating these principles to the system of relationships established in the painting in order to "internalize the objects, make the bodies become part of the landscape in which they move," as Rilke wrote. The philosopher Merleau-Ponty noted in *Cézanne's Doubt* that the artist did not accept reality as it was, but captured it in his own manner, in an intimate logic that became a model for artists of successive generations, from Brancusi to Braque.

**John Singer Sargent**
*Carnation, Lily,*
*Lily Rose*
1885–86, oil on canvas.
London, Tate Modern.

**Medardo Rosso**
*Ecce puer (Behold*
*the Child)*
1906, gesso.
Rome, National Gallery
of Modern Art.

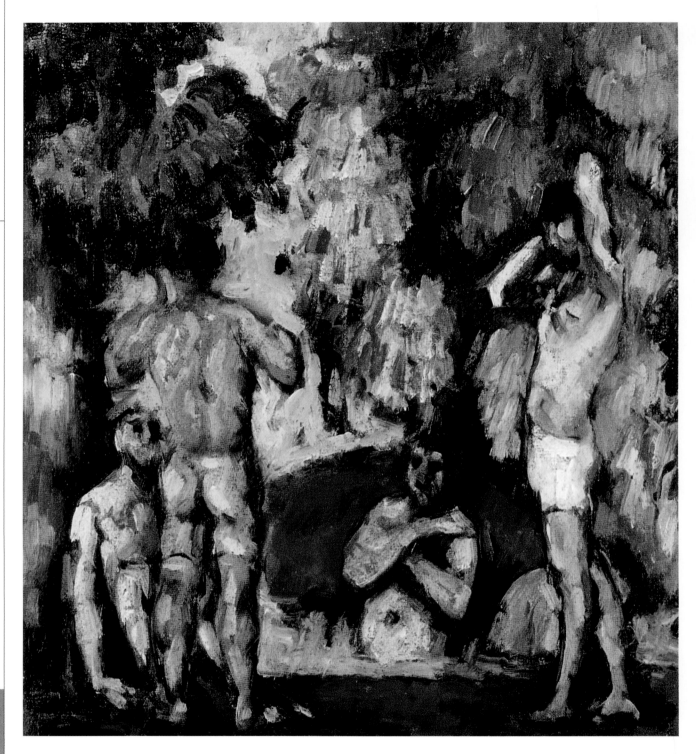

**Paul Cézanne**
*Five Bathers*
1875–77, oil on canvas.
Paris, Musée d'Orsay.

Toulouse-Lautrec is a difficult figure to classify in the period's artistic scenario: he was influenced by his contemporaries, including Seurat, Gauguin, and Cézanne, as well as by Japanese art. Toulouse-Lautrec's style, driven by a realist focus but already characterized by the fundamental language of the new Post-Impressionist tendencies and sensitive to the Art Nouveau approach, was mainly inspired by life around the Butte Montmartre; he explored this area with Emile Bernard and Louis Anquetin in

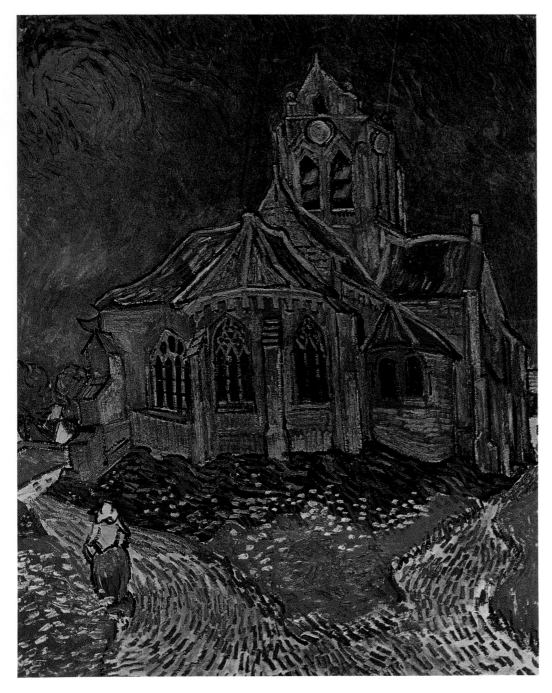

*Above:*
**Henri de Toulouse-Lautrec**
*Loïe Fuller*
1893, brush and spatter lithograph.
Paris, Bibliothèque Nationale, Collection des Estampes.

*Left:*
**Vincent van Gogh**
*The Church at Auvers-sur-Oise*
1890, oil on canvas.
Paris, Musée d'Orsay.

1885, discovering Le Chat Noir, an establishment acquired by Aristide Bruant, who opened a cabaret called Le Mirliton in its place.

In 1886, the year of the last Impressionist exhibition, van Gogh also arrived in Paris. In collective imagination, van Gogh's artistic achievements remain intimately connected to his nomadic life and psychological distress (documented in the wealth of correspondence with his brother Théo), which have made him a symbol of the existential torment of modern humanity (it is no coincidence that in the 1950s, Francis Bacon devoted a series of studies to the 1888 *Painter on the Road to Tarascon*). Although he associated with Pissarro and Signac, van Gogh most admired Gauguin and Bernard, whose Synthetist paintings were key to the

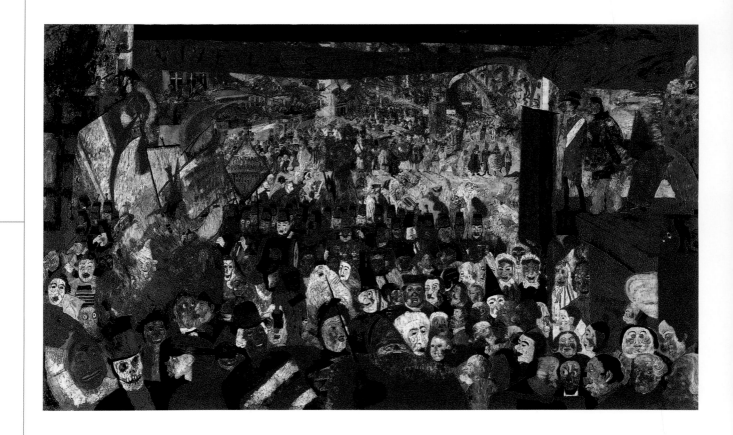

**James Ensor**
*Christ's Entry into*
*Brussels in 1889*
c. 1888–89, oil on canvas.
Malibu, J. Paul Getty
Museum.

development of van Gogh's very personal style. His works use a rich impasto, applied with distinctive brushstrokes that form large areas of intense color and create simplified images, without shading or perspective; the forms, which displayed increasing undulation and movement as time progressed, speak of a deep spiritual tension that lies beyond the objective state of the individual portrayed or the landscape depicted.

Ensor's world was marked by a taste for the macabre, by masks and skeletons, albeit in an invariable desecrating irony (particularly in his repeated self-portraits). When searching for inspiration in the past, Ensor looked primarily to the Flemish and Dutch traditions, including Bosch, Brueghel, and Jordaens. In *Christ's Entry into Brussels in 1889*, a crowd filled with strange faces surrounds Jesus, who rides a donkey and is the intended victim of that carnival-like atmosphere. Christ represents the artist's alter ego, as is also

revealed in the painting of Jesus wearing a crown of thorns between two art critics wearing elegant nineteenth-century attire. Ensor left this disturbing and demonic world to seek a "pure sea" in Nature that would inspire "energy, insatiable constancy" in the light of those "blood-colored suns," contemplated in Permeke sunsets and poured into landscapes of Symbolist temperament.

## Neo-Impressionism: Toward a New Symbolism

Seurat displayed *A Sunday on La Grande Jatte– 1884* at the last Impressionist exhibit in 1886. This was the first painting that used a Pointillist technique, and it was interpreted with insight by the art critic Félix Fénéon, who recognized its logically transposed chromatic structure as the evolution of the 1839 studies carried out by the scientist

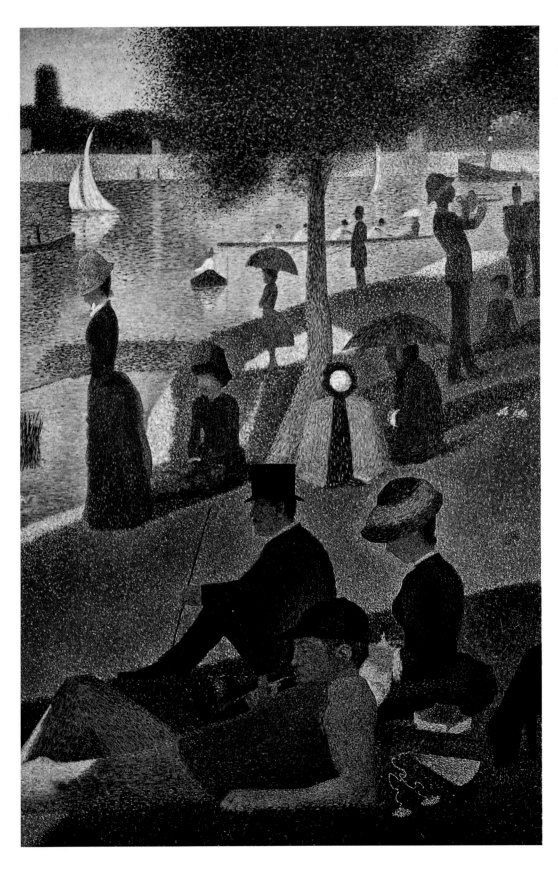

**Georges Seurat**
*A Sunday Afternoon on*
*La Grande Jatte–1884,*
detail (full image on
page 85)
1884–86 (shown at the
eighth Impressionist
Exhibition in 1886),
oil on canvas.
Chicago, Art Institute.

Chevreul. That same year, the Belgian magazine *L'Art Moderne* reviewed the second exhibition organized by the Societé des Artistes Indépendants (founded in 1884 by a few painters whose works were refused by the official Salon, including Seurat, Signac, and Redon) and coined the term *Neo-Impressionism* to describe the group of artists who used this technique, including Charles Angrand, Henri Edmond Cross, Albert Dubois-Pillet, and Signac. The basis of their artistic mission was to avoid attempts at pictorial realism, favoring the exploration of a more intimate harmony, deeper than mere appearance. Even though in recent years the Impressionists had developed an interest in the pictorial surface that diverged from their initial scrupulous transposition of atmospheric effects to the canvas, for Neo-Impressionists the conflict between representation and abstraction was much more evident. Signac's *Portrait of Félix Fénéon*, in which the figure stands out "against the enamel of a background rhythmic with beats and angles, tones and tints," embodies the subject with the utmost lucidity. Seurat, the group's leader until his premature death in 1891, had a profoundly classical spirit and from 1884 took an interest in *Grammaire des Arts du Dessin* by Charles Blanc, art critic for *La Gazette des Beaux-Arts* and advocate of the *l'art pour l'art* movement. It was here that Seurat happened on a broad theory that saw works of art as autonomous from objective reality, but he also encountered the theories of Eugène Chevreul regarding the distinction between tones and hues, colors and values, and the idea of replacing *mélange optique* with a chemical blending of pigments and chromatic vibrations obtained by flanking different tones of the same color.

Although Angrand's and Seurat's visit/pilgrimage to Chevreul did not provide the enlightenment they desired (given the advanced age of the scientist, by then one hundred years old), through Charles Henry—a mentor of the Neo-Impressionists, a mathematician, and a lover of

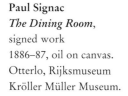

**Paul Signac**
*The Dining Room*,
signed work
1886–87, oil on canvas.
Otterlo, Rijksmuseum
Kröller Müller Museum.

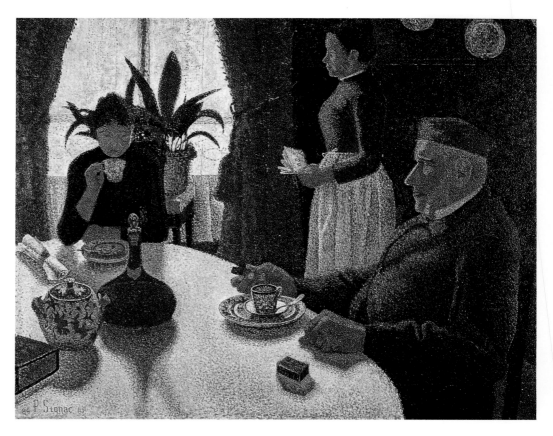

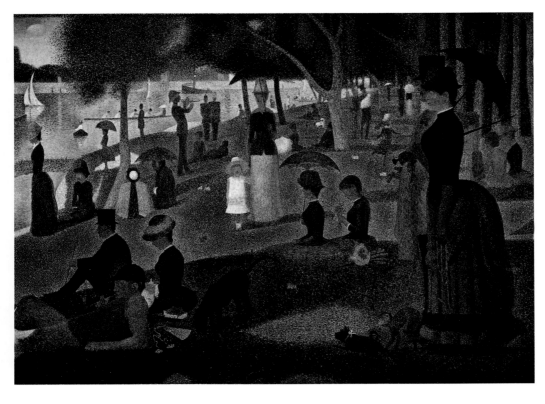

Symbolist literature and Wagnerism—they did discover James Clerk Maxwell's and Hermann Ludwig von Helmholtz's studies on physiological optics (regarding the distinction between pigment colors and colored light) and Rood's *Modern Chromatics*, which prompted a transition from pure physics to the artistic application of the results. In his publications, Henry was able to divulge scientific knowledge that might appear too complicated for artists. Seurat started with the ideas in Henry's *Introduction to a Scientific Aesthetic*, which discussed the concepts of the "color wheel" and "aesthetic reporters" and went so far as to eliminate the notion of chiaroscuro, of the optical blending of colors, and to allow the lightening of tones only by addition of white, perhaps prompted by the Impressionists. The Neo-Impressionist interest in science (no longer seen as contradictory to the image's spontaneity) also echoed the ideas developed by the philosopher Jean-Marie Guyau during that period. In his works, Guyau stated that art and science were both creative activities deriving from

similar principles, and demonstrated how art, drawing on the modern spirit and its progress, could rediscover its original identity and develop its own new poetry: "this realism is genuine and compatible with true idealism" and leads to "the discovery of the new in what is old, including everyday life, and causes the unexpected to spring from the habitual." In fact, an absolutely new iconography was introduced regarding the same themes that inspired the Impressionists, recognized by the art critic Paul Adam. On seeing *A Sunday on La Grande Jatte–1884*, Adam noted how "the rigidity of the people, the sharp forms" contributed to "producing the sound of modernity," and further noted in Neo-Impressionism "a school of abstraction" that teaches the viewing of "the initial state of things" rather than their appearance. The artist is therefore to pursue "to its most abstract form the subjectivity of conscious perception," a slow and painstaking process, an immersion in the images that Seurat achieved through numerous sketches (163 are cataloged) and preparatory drawings (582). The

instantaneity and transience that had characterized Impressionist paintings were therefore supplanted by a "non-temporal" dimension that even Monet sought, not through form, but in his desire to capture a permanence of the subject through a large number of consecutive images, first seen in his "series" corpus. The use of fractioned color allowed light and shadow to create monumental fleeting light effects that "synthesized the landscape in a definitive appearance that immortalized the sensation"; Nature was no longer "viewed through compromise" (as Zola wrote of Manet), but became "the externalization of an idea."

Impressionist illusionism was followed by a purified vision of reality that was often achieved by relying on the same sources of inspiration as the Impressionists and Symbolists. Although a complex interpretation of the relationship connecting Wagner's music and Seurat's paintings was proposed by Maria Grazia Messina, it should be sufficient to remember that Seurat took cues from the lighting of Wagner's operas on the Bayreuth stage, creating and painting his own frames so that they would act not as a border, but rather as a vehicle for carrying the work into the surrounding world. In addition to the absolute two-dimensionality of the planes and a taste for arabesques (borrowed, as previously noted, from Japanese art circulated in the West through prints), Neo-Impressionist paintings are also characterized by the strong rhythmic sense of the composition, where the viewer's gaze is guided from one part of the canvas to another. In Cross's 1896 painting, *Nocturne with Cypresses*, the landscape is arranged in three horizontal bands and split vertically by the contours of the cypress trees and the folds in the women's dresses. In the

**Henri Edmond Cross**
*Nocturne with Cypresses*
1896.
Geneva, Modern Art Foundation, Musée du Petit Palais.

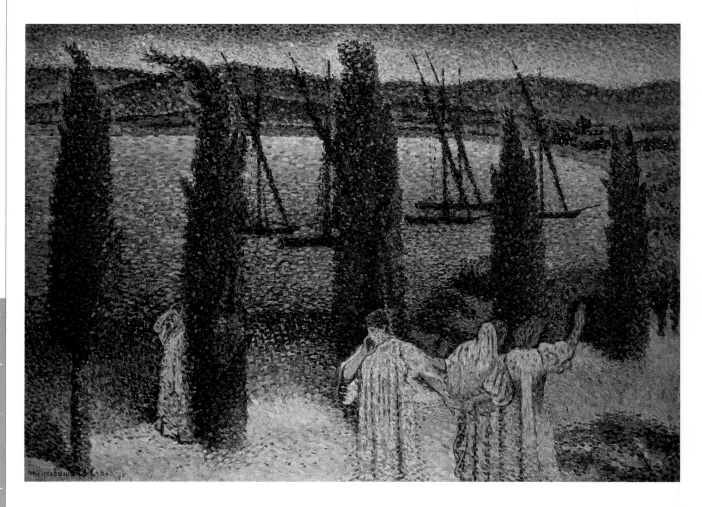

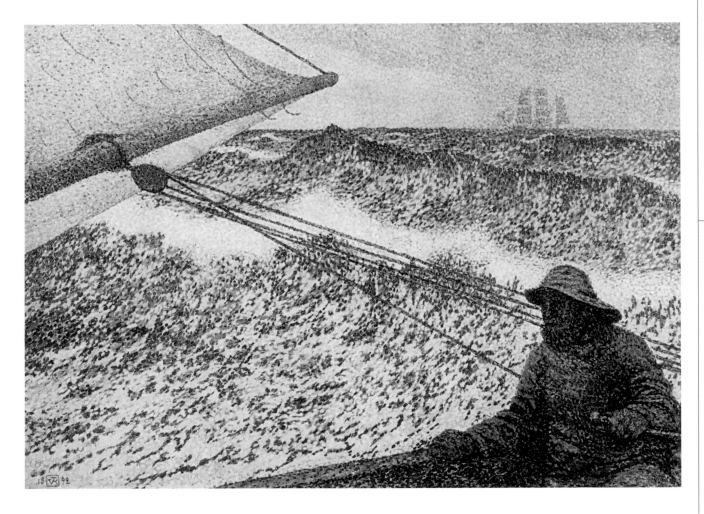

urban scenes, the pursuit of rhythm combines with a difficult exercise in severe spatial geometry; Albert Dubois-Pillet depicted the Saint-Sulpice church towers that rise above the rooftops under an uncertain, backlit sky, and with this new technique achieved notable dynamic success in the composition.

Various galleries supported the Neo-Impressionists, including Le Barc de Bouteville, which organized shows that added Léo Gausson, Maximilien Luce, Hippolyte Petitjean, and even Pissarro to the initial group of artists. In the 1889 pamphlet "L'Art Symboliste," George Vanor explained the desire to bring intellectual and sensorial phenomena back to their original source, "the unique and perpetually fertile essence of form," the "phenomenon-concept." In the work, the concept is actually symbolized by the light, and the painting, thanks to the light's transfiguring power, becomes an evocative fragment of the entirety of the infinite. It was therefore an atmosphere increasingly touched with mysticism that rejected Positivist and materialist science for a new discipline that announced the "discovery of the divine" and increasingly infused rapturous calm in the landscapes painted by Signac and Seurat. The solemn, archaic aspect of these paintings found particular inspiration for the form in the art of ancient Egypt, which was less descriptive and therefore more symbolic. This conformed to a recurring tendency by other artists at that time, when a fascination for distant cultures (artifacts from Java, New Guinea, and Africa were on display at the world exhibitions) provided valuable suggestions for a new expressive language, as will be explained in the final chapter.

That "new method of seeing," obtained by arranging paints on the palette according to the

**Théo van Rijsselberghe**
*The Man at the Helm*
Opus signed and dated 1892, oil on canvas. Paris, Musée d'Orsay.

**Giovanni Segantini**
*The Two Mothers*
1889, oil on canvas.
Milan, Civica Galleria
d'arte moderna.

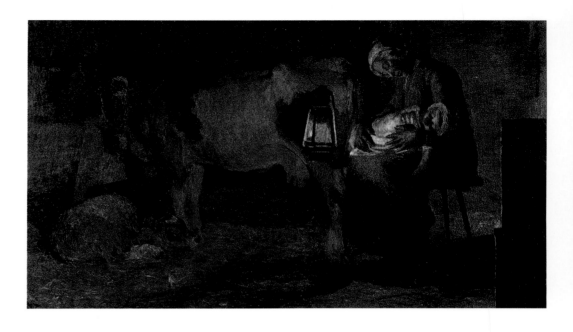

**Gaetano Previati**
*Motherhood*
1891, oil on canvas.
Novara, Banca Popolare.

order of a prism, spread very rapidly in Europe, due to the numerous events held during those years by the Antwerp Association pour l'Art and the Brussels Cercle des XX, including artists like Théovan Rijsselberghe and Willy Finch. In Finch's 1889 painting, *Nieuport Canal* (not shown here), he created an image bordering on abstraction, where the light-filled landscape is cadenced only by the landing piers. The Dutch artist Jan Toorop, on the other hand, sometimes departed from the rigid rules of two-dimensionality, harmonization, and division of tones in an attempt to create a more dreamlike view, as can be seen in *Landscape with Horse Chestnuts* from 1889 (not shown here). Neo-Impressionism was a great success in Holland, where the artists Jan Vijlbrief, Johan Joseph Aarts, and Petrus Bremmer were followers of Divisionist brushwork. The new French school also infiltrated the Munich (1892), Vienna (1897), and Berlin (1898) Secessions and even reached Russia, convincing artists who were Naturalists, Impressionists, and Symbolists. During the revival of idealism, some

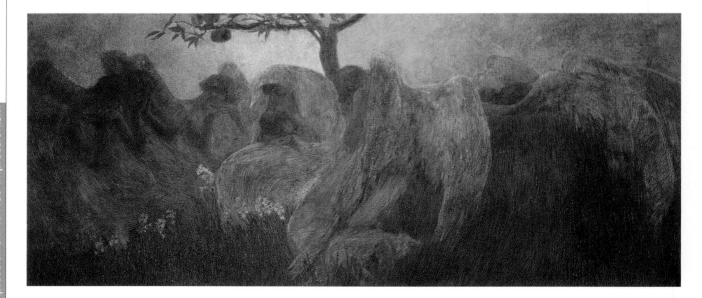

**Angelo Morbelli**
*For 80 Cents!*
Opus signed and dated
1895, oil on canvas.
Vercelli, Civico Museo
Borgogna.

preferred exploration of more essential symbols and clothed their own aspirations in new garb, rather than using the redundant motifs and obscure symbols of a decadent culture.

This shift was very evident in Italy, where the Milan and Turin Triennale exhibits affirmed a painting movement that was very similar to that in France—called Divisionism—and contrasted with the overrefined classicism of the Roman area. Giovanni Segantini (the "revealer of mountains," as Angelo Conti described him), through the study of light and the division of color technique, found the most suitable method for expressing knowledge of reality, penetrating the mystery, and giving voice to the immateriality of emotion. In fact, after his Naturalist debut (*The Two Mothers*), Segantini adopted Divisionist technique and professed his conviction that art had "nothing to do with the imitation of the real, because creation is possible only through the drive of the spirit and the human soul," which receives "an impression, by means of the nervous system, that is fixed and nourished in the brain." Segantini also stressed the role of artist as spiritual guide and the educational function of

**Giuseppe Pellizza da Volpedo**
*The Mirror of Life*
1895–98, oil on canvas.
Turin, Civica galleria
d'arte moderna.

**Henri Edmond Cross**
*The Evening Air*
1893–94, oil on canvas.
Paris, Musée d'Orsay.

art, pursuing ideas already formulated by John Ruskin and that would be of great importance for the European Secessions. The *Alpine Triptychon: Life-Nature-Death* (page 117), unfinished at the time of his death, along with a few handwritten notes, symbolizes the union between humankind and Nature in a shared destiny (birth, life, and death). Segantini sought to represent this idea through the clarity of the illustration ("It is true that in color and form there is a true and living sense of nature"). Previati, on the other hand, believed that painting should be similar to music, where beauty derives from the indefinite, rather than the precision valued by Segantini and the French Pointillists. Thus, in Previati's painting *Motherhood*, which outraged critics at the 1891 Milan Triennale, the filamentous brushstrokes of divided colors create

bodies with erratic outlines—forms and colors are nothing more than marks, the symbolic equivalents of sensations. In Previati's works, Nature is transformed before the observer's eye, to the point of eliciting the sensation of hearing "numerous violin bows, while birches flash white before my eyes," as Vittore Grubicy wrote. The latter was a painter as well as an art dealer, and coined the term *ideista* painting for his friend's works.

These same concepts were also expressed later in Kandinsky's "spiritual in art," where the association among colors, forms, and sounds led to lyric abstractionism. Apart from this corpus, Kandinsky also created figurative work including *Saint Ludwig's Church in Munich* and *Before the City*, painted in 1908, with explicit divided color references, which was also seen in Klee's works,

until 1931. The course of French and Italian Neo-Impressionism also shared the conviction that art was a form of "social outpouring" and that aesthetic emotion should have a social nature: humanitarian symbolism replaced realism, also driven by Leo Tolstoy's aesthetic and moral ideas. Artwork was no longer intended for a refined elite, and the theories of scientific philosophers were read and applied to give voice to a strong idealist impulse, as seen in Giuseppe Pellizza da Volpedo's famous painting, *The Fourth State* (where the veristic subject of workers marching in the light was elevated to a universal symbol of humanity in search of liberation), and in works by Angelo Morbelli and Plinio Nomellini (*The Haymaker*). However, in an article that appeared in the magazine *La Révolte* titled "Impressionistes et Révolutionnaires," Paul Signac declared that the revolutionary aspect of painting lay not only and not really in the subject but in the style and in the "unconscious social quality" of the aesthetic emotion leading to an anarchic utopia.

Thus, a sort of "golden age," in which humankind possesses the key to a better world, is evoked in various Neo-Impressionist paintings, like the landscapes of Henri Edmond Cross, including *The Evening Air* (1893–94), set in the light of a Mediterranean landscape, which undoubtedly influenced Henri Matisse's famous *Luxury, Calm and Pleasure* (1904–5). An Arcadian sentiment also imbues contemporary views that appear banal, like the public garden in George Morren's 1891 *At Harmony*, in which the central path stretching into the shade of the trees alludes to a mythical past, evoked by the figures of the girl in profile and a nanny at the center, seen from the back, who moves away, taking the illusions of childhood with her. A suggestion that chance is immaterial also appears in Pellizza's landscapes, including *The Mirror of Life*, based on Dante's verses from *Purgatory*: "What one does, the others do." Pellizza actually consulted Segantini about "how to

capture the movements of sheep," but the painting was later structured in such a manner that the landscape, supporting the supple, sinuous lines of sheep and clouds, emanated the "living sense of perfect calm sought in the gentle abandonment of Nature's predestined events," and it was noted that the image of the sheep became "symbolic" (Viazzi). The artists were convinced that secret communication existed between the human soul and the soul of things, and therefore felt obliged to express the necessity and intensity of the forms of Nature, as this was the only way its intimate secrets could be revealed.

**Wassily Kandinsky**
*Before the City*
Opus signed and dated 1908, oil on cardboard. Munich, State Gallery in Lenbachhaus.

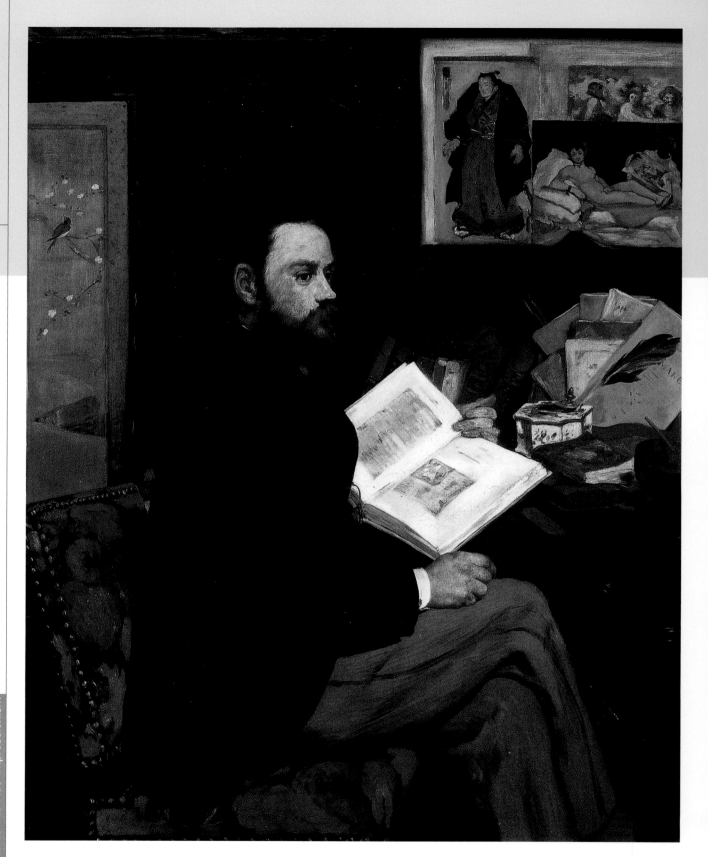

# The Influence of the Japanese World

In 1854, when the isolation that had segregated Japan from the Western world for two centuries had been overcome, imports of Japanese prints to Europe revealed a totally new type of aesthetic concept. Compared to Western art's situation of decline, Japanese forms appeared to the artist's eye with traits of naivety, purity, and authenticity that soon became models for a radical renewal of codes of expression. Charles Baudelaire was one of the first to take an interest in the art of that distant, unknown nation. At that time, ukiyo-e (images of the "unpredictable world," of the senses, and of fleeting pleasure) prints, which had no fixed, unitary perspective, but several viewpoints that generated a moving, variable vision, featuring sinuous, flowing, almost disarticulated silhouettes—but not without depth—were achieved on flat surfaces. The subsequent decades were filled with growing enthusiasm for the products arriving from the people of "childlike art," and the outright admiration that developed attributed them with a guiding role—alongside models from other archaic cultures, from the European Middle Ages to the art of Oceanic and African peoples—in asserting spiritual rather than the material values of Western culture. Ary Renan invited Hokusai, a legendary Japanese artist—author of the famous crashing, foaming *Wave*—to reveal his secrets: "You have always been young, [and] we are old before our time." The innate faculty of Far Eastern painting to translate only the very essence

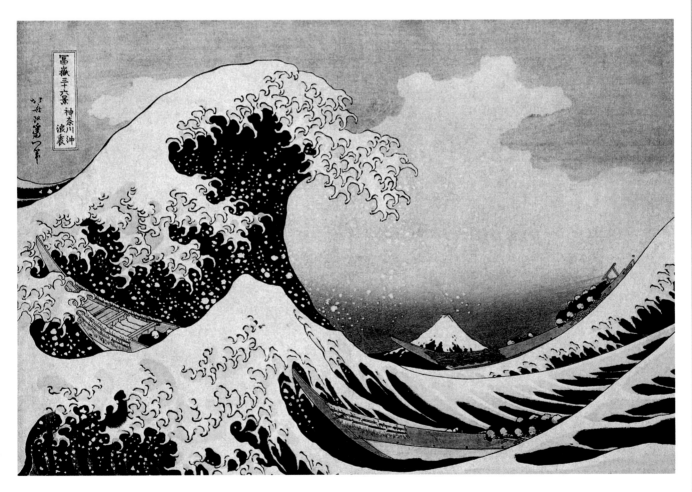

**Édouard Manet**
*Portrait of Émile Zola*
1868, oil on canvas.
Paris, Musée d'Orsay.

**Katsushika Hokusai**
*Wave* (*The Great Wave off Kanagawa*), from the series *36 Views of Mount Fuji*
c. 1830–32, nishiki-e.
Obuse, Hokusai kan.

of things, leaving the spectator the task of using his or her imagination to develop what is expressed so succinctly, corresponded to the tenets of the Symbolist aesthetic, almost echoing the thoughts of Mallarmé, who felt that "naming an object" was the equivalent of "suppressing three quarters of the enjoyment of the poem, which lies in guessing a little at a time." The prints of Japanese artists like Hiroshige (1797–1858), Utamaro (1753–1806), Utagawa Toyokui (1769–1825), Kunisada (1786–1864), Kuniyoshi (1792–1861), and Keisai Eisen (1790–1848), initially found only in Parisian Oriental art stores, then went on sale in the newly opened department stores (Printemps and Bon Marché), and spreading thanks to exposure during the 1889 and 1900 Worlds Fairs. A great purveyor of these products was the dealer

Siegfrid Bing, who not only organized annual Japanese art salons in his gallery and published the review *Le Japon Artistique*, but in 1890 also arranged for a huge exhibition to take place at the École des Beaux-Arts, with numerous works loaned by private Parisian collectors, offering a truly exhaustive panorama of Japan's xylographic history. The fascination for *Japonisme* also had a strong impact on applied arts, since furnishings comprising decorated screens and understated, but extremely refined, designs arrived as an exquisitely elegant alternative to the opulence of English Victoriana or French Napoleon III and Third Republic.

Years before, Whistler's paintings had reflected this new style of living, but also of thinking, in the urge to escape contemporary vulgarity and take refuge in poetry, beauty, and dreams.

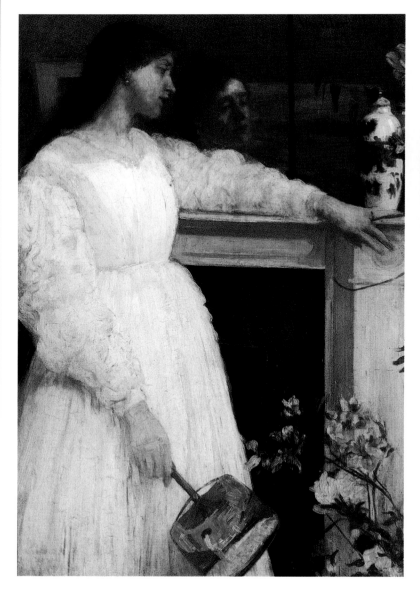

**James Abbott McNeill Whistler**
*Symphony in White, No. 2: Little White Girl*
1864, oil on canvas.
London, Tate Modern.

**Kitagawa Utamaro**
*The Manners of Young Middle Class Women,*
from the series *Manners of Young Women (of Three Classes) (The Upper Class, The Middle Class, The Lower Class)*
1795–96, nishiki-e.
Tokyo National Museum.

Examples include *Symphony in White No. 2: Little White Girl* (1864), *Rose and Silver: The Princess from the Land of Porcelain* (1863–64, Washington, Freer Gallery), or the girls in the 1868 *Three Figures: Pink and Grey*, whose stances seem to derive precisely from Utamaro figures. In Manet's 1868 *Portrait of Émile Zola* (page 92), the writer sits at his desk, and alongside a reproduction of *Olympia*, a Japanese print of a sumo wrestler can be seen (identified as a work by Kuniaki II, 1835–88), as well as the screen with gold backdrop in a pale blue frame to the left—all proving how interest in that culture even appealed to a partisan supporter of Naturalism, nonetheless ready to be charmed by a taste that would soon seduce his Impressionist friends. In any case, the fact that the homes of artists differed from prevailing

opulence is shown by Mariano Fortuny's 1874 painting of his children in the Japanese salon (page 26); while paying homage to Oriental models in his two-dimensional rendering of the planes and color application, Fortuny did not forsake a more resolute line and several details that enhance the image, raising the opus to a level of communication differing from that sought by Impressionists, Neo-Impressionists, and Nabis. In point of fact, Japanese art guided Impressionist research toward the preference for a simple, distinct stroke, without chiaroscuro drama, using an application of smooth, brilliant blocks of color. This influence was noted by Théodore Duret, who traced the palette and luminosity of Monet's corpus to the exacting, physiological acuity of Oriental perceptions, whereas Edmond de Goncourt made a

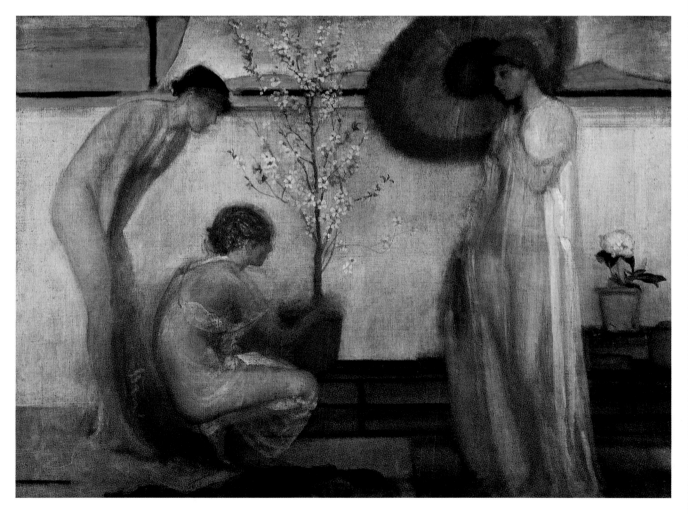

**James Abbott McNeill Whistler**
*Three Figures: Pink and Grey*
1868, oil on canvas.
London, Tate Modern.

critical entry in his diary on May 8, 1888, convinced that the Impressionists were simply "creators of stains and more stains, pilfered from the Japanese."

The rejection of traditional Renaissance perspective rules was then accepted and developed according to personal criteria by the groups of artists defined as Neo-Impressionists. They actually abandoned the scansion of space and preferred to define it through a layering of planes, which can be seen in Georges Seurat's 1883–84 *Bathers at Asnières* (London, National Gallery), or his 1885 *Le Bec du Hoc, Grandcamp* landscape: in the painting, shown here, the horizon is set very high, which leaves little room for the sky, while the rock in the center is outlined

geometrically against the sea. Japanese color and composition schemes, as well as some decorative expedients whose purpose was narration, also interested Gauguin a great deal, and he focused mainly on the theme of origins at the heart of his research. In the 1888 *Vision After the Sermon*, Gauguin used a branch to separate the real event from the imagined fact, as Hiroshige did in some of his famous *One Hundred Famous Views of Edo*. Gauguin's Breton peasant women meditate with their simple thought processes on the sermon they have just heard from the priest, and see the biblical event materialize before their eyes as they leave the church. A Hiroshige print also provided cues for the two versions of Henri Edmond Cross's *Farm* (not

*Top:*
**Georges Seurat**
*Le Bec du Hoc,*
*Grandcamp*
1885, oil on panel.
London, Tate Modern.

**Paul Gauguin**
*Vision After the Sermon*
1888, oil on canvas.
Edinburgh, National
Gallery of Scotland.

shown here); in the first opus, the movement of the woman carrying a jar on her shoulder assumes a sinuous cadence that blends totally into that of the surrounding countryside. *Japonisme* triumphed among the Nabis, encountering much favor with these artists who were disposed to replace illustration—or rather reproduction—of the outside world with translation of the quintessence of the universe: in the 1892 *The Croquet Game*, where a game is being played in the family garden at Grand-Lemps, Bonnard veils the scene in a dreamy, mysterious atmosphere, with a crescendo that culminates in the luminous apparition of the girls dancing on the lawn to the right, achieving two-dimensional effects for the concentrated gestures of the solemn players, but

"cut" by bushes in the lower section so that their movements seem almost unreal. The Japanese model was also of great inspiration to Toulouse-Lautrec, in his paintings but more so in his posters, which have all the dignity of canvas works. The fluid, incisive stroke Toulouse-Lautrec preferred for immortalizing the strange charm of the absent expression of the women he saw in cabarets when they were off duty, in the washroom, or slumped on brothel sofas was always combined with off-center composition, in homage not only to Japan but also to photography. His was not just a love of the exotic or ethnological curiosity, but the quest for a more symbolic expression.

97

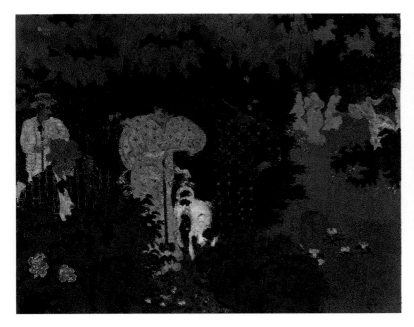

*Facing page:*
**Utagawa Hiroshige**
*The Plum Garden in Kameido,* from the series
*One Hundred Famous Views of Edo*
1857, nishiki-e.
Köln, Museum für Ostasiatische Kunst.

*Above:*
**Pierre Bonnard**
*The Croquet Game*
1892, oil on canvas.
Paris, Musée d'Orsay.

*Top right:*
**Édouard Vuillard**
*At the Divan Japonais*
c. 1890–91, oil on panel.

*Right:*
**Henri de Toulouse-Lautrec**
*The Clowness Cha-U-Kao,* detail
1895, oil on cardboard.
Paris, Musée d'Orsay.

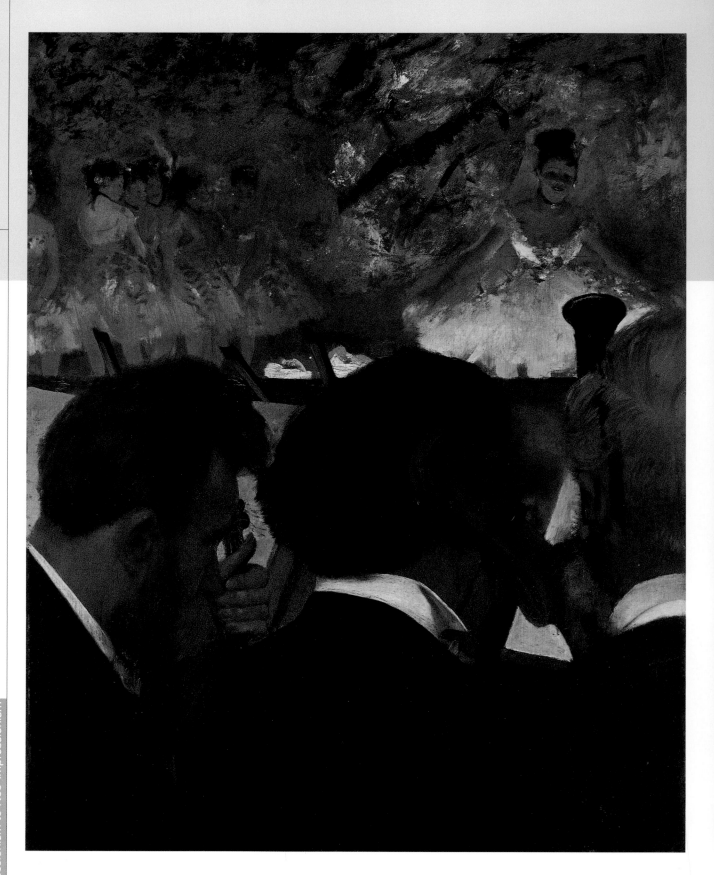

# Photography and Art: Exchanging Glances

"From that moment, the vile company rushed, united like a Narcissus, to contemplate their trivial likeness on the plate." With these words Charles Baudelaire expressed his reticence with regard to Daguerre's invention of photography, officially announced to the French Chamber of Deputies by the physicist François Arago on July 3, 1839. If Baudelaire feared that the photographic image would encroach on and invade the sphere of the imagination (he finally accepted it only as a means of documenting travel), Balzac, in his *Theory of Specters*, declared that Daguerre's operation brought a detachment of layers from the body photographed, thereby undermining its physical essence. The bond between photography and painting, on the other hand, actually intensified over the century, not least of all because of the rapport that often already existed between artists and photographers, generating significant, reciprocal, and increasingly recurrent influences on both sides. One example was Gustave Le Gray, who had studied with François Edouard Picot and Paul Delaroche but became director of a school of photography, La Barrière de Clichy, in 1849. One of the first to lay claim to photography's significance of expression was Eugène Durieu—a friend of Delacroix—who noted at the time that if "the lens is a pure tool that can gather only

**Fernand Khnopff**
*Portrait of Marguerite Khnopff, Sister of the Painter*
Last quarter of the 19th century, original photographic print.

*Facing page:*
**Edgar Degas**
*Orchestra Musicians*
1874–76, oil on canvas.
Frankfurt, Städelsches Kunstinstitut.

**Honoré Daumier**
*Félix Nadar Elevating Photography to the Height of Art*
c. 1858, lithograph.

what it sees, the photographer's task is to show what they wish to be seen."

Gaspard-Félix Tournachon, author of hundreds of famous portraits, also wrote that photography was a "marvelous discovery, a science that sharpens the most elective intellects," underscoring the subjectivity of a tool that could respond so differently depending on who was using it. An example of the relationship between photography and painting in the 1850s can be seen in the images made using the calotype process (a photographic process using iodized paper), which creates great contrasting black and white masses, and in canvases painted by Barbizon School artists, including Daubigny. These paintings have large areas of contrasting light and shade, without definition, since the details

of the drawing merge into the two extremities of the light specter. Moreover, Arago's "light meter"—a device allowing the identification of deviation between lighter and darker tones—had shown that the range of contrasts in Nature went far beyond human eyesight potential and thus could not be reproduced in art. This awareness, expressed in reviews of the time and reflected in the work of the *Barbizonnier* artists, in Italy touched mainly the Tuscan Macchiaioli painters, who observed France with attention. However, photography was also used at that time as a method for visualizing a unitary image of a painter's idea: we find proof in letters written by Bernando Celentano to his family in 1857, when he was developing his *Benvenuto Cellini at Castel Sant'Angelo* (shown here). This painting has a historical theme, but Celentano

*Far left:*
**Charles-François Daubigny**
*Harvest*
1851, oil on canvas.
Paris, Musée d'Orsay.

*Left:*
**Edgar Degas**
*Landscape*
1892, crayon over monotype.
Boston, Museum of Fine Arts.

**Bernardo Celentano**
*Benvenuto Cellini at Castel Sant'Angelo,* a work completed on the basis of a series of photographs taken for the occasion
c. 1857, oil on canvas.
Naples, Capodimonte Museum.

wanted to work in the open, and he went so far as to design a canvas that folded like a screen so that he could carry it around: "We are arranging a general photograph of the painting, with all the artists on [his teacher] Simelli's terrace, to address the overall composition and chance incidence of light. Morelli, Vertunni, Prosperi, Ruspi, Papale Cortese, Toro will all be there," he told his brother. After the photograph was taken, he informed his father, "Seeing all those persons dressed in character costume and all expressing the same sentiments and passions that I harbor, and all lit by a ray of sunlight, I perceived exactly how my imagined painting will be."

From the 1870s onward, we know that as he got older, Émile Zola, father of Naturalism, began to carry a camera with him, as inseparable as his notebooks. Moreover, the echo of the illustration strategies developed by Naturalist writers in the *Serate di Médan* (title of the 1880 compendium of writings, to which Joris-Karl Huysmans also contributed) can be felt very precisely in painting. It is actually thought that a master of rural painting like Jules Bastien-Lepage used photographic sources for his large works. This was also typical of Dagnan-Bouveret, who depicted himself in *Wedding at the Photographer's* (1878–79, Lyon, Musée des Beaux-Arts), along with his painter friend, Jules-Alexis Meunier; in 1884 he painted *Horses at the Water Trough*, based on photographs that are still in existence. There was no shortage of artists using this technique, including Thomas Eakins, an American who trained in Paris

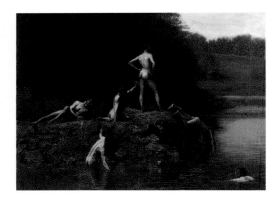

**Thomas Eakins**
*The Swimming Hole*
1884–85, oil on canvas.
Fort Worth, Amon
Carter Museum.

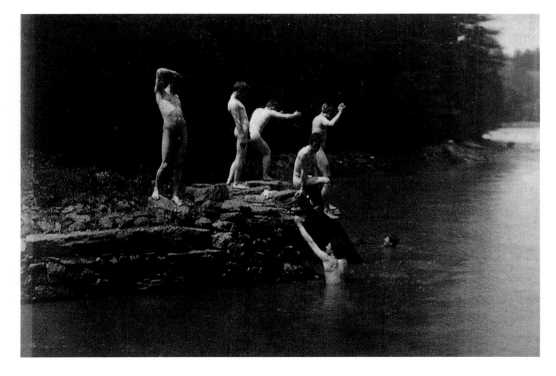

**Thomas Eakins and students**
*At the Swimming Hole*
1884–85, albumen print.
Los Angeles, J. Paul
Getty Museum.

(see *The Swimming Hole*, 1884–85, page 101). In Impressionist circles, photography was embraced with enthusiasm, as it allowed a large range of frames that in painting made it possible to "break" the perspective rule of academic tradition, but also (as Rosalind Krauss pointed out) because it revealed—especially to Degas and Monet—the distance that exists between perception and reality. Degas left some memorable perspective views of domestic interiors, horse races, and stages with orchestras or ballerinas in the spotlight; in sculpting his small, moving animal figures, he observed the photographic experiments of Eadweard Muybridge, shown in 1878 at the Cercle de l'Union Artistique. Moreover, from 1874, Degas began to use the monotype, a process involving painting oil onto copper or zinc plates with a spatula or fingers, then wiping off the excess with a pad. He used an old press to transfer the painting from the plate to damp Chinese paper, later making three or four impressions, each becoming gradually paler; when they were dry, he retouched with crayon. He defined these landscapes—which have the opacity of a photographic print—"imaginary." Monet was also interested in photography as a support to rendering light and in the various notions of the "view" (now intended to mean a spectacular place that would depict even the most hidden aspects), starting at the time of *Femmes au Jardin* until his *Cathedrals* and *Water Lilies* series: the photographic angle is recurrent especially in the views of Parisian boulevards seen from above.

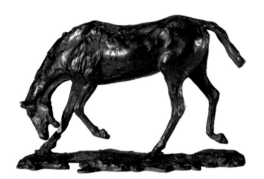

**Edgar Degas**
*Horse with Head Lowered*
1919–21, bronze.
Cambridge, Fitzwilliam Museum, University of Cambridge.

**Eadweard Muybridge**
*Jockey on a Galloping Horse,* from *Animal Locomotion, plate 627*
1878.
Stapleton Collection.

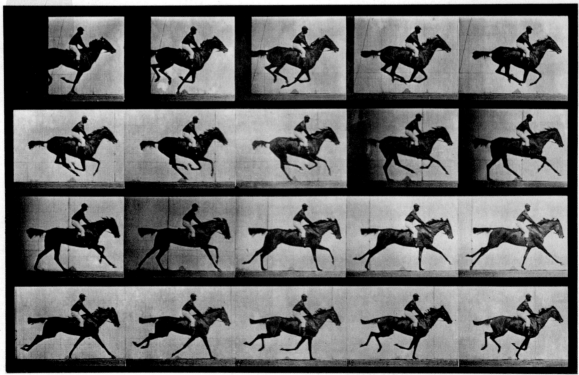

In Great Britain, the deep, intense bond between photography and painting was seen in the Pre-Raphaelite circle. Ruskin defined the daguerreotypes he purchased in Venice as "small gems," almost as if a wizard had caused the real St. Mark's and Grand Canal to be transported into an enchanted world. Although the effects of light and clarity have dimmed with time, it is still possible to understand how painters would have been affected, and in fact, they were not slow to try their hand at photography. Apart from images by Millais, Rossetti, and Brown, almost identical to the paintings they executed, the affinity between painting and photography also existed in the approach to Nature: Hunt's reluctance to set up his easel before he had found just the right tree and leaves to copy is no different from Roger Fenton, a great photographer, who was untiring in his wanderings with the weighty equipment he needed for the collodion process, invented by Frederick Scott Arch, who changed to the use of a glass negative rather than the paper version used by Fox Talbot. Photography and painting alike become the transmutation of Nature and visual fact, seeking to evoke all that is complex and densely articulated: from the field of corn to the pebbles on a beach. We know that Ruskin distinguished between "prosaic" Pre-Raphaelitism, faithful to Nature, and "poetic" Pre-Raphaelitism, considering Rossetti to be the artist of the latter for his lifelong inclination to celebrate the mystery of beauty.

During the same period, a similar spiritual tension animated the photographer Julia Margaret Cameron—who ardently wished to

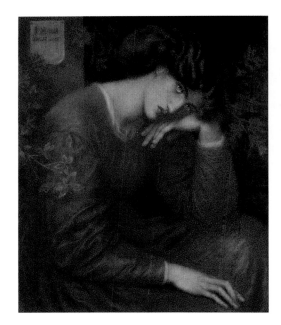

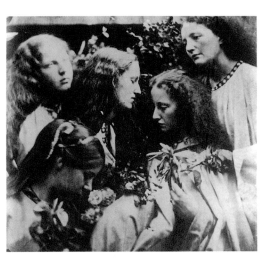

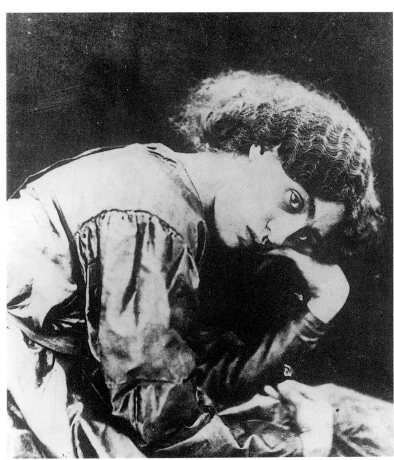

*Top left:*
**Dante Gabriele Rossetti**
*The Day Dream*
1868, crayon.
Oxford, Ashmolean
Museum.

*Left:*
**Julia Margaret
Cameron**
*The Rosebud Garden
of Girls*
1870, original
photographic print.

*Above:*
**Dante Gabriele
Rossetti**
*Portrait of Jane Morris*
1865, original
photographic print.

by Steichen. The desire for artistic and expressive autonomy through photography was quite evident in the work of Fred Holland-Day, from his sequence of self-portraits in the guise of a suffering Christ, framed as if they were the predella of an ancient painting (*The Seven Last Words of Christ*, 1898), to the figures emerging from misty wood atmospheres in *Prodigal Son*. The dual opportunity of referring to reality and remodeling each aspect to an inner need was also expressed in the numerous photographs of adolescent nudes, crowned with flowers, taken by Wilhelm von Gloeden in the Sicilian countryside. The artist frequented Michetti and D'Annunzio, and his work is borderline kitsch, characterized by that disturbing appeal that antiquity had for many artists, especially foreigners who arrived in Italy at the end of the nineteenth century.

A singular example of the use of photography that evolved in the next century was that of the *Toulouse-Lautrec Paints Toulouse-Lautrec* montage, conceived by the artist himself and executed by Maurice Guibert in 1890. The two Toulouse-Lautrecs contemplate each other with irony and an air of challenge, expressing that awareness of seeing oneself reflected in that extraneousness that is part of us—an "I" and an "other" ("Because 'I' am an 'other'," wrote Arthur Rimbaud)—with respect to what we believe we are or appear to be. This awareness, marking turn-of-the-century sensitivity, opened new paths and countless interpretations for the twentieth-century self-portrait. Toulouse-Lautrec's montage, for instance, was followed by one by Boccioni (*Io e Noi*, 1907–10) and an equally famous 1917 opus by Marcel Duchamp.

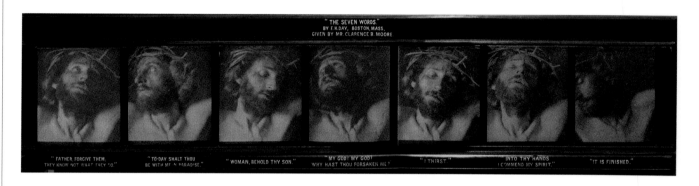

"THE SEVEN WORDS."
BY F. H. DAY, BOSTON, MASS.
GIVEN BY MR. CLARENCE B. MOORE.

"FATHER, FORGIVE THEM, THEY KNOW NOT WHAT THEY DO."    "TO-DAY SHALT THOU BE WITH ME IN PARADISE."    "WOMAN, BEHOLD THY SON."    "MY GOD! MY GOD! WHY HAST THOU FORSAKEN ME?"    "I THIRST."    "INTO THY HANDS I COMMEND MY SPIRIT."    "IT IS FINISHED."

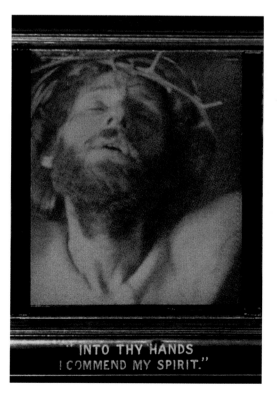

"INTO THY HANDS I COMMEND MY SPIRIT."

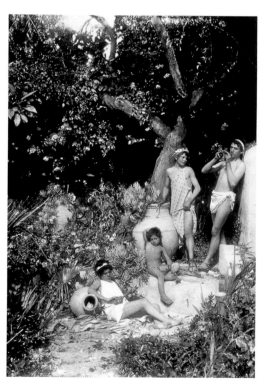

*Above and far left:*
**Fred Holland-Day**
*The Seven Last Words of Christ,* full and detail 1898, platinum print. New York, Bruce Silverstein Collection.

*Left:*
**Wilhelm von Gloeden**
*Arcadian Scene*
c. 1900, modern print from original gelatino-bromide plate. Florence, Archivi Alinari, Archivio Von Gloeden.

*Facing page:*
**Maurice Guibert**
*Toulouse-Lautrec Paints Toulouse-Lautrec*
1890, photomontage.

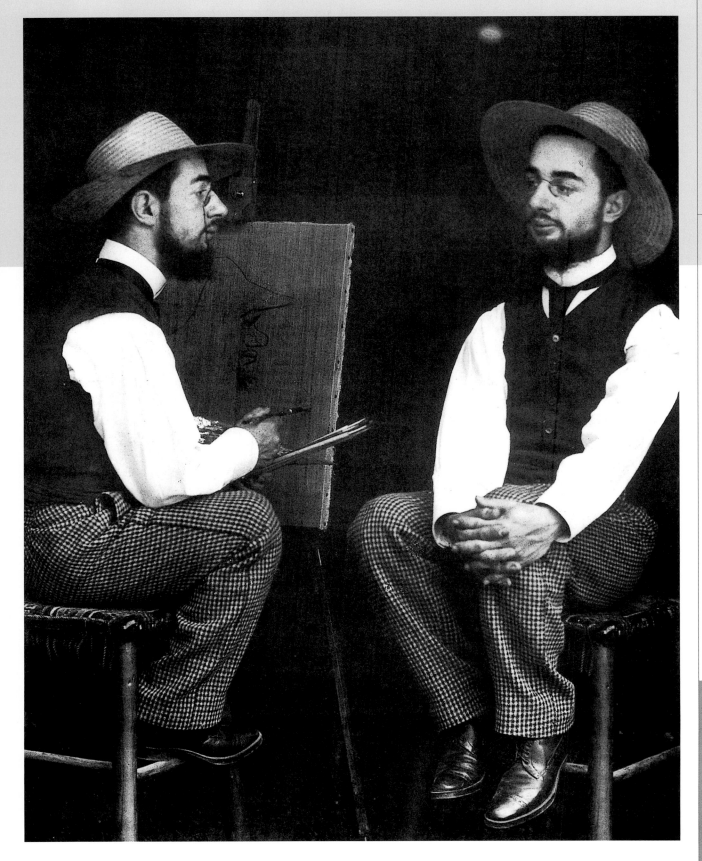

# Paul Cézanne
(b. Aix-en-Provence 1839, d. 1906)

After meeting Pissarro and Guillaumin in the Académie Suisse in Paris, Cézanne developed a fascination for sixteenth-century Venetian painters, as well as for Caravaggio, Velázquez, and Delacroix. He began frequenting the Café Guerbois, where he met Manet and Zola. From 1863 to 1870, he traveled between Florence and Aix-en-Provence, and from 1872 to 1874 he lived in Auvers-sur-Oise. Cézanne displayed work in Impressionist exhibitions between 1874 and 1877, already demonstrating a preference for more structured forms rather than ephemeral aesthetics. He continued this artistic research in Aix, where he went in 1882, concentrating on nudes (attempting to transform the lessons of Poussin's Classicism into a modern form), Mediterranean landscapes, and still lifes. In 1895, Ambroise Vollard organized a large exhibition of Cézanne's work that was not well received by the public, but was a revelation for young artists. From 1904, he exhibited at the Salon d'Automne.

**Paul Cézanne**
*Self-portrait*, detail
c. 1875, oil on canvas.
Paris, Musée d'Orsay.

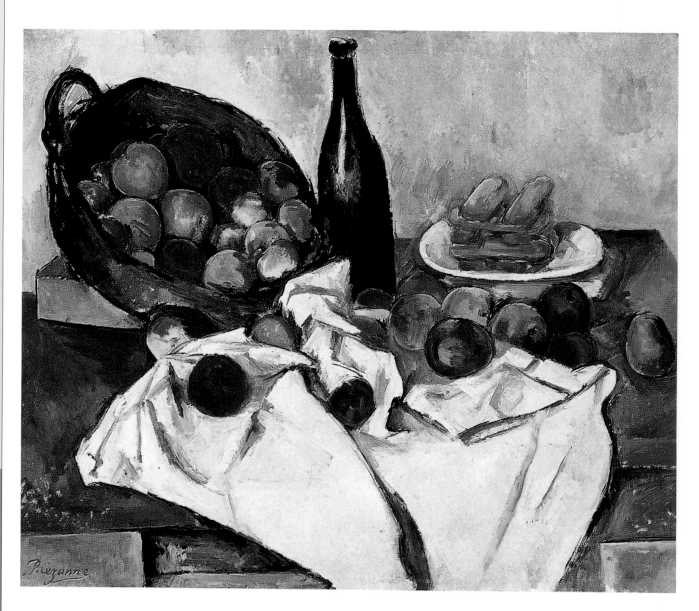

108

Leading Figures | *Paul Cézanne*

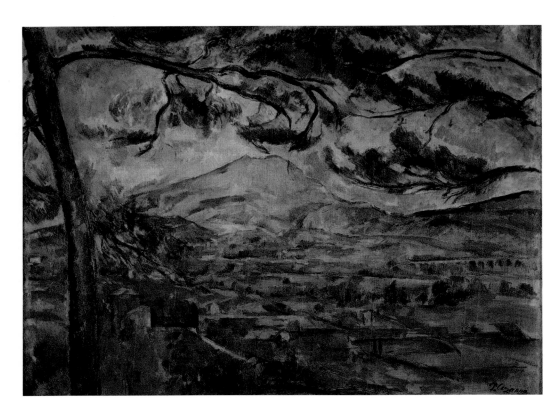

*Left and below:*
**Paul Cézanne**
*Mount Sainte-Victoire*
c. 1887 and 1890, oil on
canvas.
Paris, Musée d'Orsay.

In the series of paintings
inspired by this
landscape, Cézanne
transcends Nature's
outward appearance in an
attempt to portray matter
in its emergent phase,
when it is about to take
shape, analyzing its
layers and geological
structure.

*Facing page:*
**Paul Cézanne**
*The Basket of Apples*
c. 1895, oil on canvas.
Chicago, Art Institute.

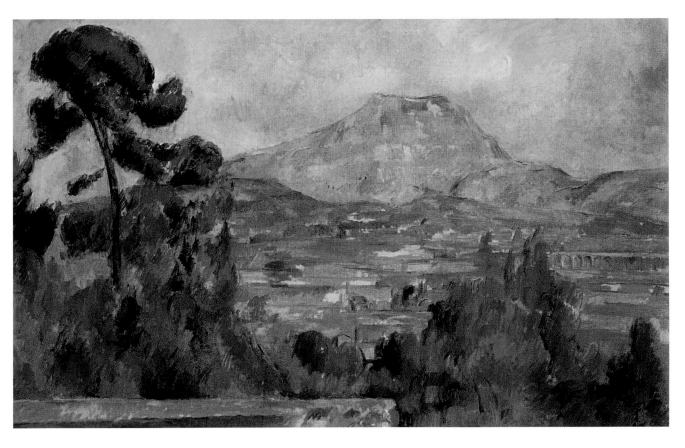

*Edgar Degas in a photograph dated 1885.*
Paris, Bibliothèque Nationale.

# Edgar Degas
(b. Paris 1834, d. 1917)

Raised in a family of bankers (who had resided in Naples until 1789), Degas studied in Paris at the École des Beaux-Arts under Lamothe, a student of Ingres and Flandrin. In 1856, he traveled to Italy, and in 1857 he made a thorough study in Rome, Naples, and Florence of the old masters, from Giotto to Piero della Francesca. Although Degas submitted traditional works to the Salon until 1870, he frequented the Café Guerbois and exhibited with the Impressionists (except for 1882). Some of his works featuring recurring themes, including horse racing and dancers, were particularly interesting for their draftsmanship and continuous experimentation with technique and perspective. He traveled frequently to Belgium, Holland, and Spain and also spent time with relatives in New Orleans (1872–73). During the later years of his career, Degas focused primarily on crayon, sculptures, and monotypes.

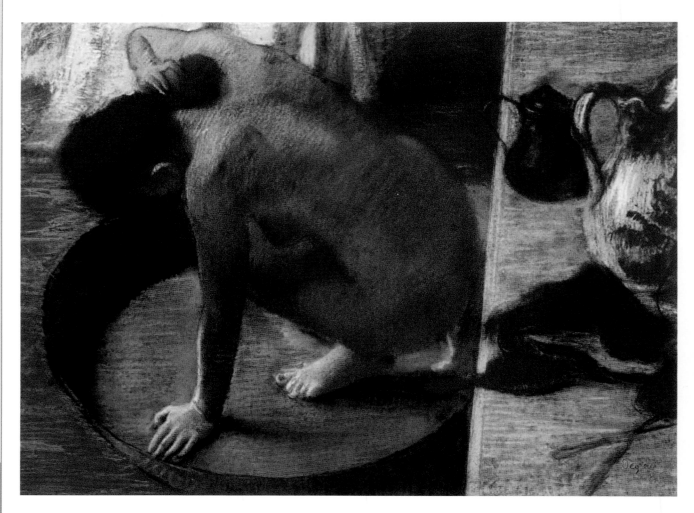

**Edgar Degas**
*The Tub*
1886, crayon.
Paris, Musée d'Orsay.

**Edgar Degas**
*L'Absinthe (The Absinthe Drinker)*
1875–76, oil on canvas.
Paris, Musée d'Orsay.

Degas revealed an intriguing insouciance in his creation of a casually asymmetrical vision, from an overhead engraving-type perspective. With rare gravity, he sums up the universe of desolation and life gone astray described by Émile Zola in his novel *L'Assommoir*. Behind the two figures, the prostitute with an alcohol-glazed expression and the vagabond at her side (who resembles Marcellin Desboutins, a friend who was an engraver and painter), a mirror diffuses light and confers depth to the sketched suggestion of the bistrot.

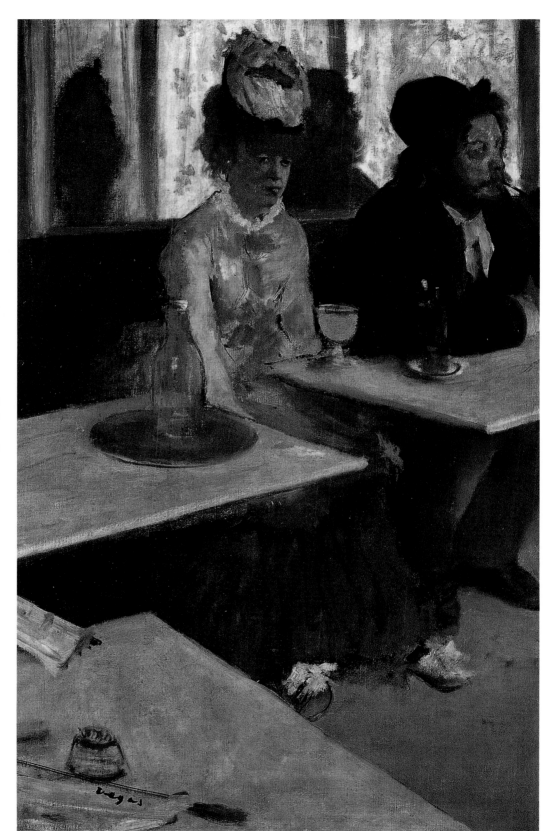

**Pierre-Auguste Renoir**
*Portrait of Claude Monet*
*Reading, detail*
1872, oil on canvas.
Paris, Musée Marmottan.

# Claude Monet
(b. Paris 1840, d. Giverny 1926)

Monet spent his adolescent years in Le Havre, where he was introduced to painting *en plein air* in the Dutch tradition by Boudin and later Jongkind. In 1859, he attended the Parisian Académie Suisse, where he met Pissarro. While Monet was at Gleyre's atelier in 1862, he met Sisley and Bazille and traveled with them to Chailly, in the Forest of Fontainebleau. In 1865, he exhibited for the first time at the Salon, with *Le déjeuner sur l'herbe*. During the war in 1870, he traveled with Pissarro to England, where he admired the works of Turner and Constable. Afterward, he traveled to Holland and lived in Argenteuil between 1872 and 1878. Monet participated in the Impressionist exhibitions from 1874, and in 1880 he had his first solo exhibition. From his studies of light (Vétheuil, 1878–83) to his time spent in Giverny (1883 to his death, with a brief interlude in Venice in 1908), Monet concentrated on atmospheric vibration, and the *Water Lilies* series (begun in 1899 as decorations) are a famous example of the results; part of the series was given to the French state in 1922 (now in the Orangerie).

**Claude Monet**
*Rouen Cathedral: The Portal, Morning Sun, Harmony*
*in Blue*
1892, oil on canvas.
Paris, Musée d'Orsay.

**Claude Monet**
*Rouen Cathedral: The Portal, Grey Weather*
1892, oil on canvas.
Paris, Musée d'Orsay.

# Camille Pissarro
(b. St. Thomas 1830, d. Paris 1903)

**Camille Pissarro**
*Self-Portrait*, detail
1903, oil on canvas.
London, Tate Modern.

Born in the Antilles, Pissarro moved to Paris in 1855 and attended the École des Beaux-Arts and the Académie Suisse. At the latter he met Monet, and later Cézanne and Guillaumin, with whom he exhibited at the 1863 Salon des Refusés. Pissarro rejected the use of bitumen, black, and raw sienna in his paintings, and was initially influenced by the works of Corot and Daubign, while Cézanne was, in turn, greatly influenced by Pissarro. For economic reasons, he frequently worked in Pontoise and Louveciennes. During the 1870 Prussian invasion, Pissarro went to London, where he met Durand-Ruel, who later became his art dealer. In 1872, he returned to Pontoise, and in 1884 he went to Eragny. In 1896, Pissarro was back in Paris, a milieu with which he had always maintained contact. He participated in all the Impressionist exhibits and defended young artists, including Gauguin, Seurat, and Signac. His works are predominately landscapes, with some industrial subjects. He experimented briefly with Neo-Impressionism in the mid-1880s.

**Camille Pissarro**
*Flock of Sheep.*
*Éragny-sur-Epte*
Signed, 1888, oil on canvas.

Pissarro was one of the first followers of Impressionism, but with his son Lucien, he converted to division of color. The traditional rural scene in this opus is thus transformed by composition and color choices, where very cold shades like the blues in the upper part cohabit with warm yellows and browns in the lower part. Whiter touches are scattered here and there. In the center, the sunlight meets the dust raised by the animals and creates a very suggestive void without matter.

# Pierre-Auguste Renoir
## (b. Limoges 1841, d. Cagnes-sur-Mer 1919)

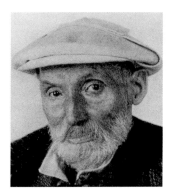

*Pierre-Auguste Renoir in a photograph dated c. 1900.*

Renoir was from a family of artisans and initially painted porcelains, and later fabrics and fans. He enrolled in the École des Beaux-Arts in 1862 and worked in Gleyre's atelier, where he met Monet, Sisley, and Diaz de la Peña, who urged Renoir to darken his palette. Renoir's first works showed Courbet's influence (*Mother Anthony's Inn*, 1866), but his style quickly moved toward *plein air* Impressionism. He participated in the group's exhibitions, from 1874 with *The Theatre Box*. His *Madame Charpentier and Her Children* was particularly well received at the 1879 Salon. In 1881, he traveled to Italy, where his fascination with Raphael led to an Ingresque period, which was also called *aigre,* or "harsh," because he used severe outlines and colder colors. Renoir suffered from severe rheumatoid arthritis but continued to paint, returning to a warmer palette inspired by Rubens's and Titian's later works; he painted numerous *Bathers* during these years.

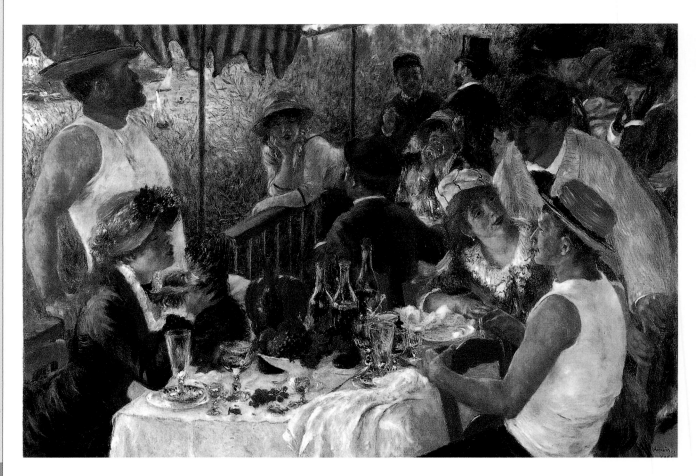

**Pierre-Auguste Renoir**
*Luncheon of the Boating Party*
1881, oil on canvas.
Washington, Phillips Collection.

With the help of a *plein air* study of light, Renoir conveys the lighthearted, lively tone of friends meeting in a restaurant along the Seine River to great effect. The work was painted on the artist's return from his 1881 trip to Algiers. Personalities like André Lhote, Pierre Lestinguez and Gustave Caillebotte, Aline Charigot, and the model Angèle are usually identified in the group.

# John Singer Sargent

(b. Florence 1856, d. London 1925)

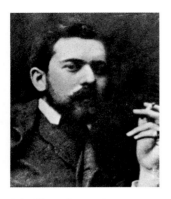

*John Singer Sargent in a photograph in the early 1880s.*

Sargent was the son of an American physician who lived in Italy. The artist studied at the Accademia di Belle Arti in Florence and under Carolus-Duran in Paris. Sargent greatly admired Manet's paintings, leading to a fondness for Velázquez's works, which is apparent in his *Portrait of Madame Gautreau*, exhibited at the 1884 Salon and now in the Metropolitan Museum of Art in New York. That same year, Sargent moved to London, where his skill as a portrait artist was highly valued by the aristocracy and the European-American upper-middle class (*Portrait of Isabella Stewart Gardner* from 1888, the 1902 *Portrait of the Acheson Sisters*, and *Portrait of Whistler* and *Portrait of Charles Martin Loeffler* from 1903). In the latter years of his life, he received commissions in the United States for important painting cycles, including murals at the Boston Public Library, the Museum of Fine Arts in Boston, and the Widener Memorial Library at Harvard University in Cambridge, Massachusetts.

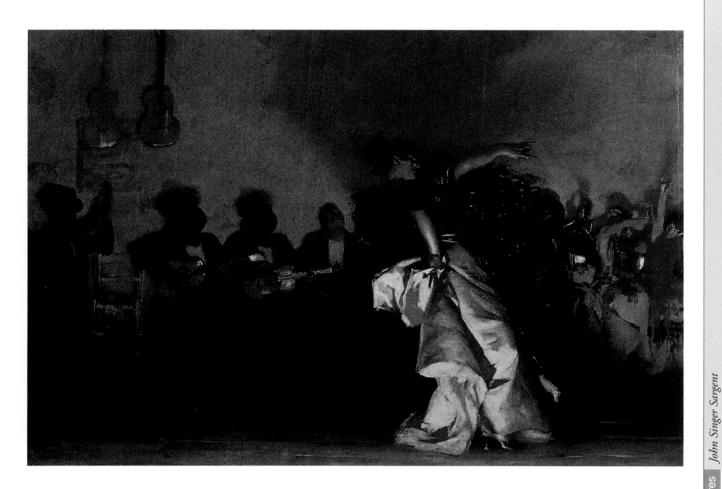

**John Singer Sargent**
*El Jaleo*
1882, oil on canvas.
Boston, Isabella Stewart Gardner Museum.

Sargent exhibited the great canvas—paying homage to Velázquez and Goya—at the Salon. With brilliant indifference to form and combining cues from Carolus Duran and Manet, he captures the dynamic intensity of the ballerina's gesture. The dazzling white of the skirt is dimmed in places, rendering the vigorous rotation of the dance step in an atmosphere laden with flashes of light and unexpected, disconcerting sparks.

*Giovanni Segantini in a
photograph dated 1897.*

# Giovanni Segantini
(b. Arco, Trento 1858, d. Schafberg 1899)

After traveling around Europe, Segantini studied at Milan's Accademia di Brera from 1875 to 1879. At some point during this period, possibly at the Triennale, he met Vittore Grubicy, who (in 1879) agreed to support Segantini financially in exchange for exclusive rights to his artistic production. Segantini's *At the Bar*, painted in Caglio, was shown at the 1889 National Exposition in Bologna and was acquired by the State for twenty thousand lire. That same year, eight of his works appeared at the Universal Expo in Paris. In 1887, he moved with his wife and three children to Savognin (in Grisons, Switzerland). He furnished their house in a striking style that incorporated Moorish and Neogothic elements. He wrote about Humanitarian Socialism (in *La Riforma*), and in 1891 his essay "Così io penso, così io sento la pittura" ("Thus I task, thus I feel like painting") was published (in *Cronaca d'arte*). The following

**Giovanni Segantini**
*Ave Maria at the Crossing*
c. 1886, oil on canvas.
St. Gallen, Fischbacher Foundation.

The work is emblematic of the artist's interest in Divisionist theories, which drew him to another colleague, Vittore Grubicy, who at that time was at Savognin posing for a portrait that Segantini was painting of him. The theme, already addressed in an 1884 canvas that won an award at Amsterdam, here has a greatly simplified composition. With the intense brightness of the sunset on the horizon, from which the boat—a symbol of maternal protection—emerges, Segantini stresses the presence of the Divine in Nature, a theme that increasingly dominated subsequent works. The result was obtained thanks to Segantini's committed exploration of divided color technique (described in letters that his friend Grubicy sent to Benvenuto Benvenuti). In fact, the artist painted long, filamentous brushstrokes of juxtaposed colors that do not blend, although he never went as far as the total breakdown of tone achieved by French artists. Grubicy also seems to have been the go-between for some Millet-style nuances, which are evident primarily in the vibrant stroke of coeval drawings.

year he won two gold medals: in Munich for *Midday* and at the Turin National Exposition for *Plowing in the Engadine*. This was followed, in 1896, by a medal in Vienna for *The Two Mothers*, which he had exhibited previously at the 1891 Triennale di Brera. No longer welcome in Savognin (due to his dubious religious beliefs and tax problems), Segantini remained in Switzerland and moved to Maloja, at an altitude of 1,800 meters. The publication *Pan* dedicated an issue to Segantini in 1895, and William Ritter wrote a monograph on him in 1897. That year, Segantini conceived an idea for *Panorama*, a sort of shrine-structure that would have reproduced the Engadine landscape for the 1900 Universal Expo, but the work was never realized because it was too expensive. In 1889, he published the article "Che cos'è l'arte" in *Ver Sacrum*, which affirmed his spiritualistic concept of art and served as a controversial response to a question posed by Tolstoy. A few months later he died in a cabin on Schafberg at 2,700 meters, where he had gone to complete the *Alpine Triptychon* (shown in detail at right).

**Giovanni Segantini**
*The Unnatural Mothers*
1894, oil on canvas.
Vienna, Österreichische Gallery in Belvedere Palace.

The painting, inspired by a Luigi Illica poem (which the author indicates as being a translation of the mysterious Indian poem *Pangiavahli*, in keeping with the trend for Hinduism spread by Schopenhauer), came three years after *The Punishment of Lust* (1891, now in the Walker Art Gallery, Liverpool). In this later canvas, mothers who had rejected maternity were punished by being made to float in eternal icy lands. The cathartic moment of redemption is evoked through the natural scenery of the *Maloja*, although light here acquires a totally transcendent value, as is the case in the *Alpine Triptychon*. The tangled bodies and tree branches, standing out against the snow-capped peaks on the horizon, indicate the Divisionist artist's early commitment to Art Nouveau–style features.

*Top:*
**Giovanni Segantini**
*Death*, detail from *Alpine Triptychon: Life-Nature-Death*
1897–99, oil on canvas.
Saint Moritz, Segantini Museum.

*Georges Seurat in a photograph dated c. 1888.*

# Georges Seurat
(b. Paris 1859, d. 1891)

In 1878, Seurat entered the École des Beaux-Arts in Paris. He also looked to Millet's works for inspiration. Seurat exhibited *La Baignade* (London, National Gallery) at the Salon des Indépendants in 1884. The painting already indicated a movement away from the variability of Impressionism, as Seurat and his friend Signac had developed a technique for dividing colors, applying the scientific theories of Chevreul, Maxwell, Helmholtz, Dove, Sutter, Rood, and Henry to the discipline of painting. The works that Seurat created during his brief lifetime established the basis for a new vision that sought to translate absolute values into painting, that vision is also an "icon" of the present, as can be seen in *A Sunday on La Grande Jatte–1884* (1886, Chicago, Art Institute), *Parade* (1888, New York, Metropolitan Museum of Art), *Le Chahut* (1890, Otterlo, Rijksmuseum Kröller Müller), and *Le Cirque* (1890–91, Paris, Musée d'Orsay). During Seurat's final years, his works adopted a more refined and detailed quality, influenced by the Art Nouveau movement.

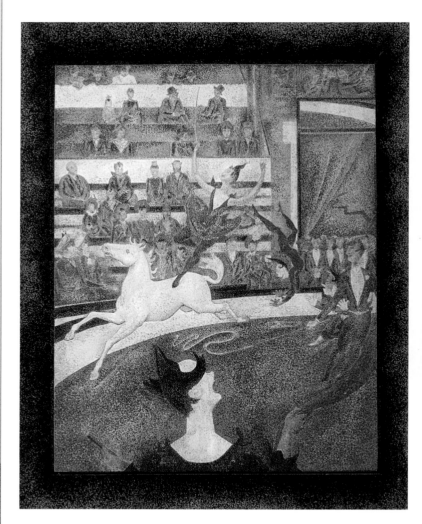

**Georges Seurat**
*The Circus*
1891, oil on canvas.
Paris, Musée d'Orsay.

**Georges Seurat**
*Model, Front View*
1887, oil on panel.
Paris, Musée d'Orsay.

# Joaquím Sorolla y Bastida
(b. Valencia 1863, d. Cercedilla 1923)

Sorolla studied at the Fine Arts School in Valencia. In 1885, he received a government scholarship to travel to Rome and remained there until 1889; he then returned to Spain and resided in Madrid, where his work *And They Still Say Fish Is Expensive* won first prize in an exhibition. He successfully competed at Salons, exhibitions in Munich and Berlin, and the Biennale in Venice. Around the beginning of the twentieth century, his Impressionist-influenced painting style evolved toward an increasingly intense luminosity that he used to depict women and playing children at the Spanish seaside. In 1908, he exhibited at the Galerie Georges Petit in Paris, then in London and the United States, where he painted President Taft's portrait and obtained a commission for a series of portraits for the Hispanic Society. In 1914, Sorolla was appointed to an academic position in the fine arts, and in 1919 he became a professor at the San Fernando School in Madrid.

*Joaquím Sorolla y Bastida showing his notes to a member of the royal family.* Early twentieth century.

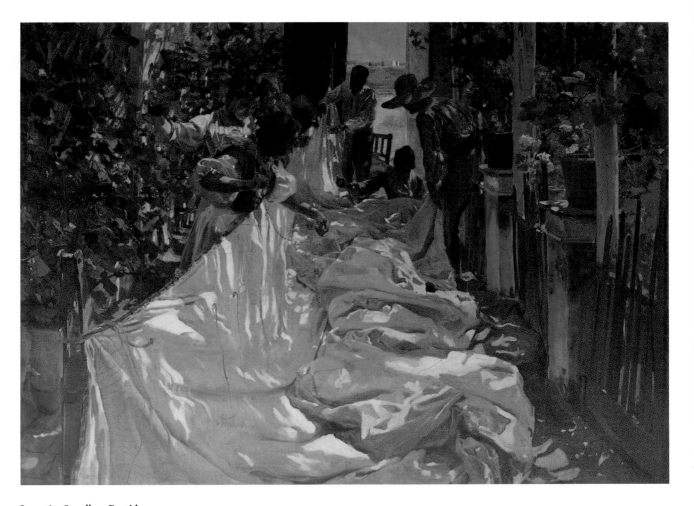

**Joaquím Sorolla y Bastida**
*Mending the Sail*
1896, oil on canvas.
Venice, Ca' Pesaro, International Gallery of Modern Art.

# Henri de Toulouse-Lautrec
(b. Albi 1864, d. Malromé 1901)

**Henri de Toulouse-Lautrec**
*Self-Portrait*, detail
1882–83, oil on canvas.
Albi, Musée Toulouse-Lautrec.

Born into an aristocratic family, Toulouse-Lautrec studied in the ateliers of Bonnat and then Cormon in 1882 and 1883. He was introduced to Cézanne's paintings by his friends Anquetin, Laval, and Bernard and also met Degas. In 1885, he exhibited at Aristide Bruant's (*Le Mirliton*) cabaret and produced humorous drawings for the *Courrier Français* and *Paris Illustré*. In 1886, he participated under a pseudonym in the Salon des Incohérents and met van Gogh. He also displayed works at the 1888 Salon des XX in Brussels, the Salon des Indépendants in 1889, and the Cercle Volvey exhibitions (until 1894). The artist regularly frequented theaters and café concerts (his favorite models were Jane Avril and later Yvette Guilbert) as well as brothels, including those located on the Rue d'Amboise. He was interested in Japanese art (he reorganized Goupil's collection), photography, and various illustration techniques (he worked for Natanson and Vollard). He died at the age of thirty-six after repeated alcohol-related collapses.

**Henri de Toulouse-Lautrec**
*La Goulue Arriving at the Moulin Rouge*
1892, oil on panel.
New York, Museum of Modern Art.

La Goulue, a famous Moulin Rouge dancer also portrayed in many posters, enters arm-in-arm with two other girls, of whom the photographic nature of the painting allows only a glimpse, preferring to focus on the artiste's world-weary expression. While a japonaiserie echo can be noted in the sinuous outlines and two-dimensional perspective, the brazenness of the figure is fully reiterated in the nonchalant exaggeration of the painting technique, which uses quick, sketchy brushstrokes and fine layers of color.

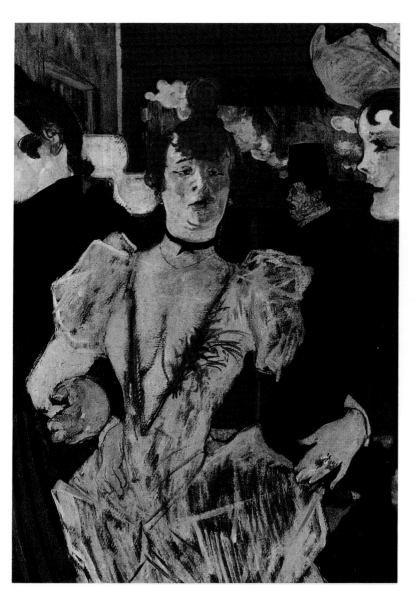

*Facing page:*
**Henri de Toulouse-Lautrec**
*Yvette Guilbert Taking a Curtain Call*
1894, lithograph.
Albi, Musée Toulouse-Lautrec.

This was the last of sixteen plates for Gustave Geffroy's illustrated book about the singer, produced by publisher André Marty in 1894. The woman's features are quickly outlined by Lautrec: heavily made-up eyes, the frozen facial expression when receiving the public's applause, her smile almost a grimace, and her gestures reminiscent of Japanese prints.

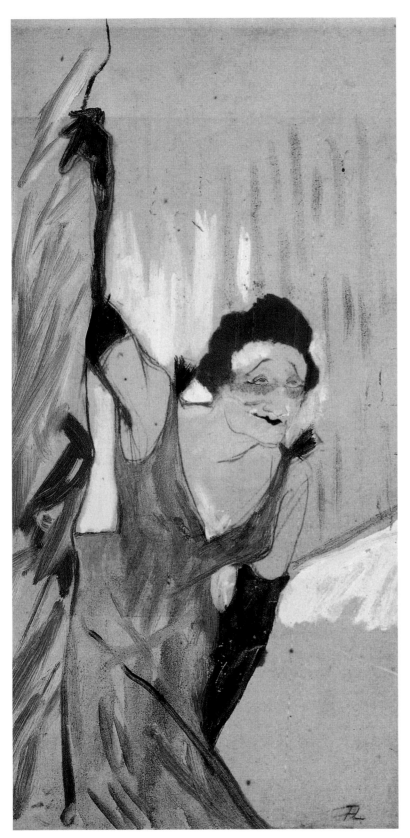

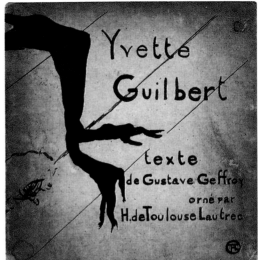

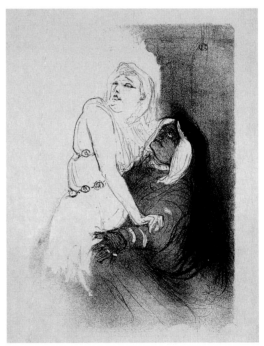

*Top:*
Henri de Toulouse-
Lautrec
*Yvette Guilbert
Album Cover*
1894.

*Above:*
Henri de Toulouse-
Lautrec
*At the Renaissance:
Sarah Bernhardt in
"Phedre"*
1893.

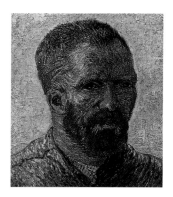

# Vincent van Gogh
(b. Groot Zundert 1853, d. Auvers-sur-Oise 1890)

Van Gogh was the son of a Protestant minister. He worked for Goupil in The Hague I 1869, then moved to London in 1873 and to Paris in 1875; he returned to Holland in 1876 and studied theology, then attended a missionary school in Brussels, but was expelled for defending striking miners in Borinage. From 1880, he studied with Van Rappard, copied the works of Millet, and painted scenes from peasant life in Nuenen (*The Potato Eaters*, 1885, Amsterdam, Rijksmuseum van Gogh). In 1886, he joined his brother Théo in Paris, where he became enthusiastic about Impressionism and Japanese art; there he met Toulouse-Lautrec, Guillaumin, and Émile Bernard. Van Gogh moved to Arles in 1888 and shared the "yellow house" with Gauguin. The subsequent years were plagued by conflict and deep depression, during which time he cut off his earlobe; he was treated in Saint-Rémy, then in Auvers-sur-Oise (near Paris), where he committed suicide on July 29, 1890.

**Vincent van Gogh**
*Self-Portrait at the Easel,* detail
1888, oil on canvas.
Amsterdam, Rijksmuseum.

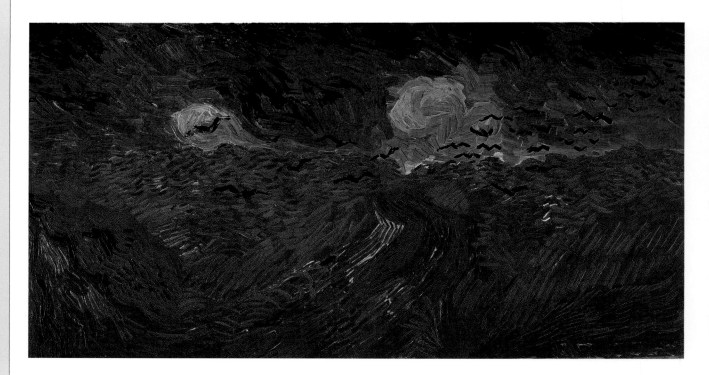

**Vincent van Gogh**
*Wheat Field with Crows*
1890, oil on canvas.
Amsterdam, Rijksmuseum.

*Facing page:*
**Vincent van Gogh**
*Dr. Paul Gachet*
1890, oil on canvas.
Paris, Musée d'Orsay.

This work can be considered a kind of "nonpersonified self-portrait": the real-life subject is in fact transfigured, conveying, through the violent contrast of the complementary colors and the undulating moving forms, the existential anguish and anxiety of the artist, who painted it in the year of his death.

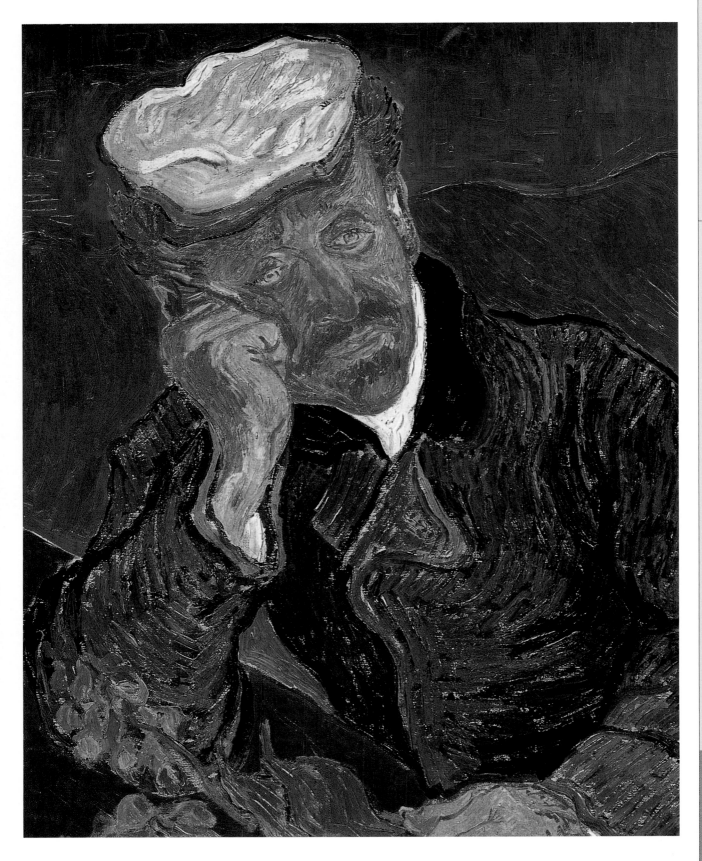

# Aesthetism
# and Symbolism

*Aesthetism and Symbolism*

**Etienne Carjat**
*Arthur Rimbaud at the
Age of 17*
1871, photograph.

*Previous page:*
**Fernand Khnopff**
*Art* or *The Sphinx*, detail
(full on page 136)
1896, oil on canvas.
Brussels, Musées Royaux
de Beaux-Arts.

## Aestheticism and Symbolism

*Nature is a temple where living pillars
Sometimes leave out of confusing words:
The man passes through forests of symbols
Who observe with familiar eyes.*
—Charles Baudelaire ("Correspondances," from *Les
Fleurs du Mal*, 1858)

The definition of Symbolist art is very broad and
does not refer to precise stylistic characteristics,
but rather to a spiritual disposition that united
artists from various groups and nationalities from
the middle of the nineteenth century. Symbolism
actually has a primarily literary meaning: the French

poetry of Rimbaud, Verlaine, and Mallarmé was
Symbolist; Jean Moréas wrote the *Symbolist
Manifesto*, which was published by the journal *Le
Figaro Littéraire* on September 18, 1886.
Symbolism is mentioned with respect to painting
mainly after about 1880, and in 1891 Albert
Aurier's famous essay "Symbolism in Painting,"
commenting on Gauguin's *The Vision After the
Sermon* (page 96), noted that the opus showed a
complete interpenetration of meaning and style
(Synthetism). Nevertheless, a Symbolist aura
pervades all the works that expressed a detach-
ment from incidental reality created after the
middle of the century, asserting the values of spirit
and imagination during the years of Realism and
Positivism—considered a quintessential creative
model for the development of pure art, whose
evocative allure would contain the object and
subject of the vision. Imagination was defined by
Baudelaire in an 1859 *La Revue Française* as "the
queen of all of the mind's faculties," since it differs
from the digressions of fantasy and approaches
true thought: "an almost divine faculty, and philo-
sophical methods notwithstanding, [that] captures
in one fell swoop the intimate and secret connec-
tions [among] things, relationships, and similari-
ties." After all, it was Baudelaire who, in his sonnet
"Correspondances" from *Les Fleurs du Mal*,
described Nature as "a temple where at times the
living columns let confused words slip." The poet
and the artist are thus called to interpret this forest
of symbols, going beyond the mere appearances
of things.

A decade later, expanding on Baudelaire's
warnings about confusing the sensitivity of the
imagination with that of the heart, Arthur Rimbaud
clarified the characteristics of the new art in *Letters
of the Seer*: the poet must become "a seer through
a long, limitless, *rational distortion* of the senses."
The opposition between reason and violation of
rules is suggestive of a desire to shrug off the
vulgarity and dullness of surroundings, opposing

Positivist mentality and its belief in all that is measurable and scientifically demonstrable, without indulging in uncontrolled sentimentality. It is preferable for the artist to subject instinct itself to strict rules, in pursuit of an expression with meaningful content and elegant form. In addition, the philosophical principles expressed by Arthur Schopenhauer in *The World as Will and Representation* (1819) were passionately debated in the artistic community of the closing decades of the century. According to Schopenhauer, everything outside of the "I," of humankind, the world's rational being, exists only in the individual's own notion of it. In France, where Schopenhauer's text was translated for the first time in 1886, the young Henri Bergson declared in *An Essay on the Immediate Data of Consciousness* (1889): "the objective of art is to dull the active or rather resistant powers of our personality and bring us to a state of perfect submissiveness in which we understand the idea that is suggested or we sympathize with the sentiment expressed."

The literary and philosophical examples presented above include only a few of the sources forming the basis of this exploration in the field of figurative arts, which asserted—in contrast to Realism—a type of representation beyond mere "reality" analysis. Thanks to this, an ability to convey eternal truths about humanity and Nature through a fascinating interconnection of symbols was developed, using evocative metaphors. According to the critics of Symbolism, these metaphors apparently even affected a "Realist" painter like Millet (who was discussed in the first chapter) or even Claude Monet who, in the later years of the *Water Lilies*, shifted from Impressionism—a movement deemed by Odilon Redon to be like "a building at times too low," alluding to that impossibility of transcending objective reality—and turned instead, as Camille Mauclair wrote, toward "unknown entities." The appearance of Symbolism heralded an openness toward the ideal world; some artists chose to highlight Symbolist traits thematically (with imagery strongly influenced by literary decadence), while others used metaphoric symbols based on a separate vocabulary that was no longer representational and imitative of reality, but had its roots in the origins of things and of the world. Symbolist art studied the evocative potential of music with great interest, particularly that of Richard Wagner. There was even a magazine dedicated to the Wagnerian influence on art and literature, *La Revue Wagnérienne*, established in 1885 by Théodore de Wyzewa. In the magazine, supporters of the Wagner phenomenon, including Joris-Karl Huysmans (captivated by the fantastic fluidity of the performances, the exuberant role of the orchestra, and the alternations of light and darkness, of good and evil, of tormented and wavering forms), clashed with those who, like the poet Mallarmé, criticized the undefined aspect, the sometimes confused prosody, the desire to dramatize the music, and supported a symbolism based on syntactic precision, on the

**Claude Monet**
*Water Lilies*
1908, oil on canvas.
Aichi, Maspro Denkoh
Art Museum.

Henri Fantin-Latour
*Scene from Tannhäuser*
1864, oil on canvas.
Los Angeles, Los
Angeles County
Museum of Art.

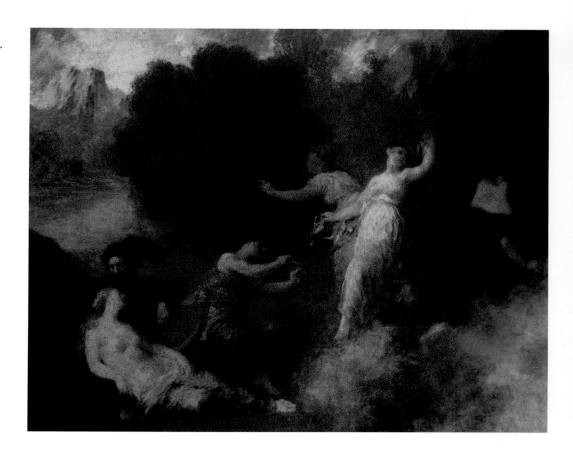

meaningful essentiality of the symbol: a direction that was also asserted in the realm of painting, particularly after 1890.

## From the Pre-Raphaelites to the "Olympian Dreamers"

The Pre-Raphaelite Brotherhood was founded in 1848 by a group of young English painters, whose champion and mentor was John Ruskin. Despite the group's profession of Realism, the "schism" that the Pre-Raphaelites created by appealing for new sincerity and authenticity of vision, reasserting forgotten principles of truth and ethics in painting, and exhibiting their works at the Royal Academy with the acronym PRB was one of the earliest and boldest demonstrations against prevailing materialism, compliant with the ideas expressed in *The Germ*, a magazine the group published in 1850. This

was the first periodical designed to combine painting with poetry, one of the movement's primary inspirations: the relationship with poets—whose works they also illustrated, such Hunt for Tennyson's *Poems*—was in fact very close and fertile.

The desire for a natural approach was also applied extremely scrupulously by these painters in their handling of subjects inspired by ancient fables, sacred stories, or literature, from Medieval to Shakespeare. It is said that Elisabeth Siddal, the model for *Ophelia*, floated in a bathtub for so long that she became ill so that Millais could accurately portray the billowing of her dress in the water. Yet, Pre-Raphaelite paintings embodied every aspiration to furthering of vision, a characteristic of the Symbolist movement. When Ruskin's strong moral stimulus to the movement was declining, in about 1853, as he and Morris began focusing on decorative arts reform and the relationship between the arts and industry (see the section that follows), the

THE LADY OF SHALOTT.

**William Morris**
*La Belle Iseult (or Queen
Guinevere)*
1858, oil on canvas.
London, Tate Britain.

**William Holman Hunt**
*Illustration for
Tennyson's Poems*
1859, wood engraving.
London.

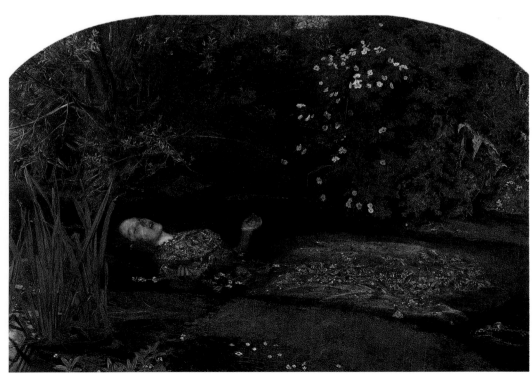

**John Everett Millais**
*Ophelia*
1851–52, oil on canvas.
London, Tate Britain.

**Dante Gabriele Rossetti**
*The Beloved*
1865–66, oil on canvas.
London, Tate Britain.

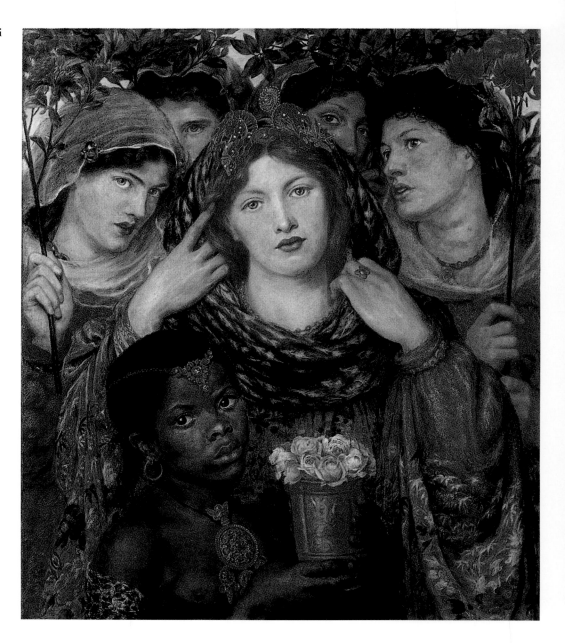

Pre-Raphaelites captured in their works not only the fragile, pure forms of the fourteenth and early fifteenth centuries, but also elegant, faux-classical High Renaissance beauty, in an aura not unrelated to the suggestion of Walter Pater's 1873 essays in *Studies in the History of the Renaissance*, characterized by a completely Neo-Platonic concept of art. The women featured in the paintings of Dante Gabriele Rossetti (also shown on pages 58–59)— who for years shared a house with the poet Swinburne and who also wrote verse—embodied a union of mysticism nourished by Dante Aligheri's literature and a mysterious, disturbing sensuality in an evocative, eloquent manner: women with intense, profound gazes and languid, spiritual poses (in complete contrast with the canons of Victorian England). The young women in Burne-Jones's paintings, drawings, and pastels were also priestesses in a cult of beauty and poetry. This slightly younger artist quickly departed from Ruskin's teachings and became the idol of the "Temple of the Aesthetes" for all of Europe. The symbology that permeates his

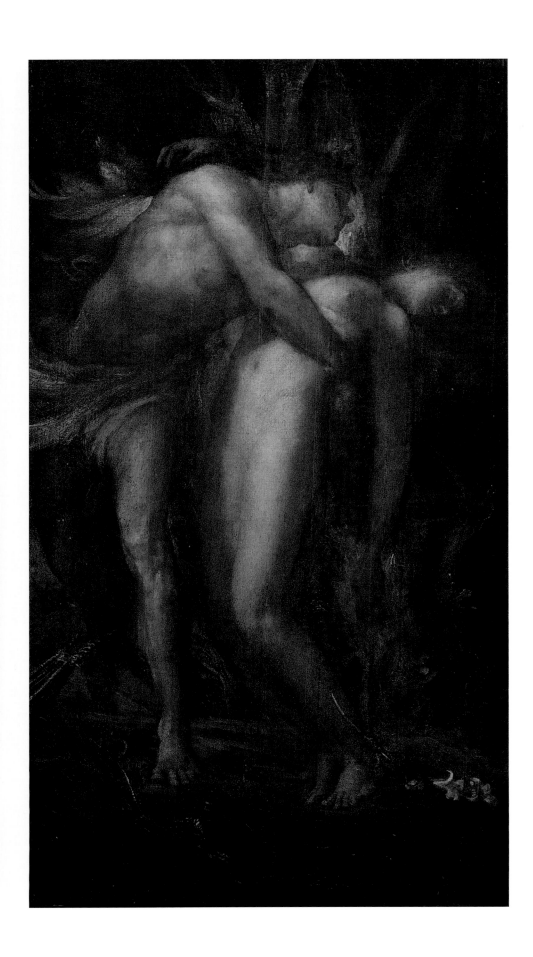

**George Frederic Watts**
*Orpheus and Eurydice*
1881, oil on canvas.
Compton, Trustees of
Watts Gallery.

**Frederick Leighton**
*Flaming June*
1895, oil on canvas.
Puerto Rico, Museo de
arte de Ponce.

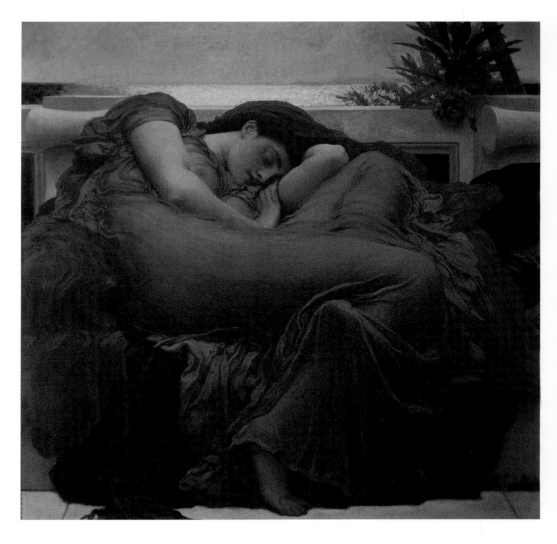

**Edward Coley
Burne-Jones**
*The Wheel of Fortune*
1883, oil on canvas.
Paris, Musée d'Orsay.

*Facing page:*
**Frederick Leighton**
*Self-Portrait as Oxford
Graduate with President
of the Royal Academy
Medal and Frieze of the
Parthenon in the
Background*
Opus signed and dated
1820, oil on canvas.
Florence, Uffizi Gallery.

works is, in fact, entrusted to linguistic choices of great meaning and suggestion, revealing the influence of Botticelli as well as 1500s masters, including Michelangelo (*The Wheel of Fortune*) and Giorgione (*The Love Song*). Burne-Jones was no longer faithful—in the opinion of the stricter Pre-Raphaelites—to the simplicity of reality shattered by Raphael, particularly in *The Transfiguration*.

An aura of alluring languidness also pervades George Frederic Watts's sumptuous allegories of human existence, for instance in *Endymion* (whose torso is reminiscent of the figure of Theseus, in the Elgin Marbles, brought from the Parthenon), where Diana, a creature of cold light enfolded in opalescent splendor, descends in a manner reminiscent of fifteenth-century Venetian painting: the mystical

image of love, of "a soul that looms over a body," as the artist himself wrote. In addition to the Renaissance, there was also a veneration of the Classical world, showing an original capacity for synthesis, which critic Walter Pater deemed to be an essential talent for every artist. According to Pater, a new organism is not fashioned "through an abrupt and sudden act of creation, but rather through the effect of a new code on elements that have already lived and died many times." Fascination for Greek sculptures in London also attracted artists like Frederick Leighton, who added cultural experiences from his travels in Italy and Germany and became Victorian England's leading exponent of Classicism, revisiting ancient myths and legends in an elegiac-sentimental tone.

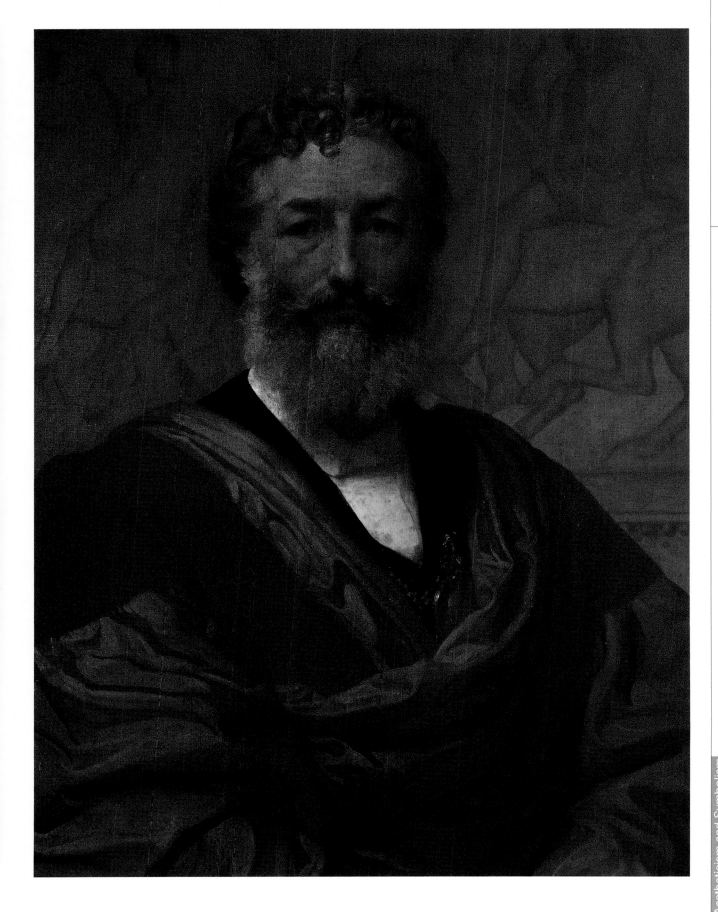

**Pierre Puvis de
Chavannes**
*The White Rock*
Signed, c. 1870, oil on
canvas.
Blessington, Fondation
Alfred Beit.

**Gustave Moreau**
*Orpheus*
1865, oil on canvas.
Paris, Musée d'Orsay.

*Facing page:*
**Pierre Puvis de
Chavannes**
*Young Girls at the
Seaside*
1879, oil on canvas.
Paris, Musée d'Orsay.

## The Cult of the Ideal in France and Belgium

In France, the banner of "idealist," and hence symbolic painting, was carried by artists including Puvis de Chavannes and Gustave Moreau, who were praised by critic Robert de la Sizeranne for aspiring to poetry, the cult of the ideal, which was already prevalent among English artists.

Puvis accused the Impressionists of being mere "poets of ephemera" and stated that "Nature contains everything, but in a confused way. It is necessary to remove what is incidental, accidental, that which does not aid our reflections. . . . art perfects what Nature sketches, enounces the words that Nature stammers." Puvis—an artist whom Redon described as "far-sighted by abstraction"—painted simplified forms of figures, trees, and objects, as though they were in the remote depths of the painting. This consistent course is evident in *Mary Magdalene in the Desert* (1869–70), *The Sacred Wood* (1884), and the frescoes for the Sorbonne amphitheater in Paris and the Picardy Museum in Amiens. The latter interested Paul Gauguin, who used them as inspiration when elaborating his

Symbolist language of ciphers independent of content.

Moreau, on the other hand, captured the dying breaths of Romantic sensibility during the era of Positivism and transformed it into the sumptuous, disturbing, and decadent universe that so fascinated Des Esseintes, the protagonist of Huysmans's novel (*Against the Grain*), who lived in his Paris house, contemplating works by old masters and Moreau, steeped in incense and music, hostile to everything that was "natural," even the sunlight that filtered through the heavy, luxurious drapes. Huysmans's elaborate portrayal, which was plausible but for its extravagance, nevertheless suggests the mood of the cultural climate in which such works were conceived. Departing from the academic training still apparent in his first works, Moreau viewed his existence as a mystical form of dedication to art, anticipating ideas that would later be the banner of the Rose-Croix movement (1887–92). This movement was founded by Josephin

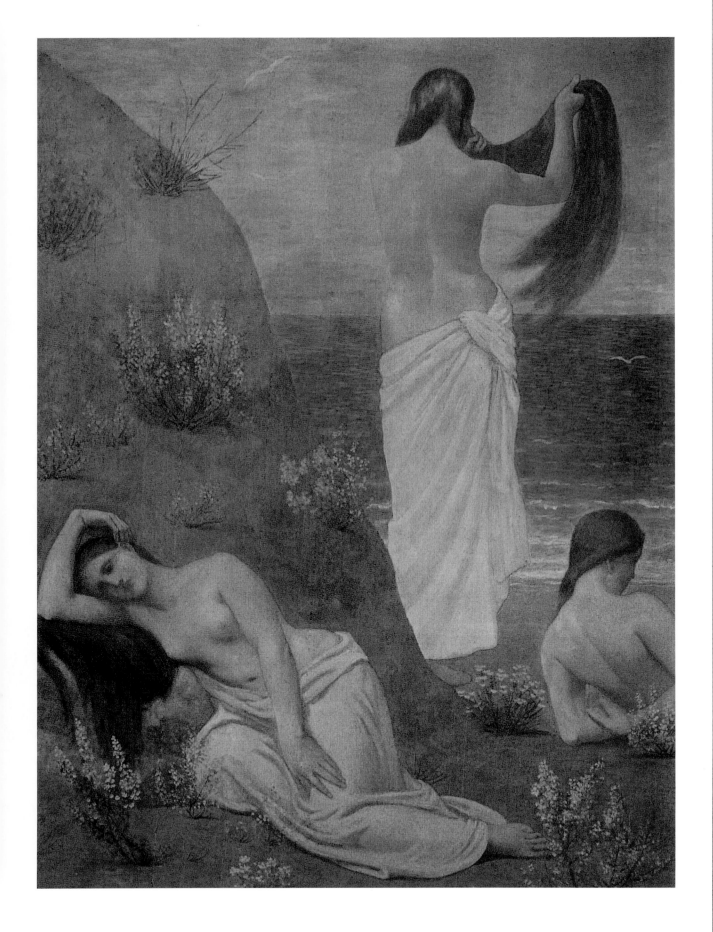

**Fernand Khnopff**
*Who Shall Deliver Me?*
1891, pencil on paper.
Paris, N. Manoukian
Collection.

Péladan, who organized exhibits, inviting artists sharing an aspiration to beauty not contaminated by the "object parasites" and the belief in the artist's role as seer, magician, and priest. These ideas were shared by Edouard Schuré in his 1889 *The Great Initiates*, a text read by many followers of Symbolism. Devoting himself to painting as a "mute poetry" clothed with symbolic and philosophical meanings, Moreau therefore viewed Nature as a nomenclature for creative imagination ("recording natural forms but in a manner artificial enough not to destroy the spirit and unity of the work they serve to decorate"); he wrote that color should only be thought, dreamed, and imagined, not imitated, and he avoided art as a photographic rendering or as "paraphrases of vulgar events." Symbolist art in Belgium was driven by similar cultural conditions. At the end of the century, Brussels was a hotbed of creativity, observed with great attention by the magazine *L'Art Moderne*, founded by Octave Maus and the poet Emile Verhaeren in 1881 and fostered

**Fernand Khnopff**
*Art* or *The Sphinx*
1896, oil on canvas.
Brussels, Musées Royaux
de Beaux-Arts.

by the formation (also by Maus) of the group Les XX.

The most intriguing figure of the new creative trend was Fernand Khnopff: his art, reminiscent of the Pre-Raphaelite model, was also imbued with contemporary literary references, from Maurice Maeterlinck (author of *Pelleas and Melisande*) and Stuart Merrill to Georges Rodembach, and combined a fascination for the atmosphere of the *villes mortes* (Venice, Bruges) with that for the great ancient tradition and mythology. His favorite model was his sister Marguerite, a woman with a pale, solemn face, who was often depicted with the image of Hypnos (of which Khnopff also owned a plaster cast), the chosen tutelary deity of an existential state always suspended among desire, sensuality, and death. On the other hand, Odilon Redon, an artist who was also enthusiastic about biological sciences and was a friend of the botanist Clavaud, was one who shared the widespread rejection of the vulgar industrial and material times, and was intent on focusing on and listening to his own interior

**Odilon Redon**
*Closed Eyes*
1890, oil on canvas.
Paris, Musée d'Orsay.

**Odilon Redon**
*The Buddha*
c. 1906–07, crayon.
Paris, Musée d'Orsay.

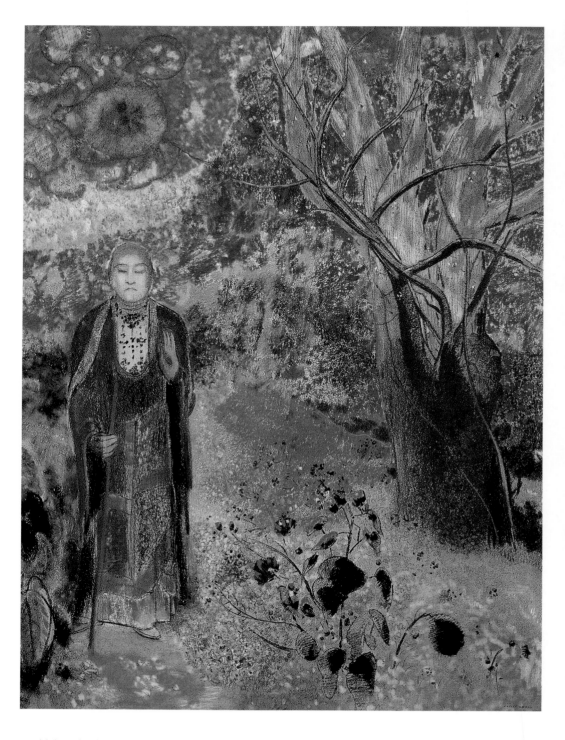

world, but simultaneously the world of Nature, as he wrote in his diary, *À soi même*. Redon's efforts to guide art toward "a quality verging on enigma" because "the future belongs to a subjective world" created a universe filled with images and forms intended to have a life of their own in the viewer's mind. Maurice Denis described Redon as "incapable of painting anything that is not representative of the spirit." Redon preferred crayon to the illusion of color given by oils or tempera because of crayon's ability to create subtle, fragile evocations in rendering "all that surpasses, makes limitless, or exaggerates the object." Redon seems to have reflected on the saying that "every certainty is in dreams," and his

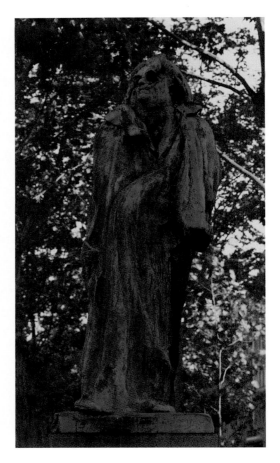

works are the result of a "docile submission to the arrival of the subconscious." Some of his works were created in the period directly preceding Freud's research and hysteria studies performed by Charcot at the La Salpetrière hospital in Paris, whose photographic documentation fascinated numerous contemporary artists because of the expressive gestures offered by hallucinatory states. Another subject arousing great interest in the early 1900s—in circles investigating the realm beyond physical reality—was the séance, which revealed materialization phenomena like those photographed by Albert von Schrenck-Notzing.

Auguste Rodin was one of the sculptors best suited to capturing and conveying the period's spiritual creative fervor. Although Rodin's works are often mentioned in conjunction with Impressionist painting, as they reflect a desire to oppose the nature of sculpture itself, breaching the immobility of the planes and giving life to more transitory effects

of the image, the sculptor's idiom also offered many parallels with Symbolism in the themes he addressed. From his youthful works, which were more Naturalistic (*The Walking Man*), Rodin shared with the artists of his time a passion for Michelangelo's sculptures, but also for his paintings; in fact, Rodin's model for his famous *The Gates of Hell* (see the commentary on page 184) was Michelangelo's Sistine Chapel *Last Judgment*. Nevertheless, despite his fascination with the Michelangelesque unfinished technique, Rodin presented a very different interpretation from that displayed in the great master's sculptures; Rodin was less interested in infusing his creations with the struggle between form and subject, spirit and body. As George Simmel indicated in a 1911 essay, the emergence of the figure from the stone, which Rodin kept partially unsculpted, is the immediate, sensitive representation of creation, which underpins the meaning of the artwork; each figure is captured at a specific point on an endless path it is traveling without pause. This flow of existence—its continual changing, transformation, and renovation—is an idea common to sensibilities at the end of that century and was the flagship philosophy of innovative movements like Jugendstil and Art Nouveau. Rodin was fascinated by the greatly varied images offered—wave, flower, or plant—by

**Auguste Rodin**
*Honoré de Balzac*
1897, bronze.
Paris, Musée Rodin.

**George Minne**
*Fountain of the Kneeling Youths*
1898, marble.
Essen, Folkwang Museum.

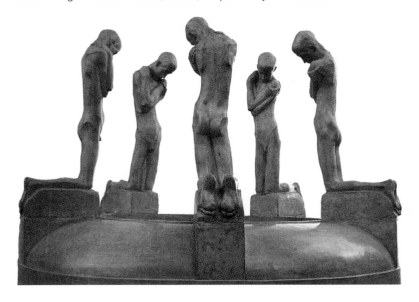

Aestheticism and Symbolism

the human body, by virtue of its innate grace and strength, and which he sculpted in the gentlest, most languid, or most tormented poses: "the bending of a torso imitates a stalk, a smile a breast, the head and the splendor of the hair correspond to the blossoming of a corolla. At other times the body is like a liana, a shrub with a refined, bold twist. . . . at other times, however, the reclining human body is like a spring, a beautiful bow on which Cupid lays his invisible arrows" (Rodin).

**Anselm Feuerbach**
*Iphigenia*
1871, oil on canvas.
Stuttgart, Staatsgalerie.

Rodin's lesson that "the body knows as much as the soul" (as Paul Claudel wrote, referring to the sculptures of his sister Camille, who suffered a tormented artistic and sentimental relationship with Rodin) entranced an entire generation of European artists. In the Symbolist milieu, it particularly attracted George Minne, a Belgian sculptor who learned from Rodin not only the subject's evocative power that "suggests more than it says" (an idea expressed by Gauguin about his own sculpture), but also the multiplication of forms. Like Rodin in *The Gates of Hell*, Minne "multiplied" the same figure in the *Fountain of the Kneeling Youths* (1898), accentuating the slenderness, fragility, and languid sense of a world closed in on itself that seems to belong to the "mystical time" announced by Gauguin.

## Germanic Culture and the Myth of Italy

From the 1850s, Germanic culture expressed indifference for the spectacle offered by contemporary life and preferred contemplation of the Italian landscape and the surviving evidence of a mythical age, or its evocation in Renaissance paintings, with a "far-sighted and dreamlike gaze" (Volpi). Thus Feuerbach's plebian lover Nanna is portrayed clothed as *Iphigenia*, swathed in a peplum as she gazes, solemn and statuesque, at the horizon. Modern nostalgia for the ancient world therefore concentrated into an inhibited gestural expression that inspired "a sinking, a succumbing, and falling into the inner self," in keeping with the desire expressed by the artist himself. The image's gray patina is almost like a veil in dulling the sensuality of local color and increases this *Stimmung*, implying that the reference to the ancient is a completely subjective need rather than the acknowledgment of a rule and a canon of Classicism in the Germanic culture. After all, Schopenhauer had written that it was precisely

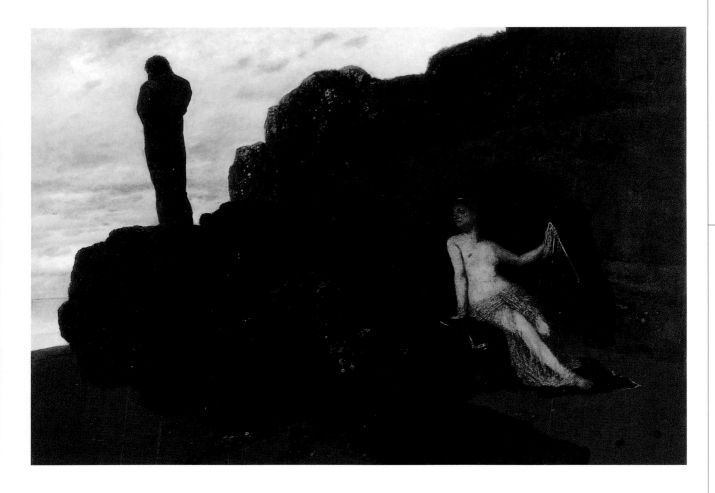

from the contemplation of beauty that existence is lacerated. However, in Feuerbach's other Pandean scenes and paintings with pastoral divinities, or versions of the same subjects painted by Arnold Böcklin from the 1860s onward, the vivid tones alternating with livid grays, deep blues, and muddy yellows do not assume a value as modern pictorial tradition of Impressionist or Post-Impressionist composition, but instead have the precise function of intensifying the allusion to remote myths, leading the image toward an accumulation of emotions that "differ" from those present in reinterpretations of antiquity in the Neoclassical and Romantic styles (like Böcklin's *Battle of the Centaurs*). Moreover, Böcklin was inspired by two great cultural figures of the time, who resided in his native city of Basel: Friedrich Nietzsche and Jacob Burckhardt. In *Birth of Tragedy* (1872), Nietzsche actually offered his contemporaries an original

interpretation of the classical world, in which Apollo, until then identified as one of the foremost figures in Greek art, became instead the "veil covering the true Dionysian effect for the entire duration of the tragedy." That a young De Chirico, who trained in Munich, was certainly influenced in his shift toward metaphysical painting by the

**Arnold Böcklin**
*Ulysses and Calypso*
1882, tempera on panel.
Basel, Kunstmuseum.

**Arnold Böcklin**
*Battle of the Centaurs*
1873, oil on canvas.
Basel, Kunstmuseum.

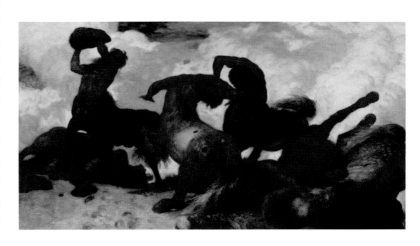

semantic ambiguity of works by Böcklin (which include the recurring "choruses of satyrs" evoked by Nietzsche) and other artists in the Germanic area is suggested by a comparison of Böcklin's original depiction of the hero, in *Ulysses and Calypso*, as a silhouette wrapped in a blue garment emerging against a cloudy sky, and de Chirico's 1910 *The Enigma of the Oracle*.

Italy became the elective domicile of those who retreated from the brutality of the present, seeking refuge and creative stimuli in a dream of ancient beauty, where artists from different nations and schools met and offered Italians great inspiration. The Italian landscape was steeped in an aesthetic ambiance that, echoing Schopenhauer, seemed the only place to exorcize the times and elude the pangs of the future (Messina). Rome, Florence, and Naples became temporary homes preferred by Germanic artists including Böcklin, as well as Adolf von Hildebrand and Hans von Marées, who together painted the frescoes in Naples Geological Station between 1873 and 1875. Von Marées focused on distilling the essence from surface appearance, and the forms he painted had an almost tangible depth, like a sculpture, as evident in *The Orange Picker* or in *Judgment of Paris*, where the figures stand out from the background and the bodies receive light almost as if they were bas-reliefs; this technique was in complete accord with Konrad Fiedler's theories on "pure visibility," defining painting as a tactile experience, as well as with Hildebrand's ideas. The three friends spent time living together in Florence, in the old San Francesco di Paola monastery, absorbed in recovering the great periods like the Greece of the Parthenon, the Late Roman era, and Michelangelo. It was from Michelangelo's sculptures that Hildebrand learned how to turn to Nature, selecting from reality and capturing its hidden images.

## Rome and the Aesthetic Concepts of D'Annunzio

Nino Costa in Rome expressed a vision of the land-scape as a "state of mind" since the 1850s. Since he was closely linked to the city's British residents, he developed a disposition to transcend reality and accentuate symbolic resonance, which led him to found In Arte Libertas in 1885. This circle was openly opposed to "Naturalism" but also to French Impressionism, which he defined as "a painstaking and utterly false realism" that had "a foot in the char-latan's shack." A leading role in coeval culture was played certainly by Gabriele D'Annunzio, a man of letters, poet and playwright, and friend of many artists, but the mouthpiece of a new trend preferring the Renaissance—"the greatest, proudest expres-sion of the race"—and the cult of Hellas from 1895 was the periodical *Il Convito*. The review insisted on the need for a revival of the legendary classical world, but rendering it a means for transformation of

**Adolfo de Carolis**
*Le Castalidi (Castalian Nymphs)*
1898, tempera and stucco on canvas.
Rome, National Gallery of Modern Art.

143

**Aristide Sartorio**
*Gorgon and the Heroes*
1895–99, oil on canvas.
Rome, National Gallery of Modern Art.

*Facing page:*
**Hans von Marées**
*The Orange Picker*
1873, fresco.
Naples, Stazione Geologica.

**Mario de Maria**
*Close of a Summer Day*
1899–1909, tempera on
canvas.
Venice, Ca' Pesaro,
International Gallery of
Modern Art.

the real world: "it is no longer the time for the solitary dream of the shadow of laurel and myrtle"; the time had come to support the "cause of Intelligence against the barbarians."

The artists who showed most openness to this aesthetic inclination were Adolfo de Carolis—who showed his work *Le Castalidi* at the 1898 In Arte Libertas exhibition, where the young girls who dance around a spring dear to Apollo symbolize the renewal of poetic inspiration and the reassuring powers of art—and Aristide Sartorio. The latter's work combined, above all, the interpretation of the myth of Idealistic-Platonic ascendancy, which

permeated British Pre-Raphaelitism extensively—as we have already seen—with the concepts upheld by D'Annunzio and Nietzsche (G. Piantoni). The lengthy development of the *Diana of Ephesus* diptych and of *Gorgon and the Heroes*, concluded in 1899, was due to a meditation on life and human illusions and delusions and was probably inspired by several passages from D'Annunzio's *Trionfo della morte* (*Triumph of Death*). The theme of fatal beauty and the hero alludes to the deepening rift between the artist and society, where he will never be able to realize his personal ideals. Another unique figure was that of Mario de Maria ("Marius Pictor"), whose art—set between Rome and Venice—offered greater veins of esotericism. His paintings are steeped in mystery, with landscapes of "skeleton factories," redolent of Baudelaire and Poe but also of ancient Medieval legends, themes where he experimented with a varnished tempera technique of striking brilliance, imitating old Venetian enamels, which enhanced the unsettling strangeness of his visions, like that of the Fondaco dei Turchi with its population of Oriental merchants. De Maria was a friend and supporter of Angelo Conti, who signed

**Mario de Maria**
*Nudentur Mimae. nel
fondaco dei Turchi a
Venezia*
1909–20, oil on canvas.

his writings with the pseudonym Doctor Mysticus, and shared the commitment of the Roman aesthetes to "praise and revive the ancient myths, so they would veil stupid reality" since "the soul of the world is concealed in the depth of the myth."

## Aspects of Symbolism in France

In France, an awareness that the artistic quest to taking the image a step further could be achieved not only through semantic elusiveness, evocation of mythological and fantastic creatures (like the sphinxes), or the disturbing, irresistible beauty of a model was aptly expressed by critics like Félix Fénéon, a Neo-Impressionism theorist. On visiting a Salon de la Rose-Croix, Fénéon wrote that he wanted to explain to Khnopff and the other artists that "a painting must attract primarily for its beat, that a painter shows too much humility by choosing subjects of great literary significance, and that Paul Cézanne's three pears on a tablecloth have an emotional impact and can even be mystical," more than "all of Wagner's Valhalla."

This reference suggests that breaking through the veneer of reality could be achieved starting precisely from apparently realistic subjects, but conceived with criteria of expression that endow them fully with symbolic meaning. In 1891, Albert Aurier identified as "symbolist, *ideista*, [and] subjective" the paintings by Paul Gauguin—an artist who had rejected Parisian worldliness since his debut and taken refuge in Pont-Aven, in the Brittany countryside—and defended him by citing Schopenhauer's philosophy: "the ultimate goal of painting would not know how to be the direct representation of objects. Its objective is to express ideas using a special language."

After his stays in Brittany and his attraction to the archaic customs of those places and the landscape populated with calvaries (the large Medieval stone crucifixes), and after his exotic voyages to discover "barbaric" cultures, which were known in the West through imperialism and whose artifacts were displayed at Paris's Universal Expos, Gauguin left Europe to live in Tahiti, the cradle of a beloved civilization. He asserted, "Primitive art comes from the spirit and makes use of Nature. . . . in our current poverty, the only salvation possible is through a logical and genuine return to the beginning." This and similar thoughts reflected a widespread cultural attitude at the end of the nineteenth century that preferred increasingly rarefied and elemental expression, in which the future met the beginning. Gauguin and many of his contemporaries sought artistic inspiration in the ancient idols of archaic, primitive, and possibly exotic civilizations, in styles characterized by a simplification of the language to the

**Paul Gauguin**
*La Belle Angèle (Portrait of Madame Satre)*
1889, oil on canvas.
Paris, Musée d'Orsay.

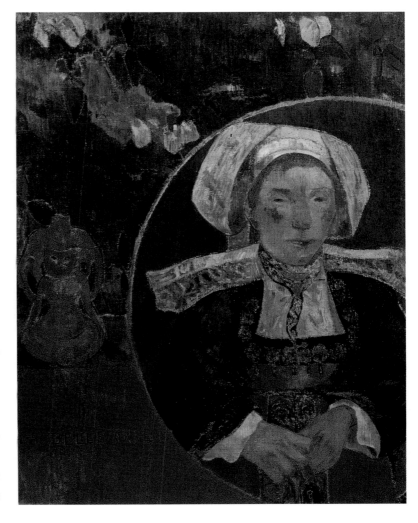

detriment of its powers of illusion, setting aside Western civilization's Naturalism, which was perceived at that point as a word whose capacity for poetic communication was corrupt and depleted, and inadequate for expressing the innermost aspirations of the human psyche.

During these years, evidence of a great diffusion of "symbolist" meaning and the repeated references to archaic civilizations that could restore purity to the *mots de la tribu* (Mallarmé) was provided by the reception of *A Sunday on La Grande Jatte—1884* by Seurat (page 85). This painting had a great impact, not just for its novel Pointillist technique, but also because of the immobility and rigidity of the figures that—as was

written—contributed to evoking "the sound of modernity," magical and solemn, like those the artist had admired in the friezes of Egyptian temples displayed in the Louvre. For supporters of Symbolism, Seurat's painting became an icon of anti-Naturalistic painting, and in one of the artist's obituaries he was likened to Assyrian dignitaries. This desire to seek inspiration from Egyptian, Archaic Greek, Indian, and African sculptural models (which finally led to the black masks dear to Picasso) to distill the essential from the apparent, to halt the beginning and capture the essence of the things, found an emblematic affirmation in *La Belle Angèle* (1889), Gauguin's portrait of the mayor of Pont-Aven's future wife. The person who commis-

**Emile Bernard**
*Breton Women in a Meadow*
1888, oil on canvas.
Private collection.

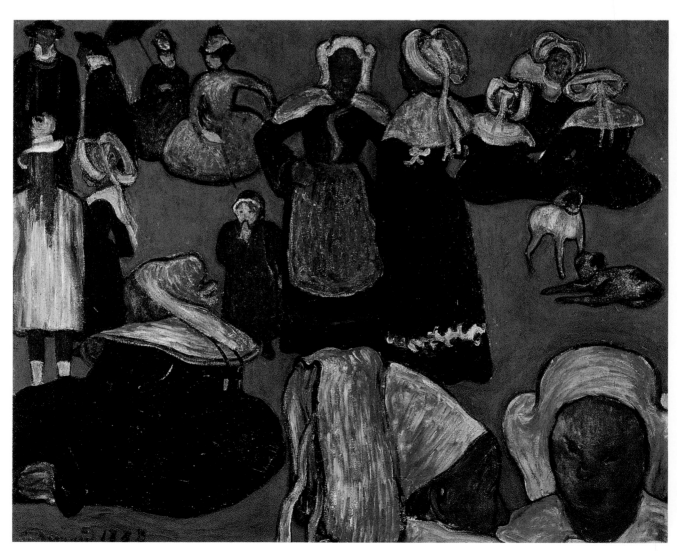

sioned the work was not pleased, and the portrait was mocked by critics for the "heifer-like" face of the woman portrayed. However, in Gauguin's opinion, this transformed the physical person into a devotional icon, an abstract depiction of a timeless archetype: in fact, the woman is posed like a Buddha of Javanese art, called into play by the statuette placed in the background.

In Pont-Aven, Gauguin's message addressing the quest for a revival of painting that flees the rules of Naturalistic mimesis was also affirmed by a preference for the so-called *cloisonnisme*. As Maurice Denis recalled in 1934, the paintings that the Pont-Aven School artists (Gauguin, Schuffenecker, Anquetin, and others) showed at the 1889 Café Volpini exhibit in Paris, along with zincographs titled *Bretonneries*, seemed "not so much windows opening onto nature, like Impressionist paintings, but rather highly decorative, strongly colored surfaces, edged with a brutal stroke." Stylization of form and the absolute two-dimensionality of the planes were influenced not only by the Japanese prints circulating throughout Europe (see the previous pages dedicated to *Japonisme*), but also by the stained-glass windows in Medieval churches, seen in the choice of outlining areas of color with a darker line, a method adopted by Bernard, who bitterly contended the leadership of pictorial Symbolism from Gauguin. Gauguin, who the French Symbolist critic Albert Aurier described in 1881 as "Plato interpreted visually by a savage genius," was a very charismatic figure who inspired both the Pont-Aven School and the Nabis, which included Paul Sérusier. Returning from a visit to Gauguin in 1888, Sérusier painted *The Talisman* on the cover of a cigar box, a landscape of the Bois d'Amour in which none of the colors corresponds to reality, but complies instead with a purely internal logic.

In Synthetist painting (as it was later called), symbols are also conventions, "letters in an immense alphabet that only a man of genius is able

to read," observed Denis, a theorist in the Nabis group that included Henri-Gabriel Ibels, Pierre Bonnard, and Paul Ranson. In his writings, Denis referred to *The Talisman* as an example of the concept that a work of art is nothing other than "a transposition, a caricature, an intense equivalent of a sensation," a translation into the special, natural language of a spiritual element. The name *Nabi* was proposed to Sérusier by his friend Auguste Cazalis and comes from the Hebrew *nebiim*, meaning "prophet," "enlightened," or even "he who receives words from the beyond." As it has the same meaning in Arabic, Ranson sometimes wrote the name in Arabic to be more esoteric. Sérusier insisted that the group members—who initially met on Passage Brady, then in Ranson's atelier—shared a feeling of being "initiates," united in a

**Paul Ranson**
*La Sorcière au Chat*
1893, oil on canvas.

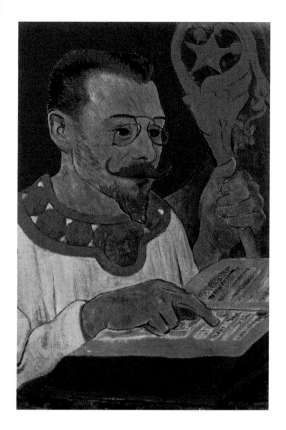

"secret and mystical society" that came together at the Académie Julian, where they distinguished themselves from the followers of Lefebvre or Bouguereau, middle-class painters and therefore "Philistines." In 1890, Vuillard and Roussel also joined the group, followed in 1891 by Dutch artist Jan Verkade, then by Lacombe and the Swiss painter Vallotton in 1892; two years later the Hungarian Rippl-Rónai joined, followed in 1895 by his friend, the painter and sculptor Aristide Maillol. Nevertheless, by 1900, when Denis had his friends pose for *Homage to Cézanne*, the Nabi experiment was effectively finished, with each artist moving on to follow his own path. Although this group's style was not defined from the beginning of its association, except in the repetition of certain features, it did share an idealistic belief: "we all work towards the same goal," Bonnard stated; "it is only the routes to reach that goal that differ." Bonnard explained the common desire to make use of lines, colors, and forms only as expressive supports of

**Paul Sérusier**
*Portrait of Paul Ranson in Nabi Costume*
1890, oil on canvas.

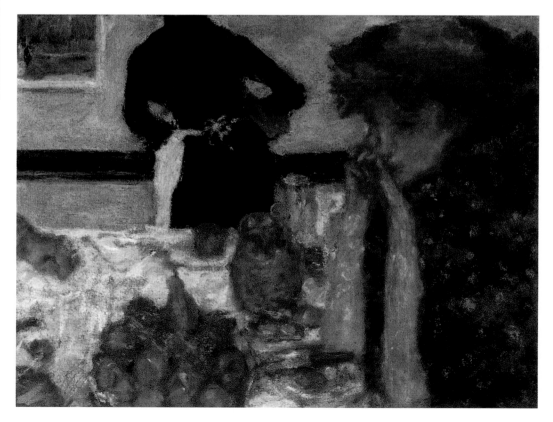

**Pierre Bonnard**
*Le Petit Déjeuner de Misia (Misia's Breakfast)*
1895–97, oil on canvas.

*Facing page:*
**Paul Sérusier**
*The Talisman*
1888, oil on panel.
Paris, Musée d'Orsay.

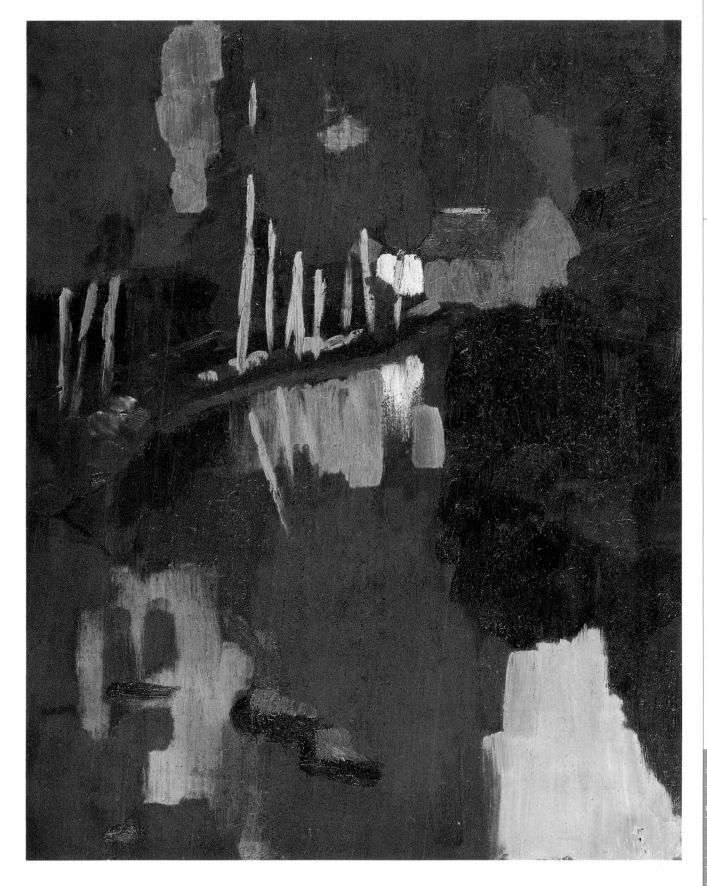

**Édouard Vuillard**
*Lady of Fashion*
1891–92, oil on
cardboard.

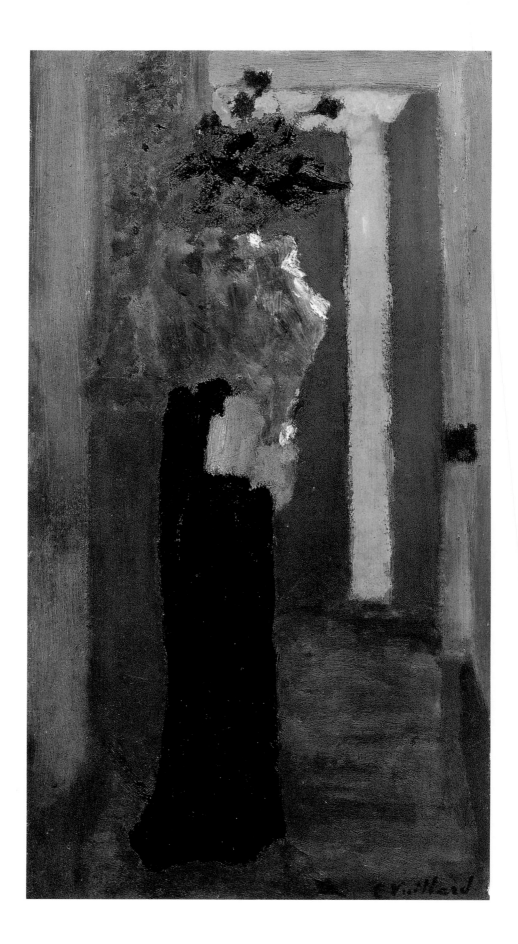

the invisible, increasing the division between imitative and symbolic art, based on the example of Puvis de Chavannes, whom they all admired.

While Sérusier, Verkade, Maillol, and Lacombe remained close to the Synthetism of Gauguin and Bernard (and dealt primarily with themes in Brittany), Bonnard, Vuillard, Vallotton, and Roussel preferred, from their debut, to paint urban subjects and transcribed in their paintings (primarily Parisian interiors in which the figures of women and children intent on their tasks become confused with the materials and elements of the refined furnishings that surround them) a temporal dimension that was internal and intuitive rather than rational and mechanical. Consequently they had a great deal in common with the world evoked by Marcel Proust in his *In Search of Lost Time* and philosopher Bergson's "durée" theories. The Nabis maintained close relationships with Symbolist poets primarily through their participation in *La Revue Blanche*, founded by Thadée

**Pierre Bonnard**
*The Omnibus*
c. 1895, oil on canvas.
Paris, Galerie Félix
Vercel.

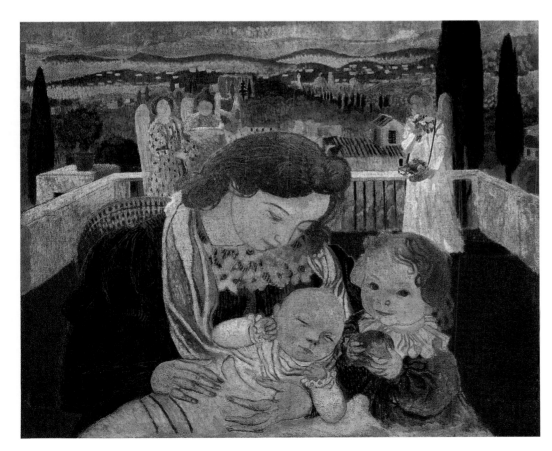

**Maurice Denis**
*Madonna and Child
with Infant Saint John*
1898, oil on canvas.
Copenhagen, Ny
Carlsberg Glyptotek.

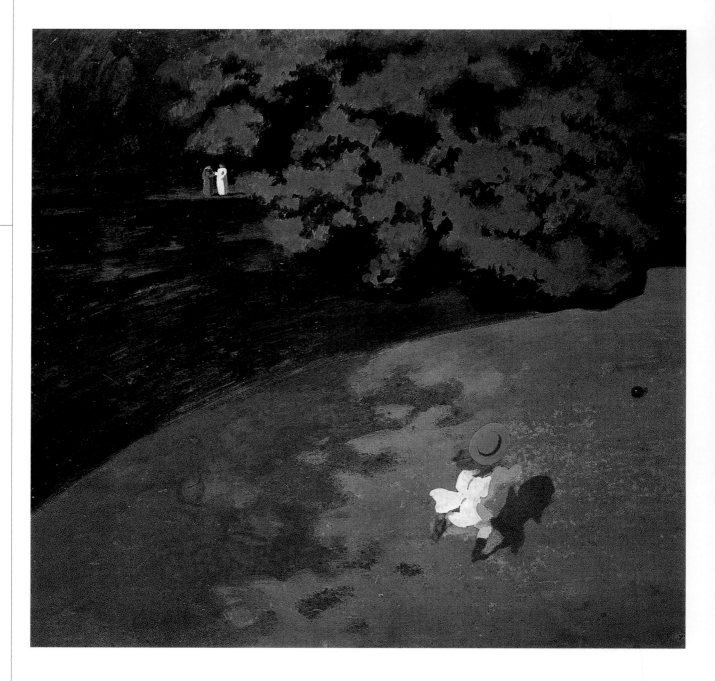

**Félix Vallotton**
*The Ball*
1899, oil on cardboard.
Paris, Musée d'Orsay.

*Facing page:*
**Gustav Klimt**
*Judith*
1901, oil on canvas.
Vienna, Österreichische
Galerie.

Natanson, and through the actor Lugné-Poe's avant-garde theater. They were interested in theosophy (in particular esoteric Buddhism popularized by Helen Petrowna Blavatsky), participated in the Rose-Croix salons organized by Joséphin Péladan, and were passionately enthusiastic about Wagner's and, most of all, Debussy's music. In tracing the movement's history, Denis recalled the eclecticism of their sources of inspiration: "primitive or Far Eastern idols, crosses in Brittany, Épinal images, tapestries,

stained glass windows, all of which were mixed with ideas from Daumier, with the crudely Poussinesque style of Cézanne's *Bathers*, with Pissarro's weighty rural landscapes," but also with Byzantine mosaics and, for Denis in particular, with Fra Angelico's *Annunciation*, admired during his stays in Florence. All these models were combined to express the desire for primeval purity that, a few years later, led to Cubist interest in African art, fascinated by the "magical" concepts it contained.

# Art Nouveau

"We are seeing the birth of a totally new art," wrote the architect Endell in 1898 in Munich. "An art whose forms mean and represent nothing, evoke nothing, yet can stimulate our spirit as deeply as musical notes do." Then, in 1901, Claude Debussy, supporting the "breaking of the melodic cell," wrote in *La Revue Blanche* that the "musical arabesque, or rather the principle of decoration is the basis of all art forms." These considerations refer to the diffusion in Europe of Art Nouveau, which was not so much one style, but several styles with specific names that were the result of thinking evolving in the breast of Symbolist culture. This led to a radical renewal of the art-life relationship, seeking to heal the existing rift. In point of fact, art was called upon to play an essential role in society, developing Morris's theory that teaching beauty also teaches goodness.

Closely connected to the diffusion of Art Nouveau in the Germanic regions was the sequence of Secessions that began in Munich on November 26, 1892, where a group of artists led by Franz von Stuck, Lovis Corinth, Fritz von Uhde, and Wilhelm Trübner united in an association that later became the model for subsequent versions, as did the chosen icon: Athena, the warrior goddess, recovered by Gustav Klimt in Vienna in 1897 (see the pages that follow that are dedicated to the Viennese Secession). The nine works that Stuck showed at the first (1893) Munich Secession exhibition included *Innocence* and *Sin*, which navigate the tradition inaugurated by the Pre-Raphaelites and Böcklin, accentuating the simplification of formal language, to achieve a type of unsettling illustration, played out on the contrast between the rarified childlike image with the lily and the frightening sensuality of the creature the serpent is enveloping.

Artists who were not involved in the Secessions also exhibited at their salons, because their poetics

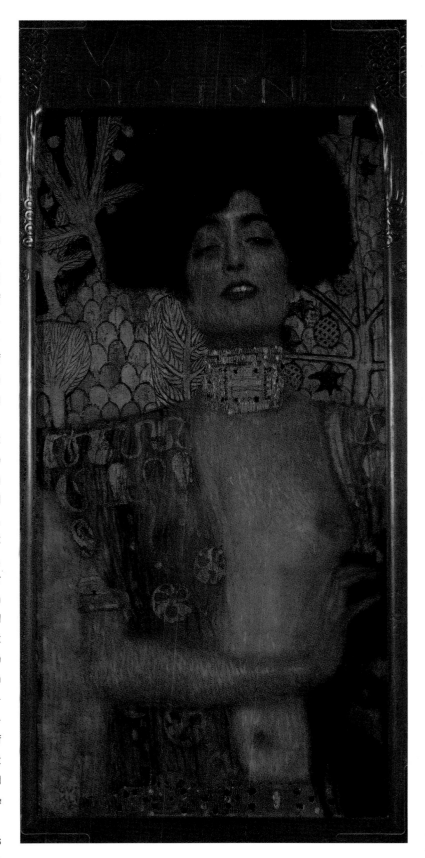

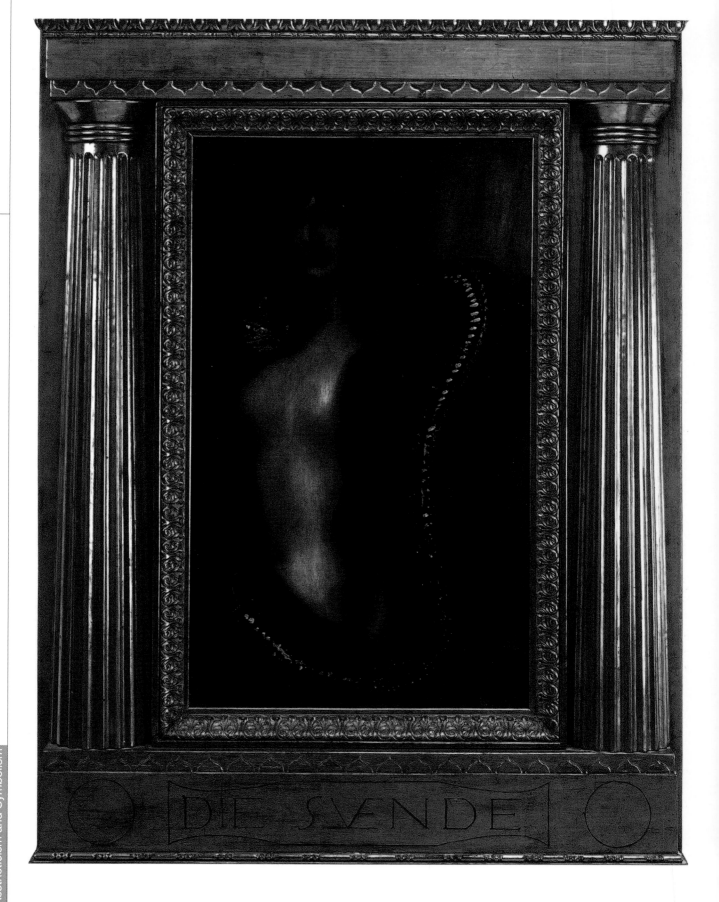

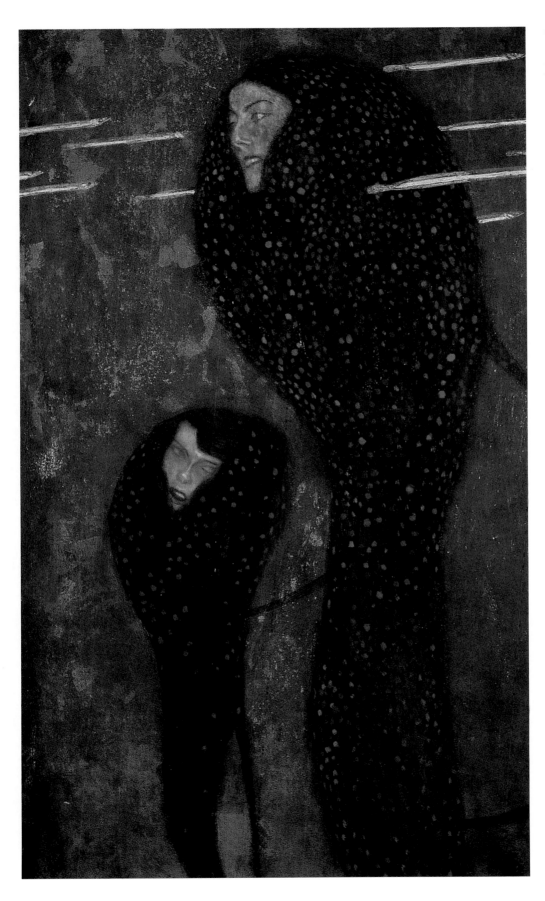

Gustav Klimt
*Water Sprites*
c. 1899, oil on canvas.
Vienna, Zentralsparkasse.

*Facing page:*
**Franz von Stuck**
*Sin*
1893, oil on panel.
Palermo, Galleria Civica
d'Arte Moderna "E.
Restivo."

*Bottom:*
**Carlos Schwabe**
*Poster of the First Rose
Croix Salon at the
Galerie Durand-Ruel*
1892, lithograph.

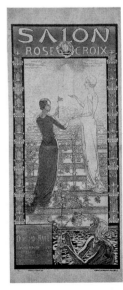

Aestheticism and Symbolism

**Ignacio Zuloaga**
*Portrait of Valentine Dethomas*
c. 1900, canvas.
Guipuzcoa (Zumaya),
Zuloaga Collection.

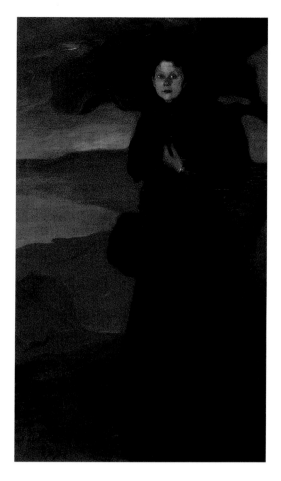

given an exhibition in 1901 and was also one of the emerging Spanish painters on the international scene (along with Sorolla and Anglada). He was a portraitist who tended to explore the depths of the Castilian soul against a backdrop of often desolate lands, of a quite spiritual loveliness; the forms of his work keenly applied the Synthetism taught by Gauguin, who had called him to Paris as early as 1891 to exhibit with the Nabis group. The French Impressionists also showed at the Secessions (Vienna, 1903), as did the Munich Scholle ("Clod"), founded in 1899 and comprising artists like Putz, Jank, Diez, Greiner, and von Habermann, all driven by a primitive attachment to Nature and to earth, which was expressed in landscapes of extremely simplified forms.

A quite exhaustive and current panorama of the European art scene was also available at the Libre Esthétique salons held in Brussels, an event that was initiated thanks to Octave Maus in 1894; the Venice Biennale international art event began in 1895, thanks to Antonio Fradeletto, where count- less expressive media were exhibited, from Realism to international Impressionism (in particular Zorn, Sorolla, and Maliavine, who have already been mentioned) and the aristocratic quests in the Symbolist context. Venice also boasted a lavish

were thought to be attuned. These included Böcklin, Khnopff, Segantini, Toulouse-Lautrec, Puvis de Chavannes (1898), several Japanese masters (1900), and Ignacio Zuloaga. Zuloaga was

**Max Klinger**
*The Judgment of Paris*
1885–87, oil on canvas.
Vienna, Österreichische
Galerie des 19.
Jahrhundert.

*Facing page:*
**Leonardo Bistolfi**
*Beauty Liberated from
Matter (Monument to
Giosuè Carducci)*
Bologna, Garden of Villa
Carducci.

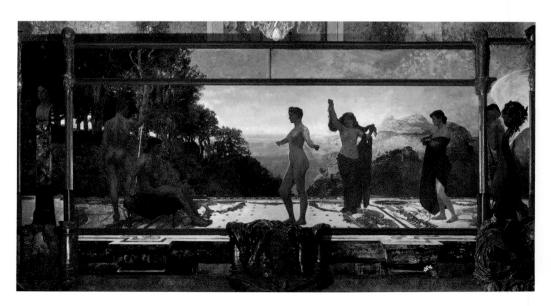

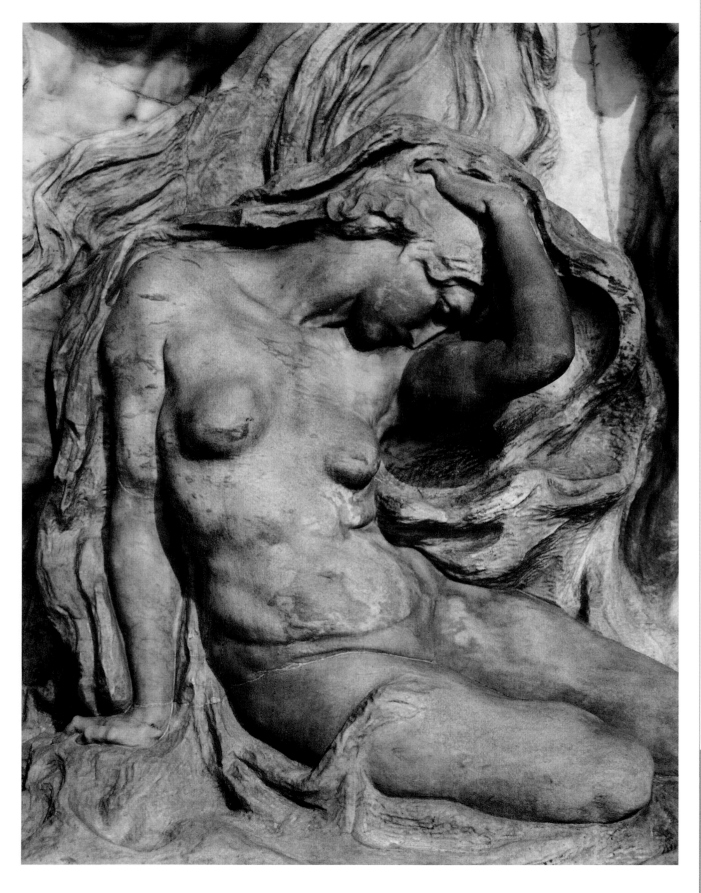

**Gustav Klimt**
*Medicine*, detail
1897–98, destroyed.

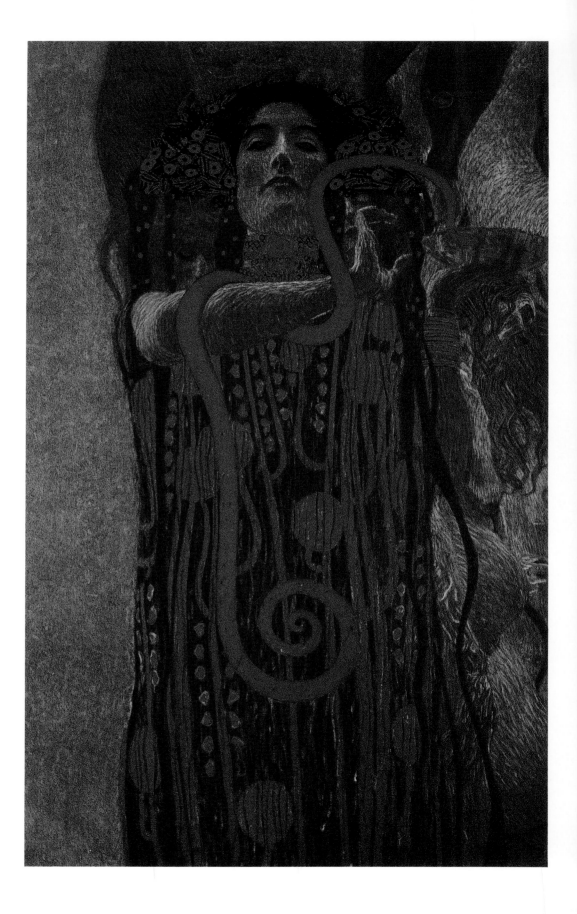

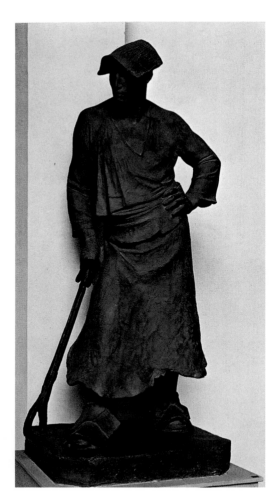

completely expressed in painting and sculpture, which led to radical changes in the style of artists like Gustav Klimt. In point of fact, Klimt rejected the teachings of the academic Hans Makart, who was more open to late Pre-Raphaelite or Belgian Symbolism. Klimt developed a simplification of idiom that left behind the sensual linearism of his painted works at the end of the century, with their fluid, filmy strokes (examples include the Vienna Faculty of Medicine or his *Goldfish* and *Water Sprites*, creatures with silver-streaked dark tresses, that Hevesi said "glittered like lost jewels"), to reach progressive geometrical stylization. This was already evident in the troubling, enigmatic 1901 *Judith*, the biblical heroine whose elegant neck is swathed in Art Nouveau trinkets, her body barely clothed in fine garments, loomed against a stylized hill landscape of gold lamellae with ornamental Mycenaean motifs. Those same slivers of gold then drenched the 1907 *Portrait of Adele Bloch-Bauer*, leaving only her face visible.

The art of Ferdinand Hodler also paid tribute to Art Nouveau graphic style themes, with its decisive

**Constantin Meunier**
*The "Puddler"*
Bronze.
Brussels, Musée
Meunier.

panorama in sculpture, with Meunier's workers (*The Hammerer*, *The Docker*, *The Puddler*); the spirituality of Minne's extenuated nudes; Bistolfi's monuments; Domenico Trentacoste's harmonious, lofty exploration reminiscent of fifteenth-century models; and the elegance of George Frampton or Max Klinger. The great merit of Art Nouveau and the Secessionist movements—which comprised those artists who chose to "detach" from traditional academic leanings, although some, like Stuck, continued to teach—was that of expressing the first real attempt to pursue the first "synthesis of the arts" that was not abstractly theoretical, a teaching taken up by the Bauhaus in the 1900s.

While the evolution of Art Nouveau aesthetics took place mostly in architecture and applied arts—where there was mainly an "active force" or so-called "whiplash effect"—the stylistic traits are

**Gustav Klimt**
*Philosophy*
1900, destroyed.

Ferdinand Hodler
*The Dream*
1887–1903.

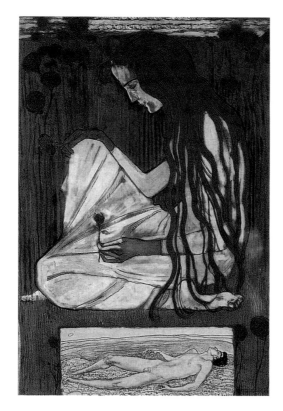

*Facing page:*
**Edvard Munch**
*The Scream*
1893, tempera and casein
on cardboard.
Oslo, National Gallery.

**Ferdinand Hodler**
*Day I*
1899–1900, oil on canvas.
Bern, Kunstmuseum.

work that brought him to the international public eye from 1891 to 1900 in Munich, Paris, and Venice: *The Night*, his symbolic illustration of sleep, love, and death, and *Day I* (shown below), an evocation of the unfolding of life, the slow awakening of the women, who gradually stretch their limbs and make movements that suggest prayer.

The painting of Norwegian Edvard Munch is also a variation permeated by Art Nouveau style traits, however crude and desolate his themes may appear. His 1892 exhibition, judged a scandal and forced to close, generated the Berlin Secession (1898), led by Max Liebermann and Ludwig von Hoffmann, founders of the dissident Alliance of Eleven. In his famous opus, *The Scream* (1893), the feverish tension of the line that springs into an arch transforms the image into a symbol and, with the help of strident colors, transforms that sentiment— influenced by Kierkegaard's philosophies—of the ego's anguished incommunicability. So a new century began, and it would not be simply one of avant-gardes: the complexity of 1800s culture would actually continue to penetrate many expressions of contemporary art.

stroke defining hieratic forms subjected to a symmetrical and axial compositional rhythm to evoke sentiments. This Swiss painter's figures embody abstract symbols, as can be seen in the

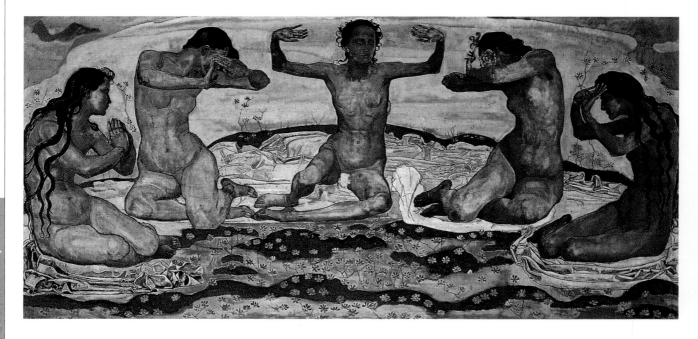

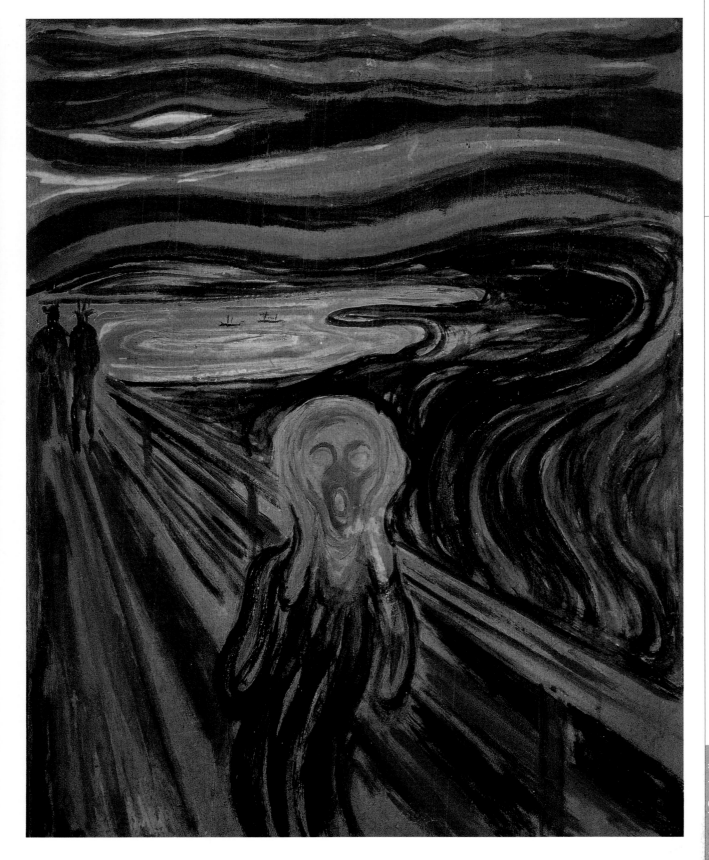

# From Morris to Art Nouveau

The second half of the nineteenth century was characterized by an intense reform in the arts, animated by a utopian ideal that sought the moralization and redemption of daily life through beauty, closing the gap between art and life. So the combination of exhibits and theoretical manifestos laid the foundations for twentieth-century avant-garde (moreover, the military concept of "vanguard" as it referred to art had its origins in the 1800s, when Rimbaud first used it in this context). The origin of the succession of movements that followed over the decades was in Great Britain, when William Morris and Edward Coley Burne-Jones met with the Pre-Raphaelite painters and came to the conclusion that there was a need to restore not only pictorial tenets (as the Pre-Raphaelites had done in 1848), but also the actual concept of living, proposing a domestic craft style founded on extreme simplification of architectural language. One example is the Red House, designed by Philip Webb in 1859, located in Uppon in Kent, with interiors designed by the group. To contemporaries, who had a preference for eclecticism and Victorian knickknacks, the overall effect appeared totally eccentric for the almost primitive crudeness of the wood furniture (with just a hint of Neogothic on the horizon), carved and then painted, and the foliage motifs used to decorate walls all the way up to ceilings with exposed beams.

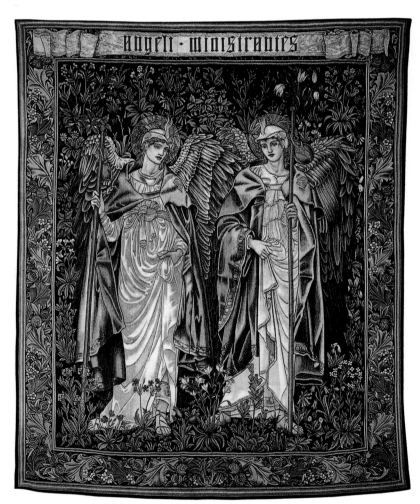

*Facing page:*
**Louis Comfort Tiffany**
*The Garden*
1895, stained-glass window from a cartoon by Ker-Xavier Roussel.

*Left:*
**Henry Dearle,** to the Edward Coley Burne-Jones design of Angeli Ministrantes 1894, wool, silk, and mohair.
London, Victoria & Albert Museum.

*Top and above:*
*Decorated wood ceiling of the main staircase and hall with carved, painted furnishings*
1859.
Uppon, Kent, Red House.

Aestheticism and Symbolism

This experience gave rise to the London company Morris, Marshall, Faulkner & Company, Fine Art Workmen in Painting, Carving and Metals, whose specific intent, voiced by Morris and intensely upheld by John Ruskin, was to reform the applied arts and integrate the ornamental quality that people desired, adding it to utilitarian objects—in other words, to mend the rift between "fine" and "applied" arts, which had been widening since the Middle Ages. In 1888, they organized the first display of their work in London as the Arts and Crafts Exhibition Society. The expression "arts and crafts" then came to identify those items made by the artistic generation born in about the middle of the nineteenth century (Mackmurdo, Crane, Voysey, Ashbee) and was seen by critics as the precursor of Art Nouveau. This name (taken from that

of a shop opened by Siegfried Bing in Paris in 1895) refers to all European movements that derive from the British experience but nonetheless acquire various specific physiognomies and titles: Jugendstil in the German area; Art Nouveau in France and Belgium; the Modern Style in Great Britain; Liberty in Italy, from the name of the London store Liberty and Co.; Arte Jóven in Spain; and Art Modernista in Cataluña. The movements are outstanding for their excellence in various fields (graphics, applied arts, architecture, painting, and sculpture) while sharing the drive toward the "total work of art" that Richard Wagner so desired. The spirit that animated Art Nouveau was contrary to Naturalism and preferred to pursue the transformation of reality, adding beauty to life and laying the foundations for a modern design concept as a

*Above:*
**Hermann Obrist**
*The Whiplash*
c. 1895, wool and silk
embroidered tapestry.
Munich, Münchner
Stadtmuseum.

*Top left:*
**Koloman Moser**
*The Dancer Loïe Fuller*
1910, watercolor and
ink.

**Walter Crane**
*Illustration for
"A Floral Fantasy in an
Old English Garden"*
1899, autotype.
London.

*Facing page:*
**Victor Horta**
*Skylight of Hôtel Van
Eetvelde*
1895.
Brussels.

means of social integration (although production requirements were at loggerheads with the ideology of this utopia). Alois Riegl, in his 1893 Stilfragen ("problems of style"), stated that "decoration is…an elementary requirement for humanity, more elementary than that of protecting the body." Art Nouveau decoration is the symbolic form in which each object is restored to its structural essence, causing the emergence of its secret vitality, the "symbol" of its function, which may be phytomorphic, or more organic, or zoomorphic. In the case of Spaniard Antoni Gaudí, his architectures were described by Salvador Dalí as evoking the impression of penetrating "grottoes through tender gates of calf liver" ("De la beauté terrifiante de l' architecture modern" [Minotaure, 1933]). The Art Nouveau line—the "active force," as

Henry van de Velde defined it—is enveloping and dynamic, with a sinuous, crisp, defined stroke that like the echo of a wave divides and multiplies into bands that branch out in parallels or fan out.

The dominant motifs in the architecture, graphics, painting, or sculpture almost all appeared at the same time in the early 1890s, testifying to the total convergence of sensitivities. While the initial *coup de fouet* (whiplash) is often attributed to the Obrist screen, this motif was actually already to be found on a book cover by Mackmurdo (1883), in turn inspired by Blake and Morris, and in the volutes of the first chairs by Michael Thonet (1835) as well as the plinth of the *Eros* fountain (Piccadilly Circus, 1887–93) by sculptor Alfred Gilbert. The same motif recurs in the curling members and cornices of Victor Horta's architectures, like the Brussels Hotel

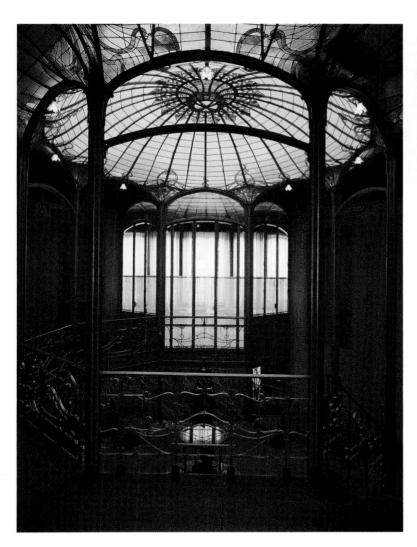

*Above:*
**Charles R. Mackintosh**
*Bedroom*
1902–6.
Helensburgh (Glasgow),
Hill House.

*Below:*
**Antoni Gaudí y Cornet**
*Expiatory Temple of the*
*Holy Family, detail of*
*pinnacles*
1884–1926.
Barcelona.

Solvay; in August Endell's decorations for the facade of the Munich Atelier Elvira (1896–1907, destroyed); and in the rostra of Gaudí's Palacio Güell portal in Barcelona (1885–90). The space defined by this line is not the Euclidean geometrical classic, but rather a cadenced, asymmetrical space created from the surface, the container that is modulated and enriched continuously, like the veils of Loïe Fuller's "Serpentine Dance," which enchanted a number of artists from Toulouse-Lautrec to Koloman Moser, and even the architects Pierre Roche and Henri Sauvage, who dedicated a theater facade to the dancer for the 1900 Universal Expo, modeling it to the spiral of her costumes. Despite stylistic diversity, the work of many authors—Horta, van de Velde, Josef Hoffmann, Endell, Gaudí, Hector Guimard, and Jules Lavirotte—was bound by a single purpose: all evolving to increasingly outrageous forms until

1908, when Adolf Loos declared that "ornament is a crime" and (like Frank Lloyd Wright and Louis Sullivan) took line back to being a real, open *structure* and no longer a *symbol*. Another trend existed within Art Nouveau, but more inclined to pureness, to a more composed but equally more abstracting channel. In the theories expressed by Wilhelm Worringer in his 1907 *Abstraction and Empathy*, this trend reflected the opposite pole of human sensitivity, tending to closed, abstract, geometrical forms, unlike those empathizing with the organic and vegetable world. This trend can be observed in the style developed in the Viennese Secession period by Joseph Maria Olbrich and is further accentuated, with recherché results, in Glasgow School architecture and artifacts produced by Charles Rennie Mackintosh, Herbert McNair, and Margaret and Frances Macdonald.

*Left:*
**Henri van de Velde**
*"Butterfly" writing table for the Hohenhof dining room in Hagen*
1908.
Trondheim,
Nordenfjeldske
Kunstindustriemuseum.

*Below:*
**Henri van de Velde**
*Bureau plat and armchair*
1898–99 (from a model of 1896), sculpted oak, bronze, copper, and leather.

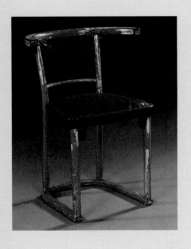

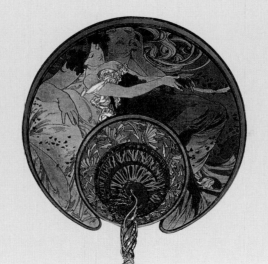

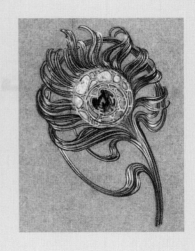

167

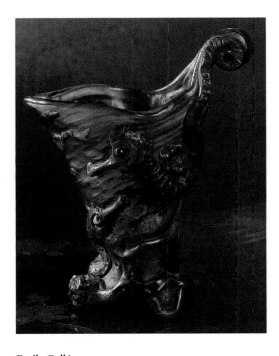

**Emile Gallé**
*Seahorses*
c. 1901–03, multilayered
blown-glass vase.

*Above, from left:*
**Josef Hoffmann**
*"Coffee" chair*
c. 1906, painted curved
wood with leather
upholstery.
Vienna, Jacob & Josef
Kohn.

**Alphonse Mucha**
*Le vent qui passe
emporte la jeunesse
drawing for a fan*
1899, lithograph.

**Alphonse Mucha**
*Drawing for a Jewel,*
detail of a page from
*Documents Décoratifs*
1902.

*Right:*
**Emile Gallé**
*Les coprins,* engraved
crystal vase
c. 1895.

Aestheticism and Symbolism

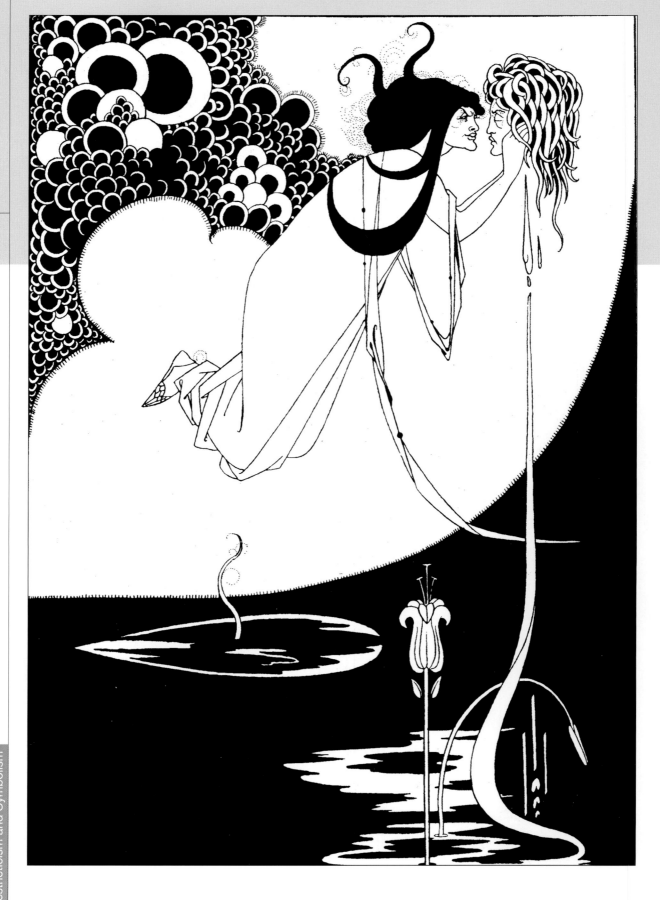

# Illustration: Examples of Its Development

The close bond that developed between art and literature in Symbolist culture—in particular in the wake of the British Pre-Raphaelites, who founded a magazine called *The Germ*—was at the root of refined developments in the field of illustration, which nonetheless enjoyed an independent evolution of great interest and substance. The etched cipher, the deep black trace on a pure white sheet, is actually acknowledged as having a unique vocation in expressing that universe of dreams, but also of nightmares, so typical of the period.

The grand master of illustration was always William Morris and he inspired the British engraver and illustrator Aubrey Beardsley, the leader of the so-called Aesthetic movement. Beardsley went to Paris in 1892 and charmed his contemporaries with his diabolical China ink creatures, images that could conjure up the oneiric world of French literature but also interpret the extravagant works of Oscar Wilde, like his 1893 *Salome*. In Italy, in Roman circles, the exhibitions organized by the Symbolist In Arte Libertas group (founded by the painter Nino Costa) revealed openness toward British painting in the illustrations for D'Annunzio's poetry collection *Isaotta Guttadauro and Other Poems*, produced in 1886 by a group of artists that revolved around Costa, including Alfredo Ricci,

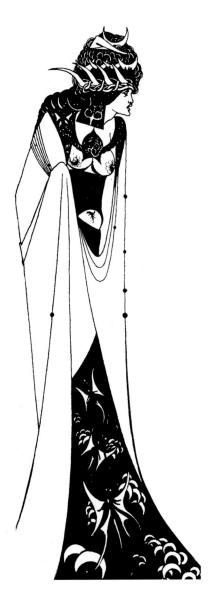

*Facing page and left:*
**Aubrey Beardsley**
*Herod Ordered Salome the Head of John the Baptist* and *Salome,*
illustrations for Oscar Wilde's *Salomè*
1893.

**Aristide Sartorio**
*Isaotta Guttadauro, Ballata VI*, illustration for Gabriele D'Annunzio's *Isaotta Guttadauro*
1886.

Onorato Carlandi, Vincenzo Cabianca (a former Macchiaioli artist), and the young Aristide Sartorio. The opus became the icon of a new aesthetic trend that found Gabriele D'Annunzio, advocate of Nietzsche's philosophies, to be one of its most enthusiastic exponents.

Max Klinger, in Germany, excelled in the engraving as a means for exploring the phantoms of the subconscious. In his series of lithographs *Paraphrase on the Discovery of a Glove* (1879–81), a lady's glove found at a skating rink undergoes several dreamlike transformations in the artist's mind, commemorating the nameless owner and becoming a symbol for the ten stages of anguish and desire. In the dramatic crescendo, the influence of music is also perceived, especially that of Wagner, so expressive of the period's decadent culture, which also interested the young Wassily Kandinsky in the 1890s. In fact, it was Kandinsky who wrote that when he heard *Lohengrin*, he saw and felt the magical spectacle of a sunset in his native city of Moscow, and understood from the dual sonority of Wagner's trumpets that painting can develop the same forces as music; these thoughts were then given a theoretical formula in 1911, in a work translated as *Concerning the Spiritual in Art*.

In France, another artist, Odilon Redon, focused on the primacy of illustration in grasping the world of the psyche, excelling in engraving with a masterly use of black, which, he wrote, "forces humanity to take refuge in its inner self." Thus, in his lithographs we find an immense eye that floats in front of the

**Max Klinger**
*Action*, lithograph from the series *Paraphrase on the Discovery of a Glove*
1881, opus VI, plate 2.

**Odilon Redon**
*The Eye, Like a Strange Balloon, Mounts Toward Infinity*, from the series *To Edgar Allan Poe*
1882, lithograph on paper.
Winterthur, Kunstmuseum.

columns of a temple and then "like a strange ball" (like a hot-air balloon) moves off "towards infinity." In other works he shows a large spider that smiles wickedly, trees stripped and scored by the wind, emaciated faces, and martyrs' heads: all images gathered from reading Charles Baudelaire or Edgar Allan Poe. While Japanese art had a decisive influence in the field of illustration the widespread longing to return to the origins to generate a new language for art, which was the key to research undertaken by Gauguin and the Nabis group, often led to a preference for xylographic techniques. This was because wood engraving was found to be more suitable for expressing the minimalism of the deliberately simplified stroke, which was less descriptive and therefore more symbolic, as in primitive art. In

the late nineteenth century, there was exceptional development of illustration in the Secession groups, with the publication of numerous magazines, mouthpieces for movements of artists who had opted to "detach" from official art canons. The freshness of their notions is expressed precisely through the complete modification of traditional graphics criteria, in line with the Jugendstil principles. Reviews like *Jugend* and *Simplicissimus*, published in Munich by Georg Hirth, as well as *Pan* in Berlin, *The Studio* in London, and the Viennese *Ver Sacrum* became the most widespread tools of the ethics and aesthetics of those movements: the actual titles ("Youth," *Jugend*; "Sacred Spring," *Ver Sacrum*) are clear declarations of their strong proactive intentions.

*Left:*
**Paul Gauguin**
*Seated Buddha*
Wood engraving.
Boston, Museum of
Fine Arts, donated by
W.G. Russell Allen.

*Fritz Erler*, cover of the
*magazine* Jugend, *1896,
Munich.*

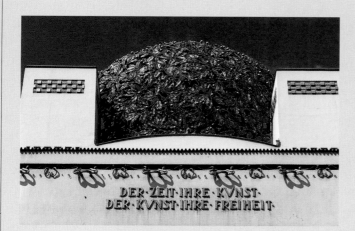

# Klimt and the Viennese Secession

The Vienna art world, in the capital of a great empire featuring palatial, traditionally designed buildings, was deeply shaken in the spring of 1897 by the founding of an association of Austrian artists known as the Viennese Secession. The group was formed through the efforts of well-established figures who separated from the official painters' association led by Eugene Felix, with headquarters in the Künstlerhaus. The painters in the Secessionist group came from various backgrounds, from Naturalism to Impressionism and Symbolism, and included Gustav Klimt, Carl Moll, Koloman Moser, Maximilien Lenz, and architects like Joseph Maria Olbrich, who immediately designed a new exhibition hall, which opened in fall

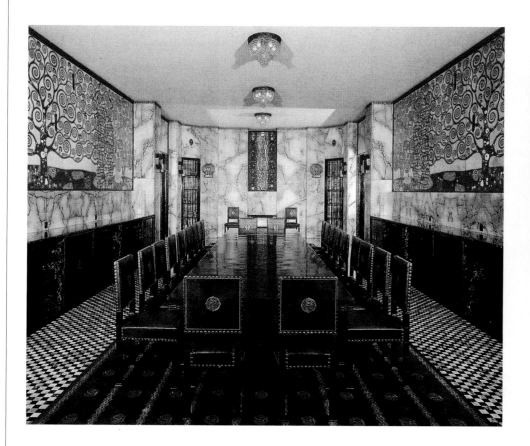

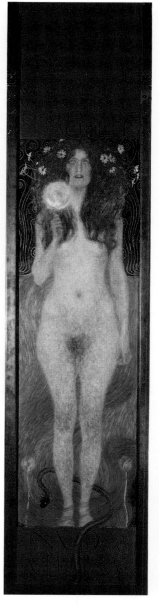

*Top:*
**Joseph Maria Olbrich**
*Entrance to the Secession Building,* detail
1897–98.
Vienna.

*Above:*
**Joseph Hoffmann**
*Dining Room Decorated with Klimt Mosaic*
c. 1910.
Brussels, Palais Stoclet.

*Right:*
**Gustav Klimt**
*Nuda Veritas*
1899, oil on canvas.
Vienna, Theatersammlung der Nationalbibliotek.

1898. Its entrance declared, "To every time its art, to art its liberty." Architects Joseph Hoffmann and, later, Otto Wagner, were also members of the group, while writer Ludwig Hevesi supported and defended the Secessionists against attacks by critics and the public. The desire to break away from official culture, in keeping with the spiritual creative fervor that permeated the European artistic world, was well illustrated by Klimt in the first Secession exhibit poster, showing Theseus battling the Minotaur. The same meaning was intended in *Pallas Athene* (1898), depicting the battle between Heracles and the monster Triton, shown behind Pallas Athene, the solemn figure of the goddess of divine wisdom—adopting her, as Stuck had in Munich, as the emblem of the Secession. Pallas Athene holds a small, blond Nike with open arms

that—in 1899—became the central character of the painting *Nuda Veritas*: a fragile, almost androgynous creature of disturbing sensuality. Nevertheless, the decision to depict this goddess with slightly terrifying features refers to an arcane polarity of meanings: on one hand the vitality of the Secession, and on the other a chilling sense of suspense typical of the Symbolist and decadent culture, imbued with echoes of Nietzschean philosophy, in which the artist was trained. Klimt, who was president of the Secession, organized exhibitions that welcomed international artists and promoted the group's new aesthetics through the magazine *Ver Sacrum*. He was also involved in the field of applied arts.

In 1903 Klimt, together with Hoffmann and Moser, created the Wiener Werkstätte, a factory inspired by the English model, which

*Above:*
**Gustav Klimt**
*Pallas Athene*
1898, oil on canvas.
Vienna, Historisches
Museum der Stadt Wien.

*Top right:*
**Koloman Moser**
**Cover of the magazine**
**"Ver Sacrum"**
1899 (II), no. 4, color
lithograph.

*Right:*
**Alfred Roller**
**Cover of the magazine**
**"Ver Sacrum"**
January 1898 (I).

combined the value and quality of a handmade artifact with larger-scale production of new materials and designs suitable for modern requirements. Another Wiener Werkstätte associate was Klimt's companion, the fascinating Emilie Flöge (who posed for *Judith* in 1901, among other works); her fashion salon, designed by Moser, became a meeting place for the Viennese avant-garde. The design of the Wiener Werkstätte—like Klimt's paintings—quickly abandoned Jugendstil fluidity for a more geometrical, abstract form, which became the distinctive feature of Viennese art in those years. This shift was clear in the 1902 *Portrait of Emilie Flöge*, shown here, which seems to have achieved an osmosis between the natural organic forms that surrounded the woman in the many photos Klimt took of her (in the painting, they are absent from the background, which is left unadorned and indistinct) and the geometric decorations on her dress, to the extent that the body tends to be transformed into ornament and the ornament into body.

An important event in the Secessionist experience was the decoration for the group's fourteenth exhibition, in 1902, designed by Hoffman for the Secession building and for which Klimt created the *Beethoven Frieze*. The frieze is an ephemeral structure (still preserved today), realized with casein paints on plaster over latticework, with the insertion of fragments of mirrors, buttons, glass costume jewelry, and touches of gold to obtain particular effects. Klimt's frieze was a pictorial paraphrase of Beethoven's Ninth Symphony—of which Gustav

**Gustav Klimt**
*Emilie Flöge*
*photographed with*
*a summer dress she*
*made,* designed by
Gustav Klimt
1907.

**Gustav Klimt**
*Portrait of Emilie Flöge*
1902, oil on canvas.
Vienna, Historisches
Museum der Stadt Wien.

Mahler performed the fourth movement at the exhibition's inauguration—and was inspired by Richard Wagner's interpretation of that music in 1865: "the battle of the spirit in search of joy against the hostile force that comes between us and earthly happiness, and oppresses us with its nocturnal wings." The battle between good and evil alludes to the difficulty of attaining the absolute freedom of art that the Secessionist artists desired. Therefore, highly stylized, lithe forms of human heads and limbs outstretched toward the infinite in tormented poses appear in rhythmic sequence. There is also the imposing presence of the horseman, a resplendent figure with the features of Mahler and, on the opposite side, the enemy forces of vice and sin: a strange horde of disquieting figures that include an apelike monster with mother-of-pearl eyes and vampirelike female faces. However, in the end, good triumphs, as depicted in the scene of the embrace inspired by Schiller's *Ode to Joy*, from the final chorus of Beethoven's symphony. In 1905, the Klimt coterie left the Secession, and the 1908 Kunstschau exhibition was already showing Expressionist traits through the New Art Group (Neukunstgruppe) led by the young artists Egon Schiele and Oskar Kokoschka.

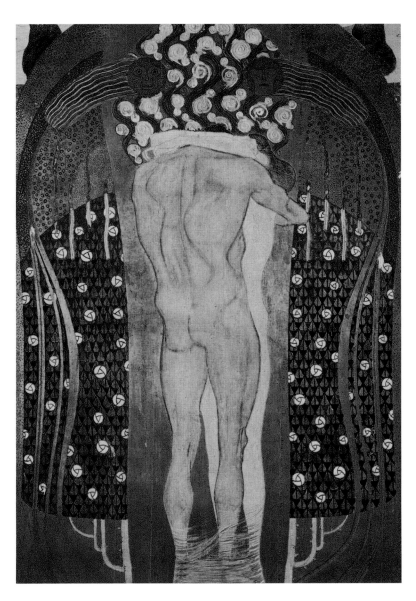

**Gustav Klimt**
*The Embrace*, detail of
the *Beethoven Frieze*
1902, casein colors
on plaster.
Vienna, Österreichische
Galerie.

**Josef Hoffmann**
*Chair for Gustav Klimt's
Viennese atelier* made by
Wiener Werkstätte
1905, carved oak, black
mordant and pores treated
with white.

# Arnold Böcklin
(b. Basel 1827, d. Fiesole 1901)

*Arnold Böcklin in a photograph dated 1842.*

Böcklin attended the Academy in Düsseldorf from 1845 to 1847 and visited Brussels, Antwerp, and Geneva, where he studied with the landscape painter Alexandre Calame. In 1848 he went to Paris and in 1850 to Italy, where he explored the Roman countryside with Franz Dreber and Oswald Aschenbach. In 1853, he married Angela Pascucci and met Feuerbach. Böcklin returned to Basel in 1857, and in 1858 he was commissioned to paint the frescoes in the Wedekind house in Hannover. He was in Munich from 1859, where his *Pan Amongst the Reeds* was purchased by Ludwig I for the Neue Pinakothek. He taught at Weimar until 1862, then returned to Italy. Böcklin visited Rome and Naples, where he met Rudolf Schick and Hans von Marées. In 1866 he returned to Basel, and in 1871 he went to Munich; he shared an atelier with Lenbach and struck up a friendship with Thoma. In 1873, he exhibited in Vienna, then went to Florence in 1874, where he met Hildebrand and the art dealer Franz Gurlitt. Böcklin lived in Zurich from 1885 to 1892, but returned definitively to Florence when he was struck by palsy.

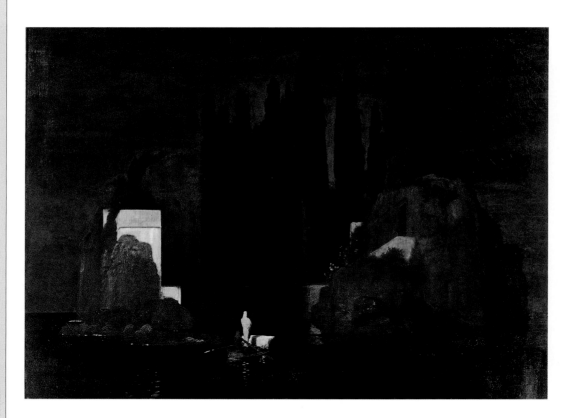

**Arnold Böcklin**
*Island of the Dead*
1880, oil on canvas.
Basel, Kunstmuseum.

Transfiguring the Swiss Cemetery (also known as the English Cemetery) in Florence, where his daughter was buried, Böcklin imbues the painting with the aura of a Nordic myth. The chilly, damp landscape, overshadowed by the rocky massif and cypress trees—

the destination of the boat carrying the turned, white-clad figure—is dominated by an almost Wagnerian sense of doom. Böcklin, rejecting an illustrative tone, entrusts his poetry to more enigmatic devices, as occurs in music, devoid of any particular connotations. The same suspended atmosphere can be found in paintings of ruined Roman villas, reminiscent of Jacob Burckhardt's Cicero, where female creatures gaze at the sea under troubled, heavy skies.

# Pierre Bonnard

(b. Fontenay-aux-Roses 1867, d. Le Cannet 1947)

A "Nabi très japonard" (Fénéon), Bonnard developed a very decorative style. From 1895, he distanced himself from Nabi propheticism. Bonnard participated in the first Art Nouveau Salon, while Durand-Ruel organized his first retrospective and Vollard commissioned a series of prints from him. In the new century, he continued to produce lithographs for poems, but he focused on more intimist paintings, still lifes, and landscapes. His first solo exhibit was organized by Bernheim Jeune in 1907, and many others followed. In 1909, he traveled to the South of France and visited the favorite village of Matisse, Signac, and other Fauves. From 1913 he sought to create forms with a more compact structure, incorporating the rapid, fluid brushstrokes he adopted during that period. By the 1920s, Bonnard had become an international success, and a large exhibit was dedicated to him at the Art Institute of Chicago.

*Pierre Bonnard in a photograph dated 1895.*

**Pierre Bonnard**
*Intimacy*
1891, oil on canvas.
Paris, Musée d'Orsay.
In this youthful work, Bonnard depicts his sister Andrée and her husband Claude Terrasse (organist, music teacher, and composer of operettas), but also allows a glimpse of himself in the foreground: the hand holding the pipe is Bonnard's. This device arranges space, also defined by marked light contrasts. The spirals of smoke are reiterated in the wallpaper arabesques, already anticipating the penchant for the extremely elaborate decorative content of the works that would soon follow.

**Pierre Bonnard**
*Portrait of Vuillard*
1892, oil on panel.
Paris, Musée d'Orsay.

*Edward Coley Burne-Jones in 1890*, detail of a photograph portraying the artist with William Morris.

# Edward Coley Burne-Jones

(b. Birmingham 1833, d. Fulham 1898)

Burne-Jones studied at Exeter College, Oxford, where he met William Morris. He developed an interest—shared by the Pre-Raphaelites—in Medieval art through the texts of Tennyson, Carlyle, and Ruskin. In 1859, Burne-Jones made his first journey to Italy, where he discovered Botticelli. This journey was followed by others: he visited Parma and Milan (with his wife Georgiana and Ruskin) in 1862, then Rome in 1871, where he became a great admirer of Michelangelo. In 1873, he traveled to Florence with Morris, then to Ravenna. In 1868, he became a member of the Old Watercolor Society, and his patrons included William Graham and Frederic Leyland; he also enjoyed friendships with Whistler and Leighton. In 1877, his fame was confirmed by an exhibit at the Grosvenor Gallery, and he exhibited in Paris in 1878. In 1885, he was elected to the Royal Academy (from which he resigned in 1893). Burne-Jones received the Legion of Honor and was knighted in 1894.

**Edward Coley Burne-Jones**
*The Legend of Perseus and Medusa*
c. 1876, gouache. Hampshire (UK), Southampton City Art Gallery.

Burne-Jones mixes pagan and Christian elements, drawing from literary sources like William Morris's *The Earthly Paradise*, and orchestrates his narrative with leaden hues and metallic lights. The forms are simplified, generating beings who are simultaneously intense, sensual, and extremely spiritual, where turmoil and aspiration to purity entwine constantly with the mystery of the images.

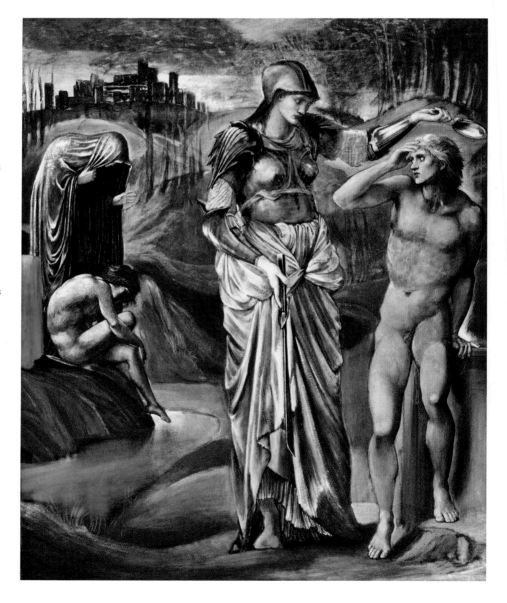

**Paul Gauguin**
*Self-Portrait with Yellow Christ,*
detail
1889–90, oil on canvas.

# Paul Gauguin
(b. Paris 1848, d. Marquesas Islands 1903)

After growing up in Peru, Gauguin returned to France and studied in Orléans. In 1865, he joined the French navy and traveled to Latin America, the Eastern Mediterranean, and the Black Sea. Gauguin began working as a stockbroker in Paris in 1871, but his guardian Arosa encouraged him to focus on painting. In 1879, Degas and Pissarro invited Gauguin to participate in the annual Impressionist exhibition. In 1884, he was in Rouen and also exhibited in Norway and Denmark. Gauguin met Bernard in Pont-Aven in 1886. The following year, he traveled to Panama and Martinique, and Théo van Gogh took over the sale of his paintings. In 1888, Gauguin went to Arles, but left after a falling-out with Vincent van Gogh. During 1889 and 1890, he lived in Pont-Aven and Le Pouldu. In 1891, he requested that the Ministry of Public Education send him to Tahiti. After returning briefly to Brittany in 1894, he remained in Polynesia for the rest of his life, although he maintained contact with the art dealers Durand-Ruel and Vollard.

**Paul Gauguin**
*Hina* (far left and middle),
*Hina and Fatou* (right)
c. 1892, bronzes from
originals in wood.
Toulouse, private
collection.

*Bottom:*
**Paul Gauguin**
*Where Do We Come
From? What Are We?
Where Are We Going?*
1897–98, oil on canvas.
Boston, Museum of
Fine Arts.

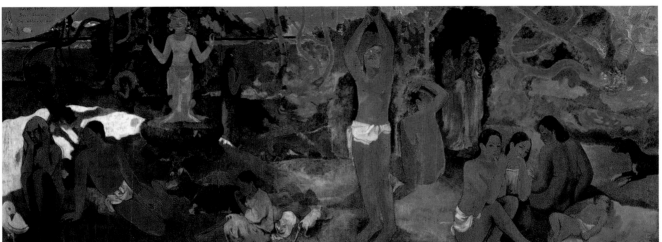

**Fernand Khnopff**
*Self-Portrait*
Pencil.

# Fernand Khnopff
(b. Grembergen-les-Termonde 1858, d. Brussels 1921)

Khnopff abandoned his law studies to attend the Academy of Fine Arts and take courses with Xavier Mellery. In 1877, he went to Paris to work in Lefebvre's atelier and study at the Académie Julian, where he admired the works of Moreau, Rossetti, and Burne-Jones. In 1883, he was one of the founders of the group Les XX. In 1892, he exhibited at the first Salon de la Rose-Croix. Khnopff collaborated with *The Studio* in 1894 and with *Ver Sacrum* in 1898. An aristocratic and refined dandy and a friend of Symbolist poets and literati (Emile Verhaeren and Georges Rodembach), Khnopff moved away from the Naturalism of his early works, turning instead to a more subjective interpretation, with a disturbing atmosphere featuring ambiguous sphinx-women and angel-women figures. Khnopff also experimented with different techniques—he loved working in crayon, produced polychrome sculptures, and created decorations for the Hôtel de Ville in Saint-Gilles and the Théâtre de la Monnaie in Brussels. At the beginning of the twentieth century, he built a house in the same style and atmosphere as his works.

**Fernand Khnopff**
*I Lock My Door upon Myself*
1891, oil on canvas.
Munich, Neue Pinakotek.

**Fernand Khnopff**
*Memories (Lawn Tennis)*
1889, oil on canvas.
Brussels, Musées Royaux des Beaux-Arts.

The painting alludes to the filter of memory, the vision re-created at a distance: these are no longer women playing tennis, but the same figure repeated in a paratactic way, evoking different moments in the life of Khnopff's sister Marguerite, who is seen from the back. While the suggestion of somnambulism is reminiscent of Moreau, this work—shown at the 1889 Universal Expo in Paris—is underpinned by the Primitivist-style features present in the culture of the time.

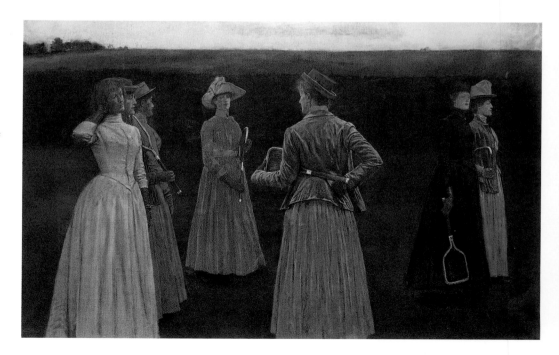

# Frederick Leighton

(b. Scarborough 1839, d. London 1896)

**Frederick Leighton**
*Self-Portrait*, detail (full on page 133) Opus signed and dated 1820, oil on canvas. Florence, Uffizi Gallery.

Sophisticated and cosmopolitan, Leighton studied at the School of Art in Berlin as well as the Academy of Fine Arts in Florence; he visited museums and ateliers throughout Europe. In 1852, Leighton was in Rome, where he established relationships with a circle of intellectuals (including Thackeray and Browning) as well as French painters. While in Rome, he conceived of the painting that brought him resounding success—*Cimabue's Celebrated Madonna Is Carried in Procession* (1855), which combined Nazarene echoes with Pre-Raphaelite ideas and was purchased by Queen Victoria. During the years that followed, Leighton showed a preference for Hellenistic-influenced Classicism and crisply austere forms, but he also experimented with contrasts of light and tone. He became a member of the Royal Academy in 1864 and was elected its president in 1878. Leighton was knighted in 1886 and given a peerage in 1896; his Holland Park house is now a museum.

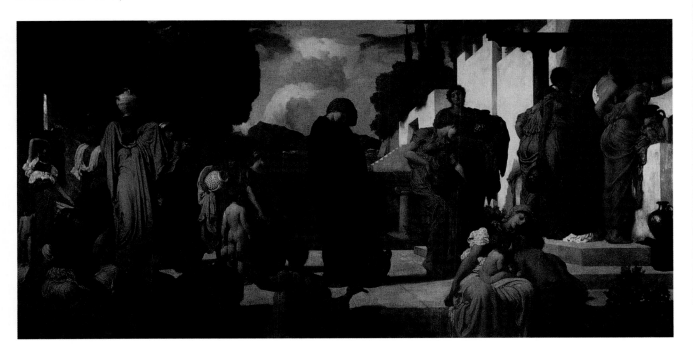

**Frederick Leighton**
*Andromache in Captivity*
1886–88, oil on canvas. Manchester, Manchester Art Galleries.

The figure of Hector's wife Andromache—captured by the Greeks at the fall of Troy and destined to lead a life of captivity, as Homer narrates in the *Iliad*—looms at the center of the painting, which imitates a bas-relief. Her pose and her dark robe falling in heavy folds underscore her distress. All around her, the Greeks continue with their everyday life, heedless of her tragedy. Leighton, in the rendering of the drapery, shows his extraordinary skill, the result of an enthusiastic study of the form of Classical and Hellenistic Greek sculpture, but the glimpse of an airy landscape in the background is also worthy of note.

# Gustave Moreau
(b. Paris 1826, d. 1898)

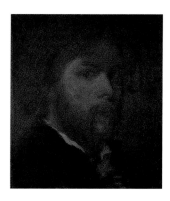

**Gustave Moreau**
*Self-Portrait*
1850, oil on canvas.
Paris, Gustave Moreau Museum.

In 1846, Moreau entered the École des Beaux-Arts and studied under Picot; he became a friend of Chasseriau and admired Delacroix's paintings. Between 1857 and 1859, he traveled in Italy, staying in Rome, Florence, Siena, Milan, Venice, and Naples, and he met Degas, Chapu, and Delaunay. At the 1864 Salon, the Symbolism perceived in Moreau's painting *Oedipus and the Sphinx* caused a sensation. After an attack against *Jupiter and Europa* and *Prometheus* in 1869, he refused to exhibit at the Salon until 1876, when *The Apparition (Salome)* was praised by Huysmans and De Montesquiou. From that point, his compositions became more complex, incorporating unrelated elements and creating scenes where myth, history, and biblical stories, although rendered in meticulous Naturalism, were transformed by his romantic and at times decadent imagination. He often repainted the same work several times. Many of his numerous sketches, drawings, and watercolors are exhibited in his former house, now a museum. From 1892, Moreau was a professor at the École des Beaux-Arts, where his students included Matisse and Rouault.

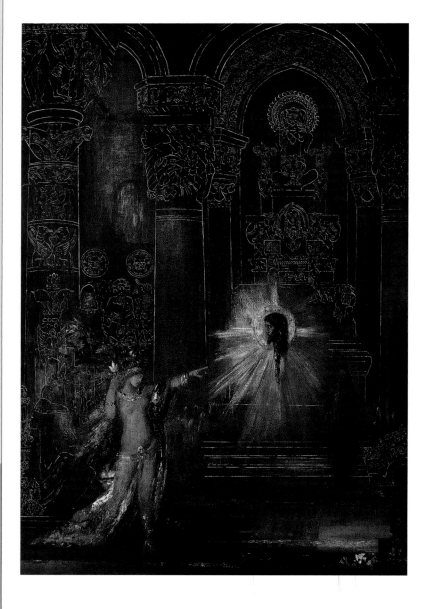

**Gustave Moreau**
*The Apparition (Salome)*
1874–75, oil on canvas.
Paris, Gustave Moreau Museum.

Conceived as the partner for *Salome Dancing Before Herod* to be exhibited at the 1876 Salon, it was never finished (the watercolor of the same subject was exhibited). The painting portrays the moment following the dance, when Salome stops, aghast at the apparition of the Baptist's head floating in the center of the scene. Ary Renan suggests that Moreau was inspired for this episode by Heine's poem *Atta Troll*, but the literary source was only a pretext for a manipulation of fantasy. Medieval motifs and refined Renaissance-style engraving intermingle with the decorative elements.

*Facing page:*
**Edvard Munch**
*Moonlight*
1895, oil on canvas.
Oslo, National Gallery.

Unlike other works (like *Melancholy* in 1892), where the landscape converses with the figure's state of mind, this contains only Asgardstrand's beach (where the artist spent his summers from 1889), steeped in melancholic meanings and whose charm is revealed on emerging from the woods, suggested by curtains of slim trees. Critics suggest that there are also erotic allusions, perhaps in the presence of the moon reflected on the water. The simplification of the forms and blocks of background color suggest Munch's interest in Synthetism.

# Edvard Munch

(b. Löten 1863, d. Ekely 1944)

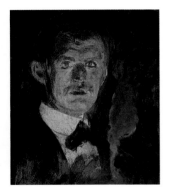

**Edvard Munch**
*Self-Portrait with Cigarette,*
detail
1895, oil on canvas
Oslo, National Gallery.

Munch attended the design school and Fritz Thaulow's Modum *plein air* academy. From 1884, he was in contact with Hans Jaeger and the Norwegian avant-garde. In 1885, after a stay in Paris, Munch painted *The Sick Child*, *The Day After*, and *Puberty*. He returned to the city in 1889, attending Bonnat's courses. In 1892, an exhibit of his works in Berlin caused a scandal, which led to the Secession movement. He lived in Germany until 1908, where he was a friend of Strindberg, Meier-Graefe, and people involved with the publication *Pan*. In Paris, in 1896, Munch associated with Natanson and Mallarmé, exhibited at the Salon des Indépendants, and illustrated Baudelaire's writings. In Berlin, Munch met Max Linde, who later became one of his main patrons. In 1904, he participated in the Secession, along with Beckmann, Nolde, and Kandinsky. Despite frequent stays at clinics and sanatoriums, Munch also traveled to and exhibited in New York. When the Nazis came to power, his works were declared "degenerate" in Germany and then resold to Norway.

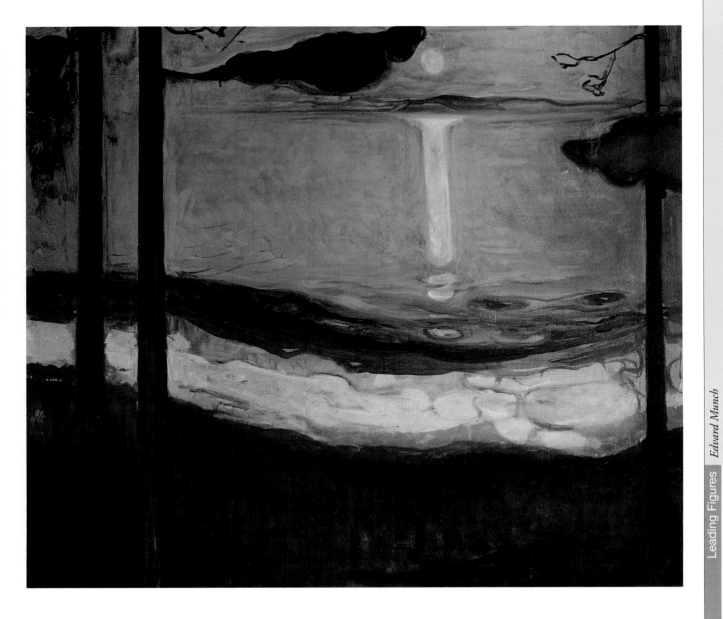

# Auguste Rodin

(b. Paris 1840, d. Meudon 1917)

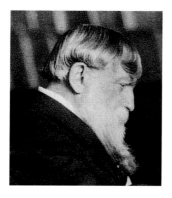

*Auguste Rodin drawing at Hôtel Biron in a photograph c. 1911.*

A student of Lecoq de Boisbaudran and Carpeaux, Rodin went to Brussels in 1871 to work with Carrier-Belleuse on decorations for the Brussels Stock Exchange. In 1875, he traveled to Italy and experienced a "revelation" when he studied the works of Michelangelo (stating "he freed me from academic sculpture"). Rodin exhibited *The Age of Bronze* at the 1878 Salon. He then worked on *The Gates of Hell*, producing studies that generated sculptures like *The Thinker* (1880) and *The Kiss* (1888). During that same period he also produced *The Burghers of Calais* (Basel). In 1889, Rodin exhibited with Monet at the Galerie Georges Petit. In the 1890s, he focused on sculpting monuments in honor of Hugo and Balzac; the rejection of the Balzac monument by the Société des Gens de Lettres caused a great controversy. Rodin's fame was confirmed by his solo exhibition at the 1900 Paris Universal Expo. By that time, he was working primarily at his Villa des Brillants in Meudon, near Paris. His Paris residence, on Rue de Varenne, is now a museum dedicated to the sculptor's works.

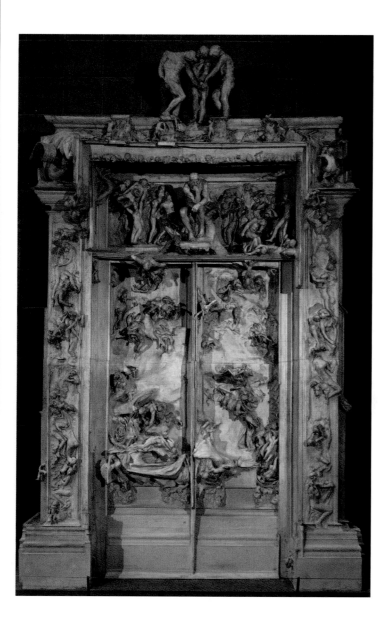

**Auguste Rodin**
*The Gates of Hell*
1880–1917, plaster.
Paris, Musée Rodin.

Here, Dante's *Inferno* is portrayed with sheer allusion. Roger Ballu commented in 1883: "This youth has an originality and tormented power of expression that is really astounding. He conceals his contempt or perhaps his indifference to the cold medium of sculpture beneath the energy of the postures, under the vehemence of the tormented poses. Rodin is obsessed by Michelangelesque visions. He may bewilder the spectator but he will not leave them unmoved." While the panel structure is a reference to Ghiberti's *Gates of Paradise*, the cosmic composition is more evocative of Michelangelo's *Last Judgment*.

*Facing page:*
**Édouard Vuillard**
*The Dress with Foliage*
1891, oil on canvas.
São Paulo, Brazil, Art Museum of Saõ Paulo.

The room that Vuillard's mother used as a small dressmaker's shop, full of fabrics of different hues and arabesques, was a place dense with sources of inspiration for the young artist, who translated all the mystery that can be aroused by the familiar vision of women engaged in sewing (his grandmother, Madame Michaud, and his sister standing on the left are busy dressing a dummy). Another silhouette, reflected in the mirror, may be a customer. The definition of space does not respect the rules of perspective, and the intersection of the planes is suggested by the clear-cut alternation of light and shade.

# Édouard Vuillard

(b. Cuiseaux 1868, d. La Baule 1940)

**Edouard Vuillard**
*Octagonal Self-Portrait,* detail
c. 1890, oil on cardboard.

Vuillard studied at the École des Beaux-Arts (1886–88) and the Académie Julian. He was a friend of Bonnard, Denis, Roussel, and Sérusier and was a member of the Nabis (from the Hebrew word for "prophets"). This group opposed Impressionism, preferring a more deliberate conception of paintings, constructed from large areas of colors applied in a flat, two-dimensional manner. In the 1890s, Vuillard's subjects embraced intimate scenes, Parisian interiors (*L'aguillée,* 1893, New Haven, Yale University), and still lifes. His appreciation for decoration and the applied arts was in keeping with the interests of the Nabis. Vuillard painted large panels for the houses of friends and for public buildings, including the ten panels called *The Public Gardens* (1894) for Natanson as well as *Figures and Interiors* (1896, Paris, Petit Palais), created for Dr. Henri Vasquez's library. In the early twentieth century, however, his paintings recovered a sense of perspective and spontaneity.

## Bibliography

*L'art en France sous le second Empire.* Paris: Réunion des musées nationaux, 1979. An exhibition catalog (Paris-Philadelphia-Detroit).

ASH, RUSSEL. *Sir Lawrence Alma Tadema.* London: Pavilion Books Limited, 1989.

AURIER, ALBERT. *Le symbolisme en peinture: Paul Gauguin, Le Mercure de France* (March 1891), 155ss.

BAHR, HERMANN. *Secession.* Vienna: 1900.

BARTRAM, M., AND L. P. FINIZIO, eds. *La fotografia e i preraffelliti.* Città del Vasto: 1983. An exhibition catalog.

BAUDELAIRE, CHARLES. *Curiosités esthétiques: L'art Romantique.* Edited by H. Lemaître. Paris: Garnier, 1986.

——. *Les Fleurs du Mal.* Paris: 1858.

BELLI, G., ed. *Divisionismo italiano.* Milan: Electa, 1990. An exhibition catalog (Trento).

BENEDETTI, M. T., G. PIANTONI, M.G. TOLOMEO, AND M. VOLPI, eds. *Dei e eroi: Classicità e mito tra '800 e '900.* Rome: De Luca, 1996. An exhibition catalog.

BÉNÉDITE, LÉONCE. *La Peinture au XIX siècle.* Paris: 1909.

BENJAMIN, WALTER. *L'opera d'arte nell'epoca della sua riproducibilità tecnica.* Turin: Einaudi, 1991.

BISCOTTINI, P., R. BOSSAGLIA, AND S. REBORA, eds. *Pittura lombarda del secondo Ottocento: Lo sguardo sulla realtà.* Milan: Electa, 1994. An exhibition catalog.

BISCOTTINI, P., AND A. SCOTTI TOSINI, eds. *La pittura russa quando era zar Alessandro II (1855–1881).* Milan: Electa, 1991. An exhibition catalog (Monza-Genoa).

BLANC, CHARLES. *Les artistes de mon temps.* Paris: 1876.

BLÜHM, A., C. STOLWIJK, H. LOYRETTE, R. THOMSON, eds. *Théo van Gogh: Marchand des tableaux, collectionneur, frère de Vincent.* Paris, 2000. An exhibition catalog (Amsterdam-Paris).

BONFAIT, O., ed. *Maestà di Roma: Da Ingres à Degas. Les artistes français à Rome.* Milan: Electa, 2003. An exhibition catalog (Rome).

BORDINI, SILVIA. *L'Ottocento, 1815–1880.* Rome: Carocci, 2002.

BURCKHARDT, JACOB. *Ciceron,* rev. ed. Paris: W. Bode, 1885.

CACHIN, F. AND C. S. MOFFET, eds. *Manet.* Paris: Réunion des musées nationaux, 1983. An exhibition catalog.

CALVESI, M., ed. *Le arti a Vienna.* Venice: Mazzotta, 1984. An exhibition catalog.

CANTELOUBE, AMEDÉE. "Le Grand Journal," *Le Salon de 1865,* March 21, 1865. In *Manet and His Critics,* by G.H. Hamilton. New Haven and London: Yale University Press, 1954.

CARBONE, GIUNIO. *Intorno l'imitazione artistic della natura.* Firenze: 1842.

CASTELNUOVO, E., ed. *La pittura in Italia: L'Ottocento.* Milan: Electa, 1991.

CECIONI, ADRIANO. *Scritti e ricordi.* Edited by G. Uzielli. Firenze: 1905.

CHIAPPINI, R., ed. *Edvard Munch.* Lugano: 1998. An exhibition catalog.

*Civiltà dell'Ottocento: Le arti a Napoli dai Borbone ai Savoia.* Naples: Electa, 1997. An exhibition catalog.

CLAIR, J., ed. *L'âme au corps, arts et sciences 1793–1993.* Paris: Réunion des musées nationaux, 1994. An exhibition catalog.

CLAIR, J., AND G. ROMANELLI, eds. *Venezia e la Biennale: I percorsi del gusto.* Milan: Fabbri Editori, 1995. An exhibition catalog (Venice).

COGEVAL, G., ed. *Edouard Vuillard 1868–1940.* Paris: Réunion des musées nationaux, 2004. An exhibition catalog (Washington-Montreal-Paris-London).

COGEVAL, G., ed. *Paradis perdus: L'Europe symboliste.* Paris: Flammarion, 1995. An exhibition catalog (Montreal).

CONTI, ANGELO. *La beata riva: Trattato dell'oblìo.* Edited by P. Gibellini. Venice: Marsilio, 2000.

DAMIGELLA, ANNA MARIA. *La pittura simbolista in Italia.* Milan: Einaudi, 1981.

DELABORDE, HENRI. "Les préraphaelites," *Revue des deux mondes* XVI (1858), 241ss.

DEL BRAVO, CARLO. *Centenario,* "Artista," 1993. *Bellezza e pensiero,* 303–9. Firenze: Le Lettere, 1993.

——. *Milleottocentosessanta,* "Annali della Scuola Normale Superiore di Pisa," 1975, 2. *Le risposte dell'arte,* 271–84. Firenze: Sansoni, 1985

DELEVOY, ROBERT. *Le symbolisme.* Geneva: Skira, 1982. First published as *Le Journal du symbolisme,* Paris, 1977.

DE LORENZI, GIOVANNA. *Ugo Ojetti, critic d'arte: dal "Marzocco" a "Dedalo."* Firenze: Le Lettere, 2004.

DENIS, MAURICE. *Théories 1890–1910: Du symbolisme et de Gauguin vers un nouvel ordre classique.* Paris: Bibliothèque de l'Occident, 1912.

DINI, F., ed. *Da Courbet a Fattori: i principi del vero.* Milan: Skira, 2005. An exhibition catalog (Castiglioncello).

DINI, F., F. MAZZOCCA, AND C. SISI, eds. *Giovanni Boldini.* Venice: Marsilio, 2005. An exhibition catalog (Padua).

DORMENT, R., AND M. MACDONALD, eds. *Whistler 1834–1903.* Paris: Réunion des musées nationaux, 1995. An exhibition catalog (London-Paris-Washington).

*Dream of a Summer Night: Scandinavian Painting at the Turn of the Century.* London: 1986. An exhibition catalog.

DRUICK, D., AND M. HOOG, eds. *Fantin-Latour.* Paris: Réunion des musées nationaux, 1983. An exhibition catalog (Paris-Ottawa-San Francisco).

FARINELLA, VINCENZO. *Pittura dei campi: La rappresentazione della vita agreste nel Naturalismo europeo*, in *Pittura dei campi: Egisto Ferroni e il Naturalismo europeo*. Edited by A. Baldinotti and V. Farinella. Firenze: Edifir, 2002, 3–40. An exhibition catalog (Livorno).

FAUNCE, S., AND L. NOCHLIN, eds. *Courbet Reconsidered*. Yale University Press: New Haven and London, 1988. An exhibition catalog.

FÉNÉON, FÉLIX. *Oeuvres plus que complètes*. Edited by J.U. Halperin. Geneva and Paris: Droz, 1970.

FOUCART, BRUNO. *Le renouveau de la peinture religieuse en France (1800–1860)*. Paris: Arthena, 1987.

FRÈSCHES-THORY, C., AND U. PERCUCCHIPETRI *Nabis 1888–1900*. Paris: Réunion des musées nationaux, 1994. An exhibition catalog (Zurich-Paris).

FRÈCHES-THORY, CLAIRE, AND ANTOINE TERRASSE. *Les Nabis*. Paris: Flammarion, 2002.

GONCOURT, EDMOND AND JULES de. *Manette Salomon*. Paris: 1867.

HANSMANN, M., ed. *Pittura italiana nell'Ottocento*. Venice: Marsilio, 2005. Conference acts for Kunst-historisches Institute in Florenz (October 7–10, 2002).

HARDING, JAMES. *Les peintres pompier: la peinture académique en France de 1830 à 1880*. Paris: Flammarion, 1980.

HEILMANN, C., AND G. PIANTONI, eds. *Deutsch-Römer: Il mito dell'Italia negli artisti tedeschi 1850–1900*. Milan and Rome: Mondadori-De Luca, 1988. An exhibition catalog (Rome).

HUNT, WILLIAM HOLMANN. *Pre-Raphaelitism and the Pre-Raphaelite Brotherhood*. London: 1905.

HUYSMANS, JORIS-KARL. *L'art moderne*. Paris: 1883.

———. *À rebours*. Paris: 1884.

JENKINS, A., ed. *Painters and Peasants: Henry la Thangue and British Rural Naturalism 1880–1905*. Bolton, England: 2000. An exhibition catalog.

JENKINS, PAUL. *The Victorians and Ancient Greece*. Oxford: 1981.

JULLIAN, PHILIPPE. *Les orientalistes: La vision de l'Orient par les peintres européens du XIXe siècle*. Fribourg: Office du Livre. Paris: Societé française du livre, 1977.

KAHN-ROSSI, M., ed. *Odilon Redon: la nature de l'invisible*. Milan: Skira, 1996. An exhibition catalog (Lugano).

KANDINSKY, WASSILY. *Lo spirituale nell'arte* (Monaco 1911). Edited by E. Pontiggia. SE, San Giuliano milanese 1989.

KEISCH, C., AND M. U. RIEMANN-REYHER, eds. *Adolph Menzel (1815-1905), "la nevrose du vrai."* Paris: Réunion des musées nationaux, 1996. An exhibition catalog (Paris-Washington-Berlin).

KILMURRAY, E., AND R. ORMOND, eds. *Sargent e l'Italia*. Ferrara: Ferrara Arte, 2002. An exhibition catalog.

KLINGER, MAX. *Pittura e disegno*. Edited by M. Dantini, with essays by G. De Chirico. Nike, Segrete: 1998.

KRAUSS, ROSALIND. *Teoria e storia della fotografia*. Edited by E. Grazioli. Milan: Mondadori, 1996.

LACAMBE, G., ed. *Le Japonisme*. Paris: Réunion des musées nationaux, 1988. An exhibition catalog.

LACAMBRE, G., D.W. DRUICK, L.J. FEINBERG, AND S. STEIN, eds. *Gustave Moreau 1826–1898*. Paris: Réunion des musées nationaux, 1999. An exhibition catalog (Paris-Chicago-New York).

LACAMBRE, G., AND G. TINTEROW, eds. *Manet, Velázquez, la manière espagnole au XIX siècle*. Paris: Réunion des musées nationaux, 2003. An exhibition catalog (Paris-New York).

LAFORGUE, JULES. *L'Impressionisme* (1883), in *Melanges posthumes. Oeuvres complètes*, III. Paris: Mercure de France, 1903, 133–45.

LAMBERTI, MARIA MIMITA. *1870–1915: i mutamenti del mercato e le ricerche degli artisti*, "Storia dell'arte italiana," VIII. Turin: Einaudi, 1982.

———. *Rodin e Michelangelo*, "... dalle vertebre alle falangi la compagine era eloquente," in *Michelangelo nell'Ottocento*. Milan: Charta, 1996, 13–24. An exhibition catalog.

LAPAUZE, HENRI. *Histoire de l'Académie de France à Rome*. Paris: Librairie Plon, 1924.

LAPI BALLERINI, ISABELLA. *Comme si c'eût été Jérusalem*, "Antichità viva," XVIII, 3, 39–48.

LAZZARINI, E., ed. *Poetiche del nudo: Mutazioni tra Ottocento e Novecento*. Firenze: Edifir, 2003. An exhibition catalog (Seravezza).

LEMOINE, S., AND M. FERRETTI BOCQUILLON, eds. *Le néo-impressionisme: de Seurat à Paul Klee*. Paris: Réunion des musées nationaux, 2005. An exhibition catalog.

LE NORMAND-ROMAIN, A., ed. *Rodin e l'Italia*. Rome: De Luca, 2001. An exhibition catalog.

LLORENS, T., AND F. GARÍN, eds. *Fortuny e la pittura preziosista spagnola*. Naples: Electa, 1998. An exhibition catalog (Catania-Rome).

LOCHNAN, K., ed. *Turner, Whistler, Monet*. Paris: Réunion des musées nationaux, 2005. An exhibition catalog (Toronto-Paris-London).

LOMBARDI, LAURA. *Diego Martelli: la lezione dei maestri antichi e la tutela dei monumenti fiorentini*, in *L'eredità di Diego Martelli. Storia. Critica. Arte*, Atto della Giornata di Studi di Montecatini Terme (October 12, 1996). Edited by C. Sisi and E. Spalletti. Pontedera: Bandecchi e Vivaldi, 1999.

———. *Scultori neofiorentini ai Salons*, "Artista." Firenze: 1995, 89–109.

LOYRETTE, H., ed. *Degas e l'Italia*. Rome: 1984–85. An exhibition catalog.

LOYRETTE, H., AND G. TINTEROW, eds. *Impressionisme: Les origines*. Paris: Réunion des musées nationaux, 1994. An exhibition catalog (Paris-New York).

MANTURA, B., ed. *Giulio Aristide Sartorio: Figura e decorazione.* Rome: 1989. An exhibition catalog.

MARGOLIS, M. FULTON, ed. *Camera Work: A Pictorial Guide.* New York: Dover Publications, 1978.

MARTINEAU, J., AND M. G. MESSINA, eds. *Shakespeare nell'arte.* Ferrara: Ferrara Arte, 2003. An exhibition catalog.

MATHIEU, PIERRE LOUIS, ed. *L'assembleur de rêves: Écrits complets de Gustave Moreau.* Paris: Fontfroide, 1984.

——. *La génération symboliste 1870–1910.* Geneva: Skira, 1990.

MATTEUCCI, G., ed. *Aria di Parigi.* Turin: Allemandi, 1998. An exhibition catalog (Livorno).

MAZZOCCA, F. *Pinacoteca di Brera: Dipinti dell'800 e del '900. Collezioni dell'Accademia e della Pinacoteca.* Scientific coordination. Milan: Electa, 1994.

MAZZOCCA, F., ed. *Romantici e Macchiaioli: Giuseppe Mazzini e la grande pittura europea.* Milan: Skira, 2005. An exhibition catalog (Genoa).

MAZZOCCA, F., AND C. SISI, eds. *I macchiaioli: prima dell'impressionismo.* Venice: Marsilio, 2003. An exhibition catalog (Padua).

MESSINA, MARIA GRAZIA. *Le muse d'oltremare: Esotismo e Primitivismo dell'arte contemporanea.* Turin: Einaudi, 1993.

MICHEL, ANDRÉ. *Jean François Millet et l'exposition de ses oeuvres à L'École des Beaux Arts,* "Gazette des Beaux-Arts", II, 1887, pp. 5-24.

MONTI, RAFFAELE. *Giovanni Fattori 1825–1908.* Livorno: Sillabe, 2002.

MORELLI, DOMENICO. *Lettere a Pasquale Villari.* Edited by A. Villari. Naples: Bibliopolis, 2002.

MORRIS, WILLIAM. *The Arts and Crafts of Today* (1889); *Art and Industry in the Fourteenth Century* (1890), both in *Opere.* Edited by M. Manieri Elia. Bari and Rome: Laterza, 1986.

MURPHY, A. R., ed. *Jean-François Millet: Drawn into the Light.* (Williamstown-Pittsburgh-Amsterdam). Singapore: 1999. An exhibition catalog.

NETTI, FRANCESCO. *Critica d'arte.* Edited by A. De Rinaldis. Bari: Laterza, 1938.

*New York et l'art moderne: Alfred Stieglitz et son cercle.* Rome: Réunion des musées nationaux, 2004. An exhibition catalog (Parigi, Madrid).

NOCHLIN, LINDA. *Realism and Tradition in Art, 1848–1900: Sources and Documents.* Englewood Cliffs, N.J.: Prentice Hall, 1966.

NUZZI, C., ed. *Arnold Böcklin e la cultura artistica in Toscana.* Rome: De Luca, 1980. An exhibition catalog (Fiesole).

OCTAVE-MAUS, MADELEINE. *Trente années de lutte pour l'art: Les XX, la Libre esthétique, 1884–1994,* rev. ed. Brussels: Lebeer Hossmann, 1980. First printed in 1926.

OVENDEN, G. *Pre-Raphaelite Photography.* New York: St. Martin's Press, 1984. First published in London by Academy Editions, 1972.

PARRIS, L., ed. *Pre-Raphaelite Papers.* London: Tate Gallery, 1984.

PATER, WALTER. *Il Rinascimento* (1873). Naples: 1946.

PEREZ, N., ed. *Corpus Christi: Les réprésentations du Christ en photographie, 1855–2002.* Paris: Marval, 2002. An exhibition catalog (Jerusalem-Paris).

PINGEOT, A., ed. *La sculpture française au XIXème siècle.* Paris: Réunion des musées nationaux, 1986. An exhibition catalog.

PINGEOT, A., AND R. HOOZE, eds. *Paris-Bruxelles, Bruxelles-Paris: les relations artistique entre la France et la Belgique, 1848–1914.* Paris: Réunion des musées nationaux, 1997. An exhibition catalog (Paris-Ghent).

PINTO, S., L. BARROERO, AND F. MAZZOCCA, eds. *Maestà di Roma: Universale ed eterna, Capitale delle arti.* Project by S. Susinno. Milan: Electa, 2003. An exhibition catalog (Rome).

*The Pre-Raphaelites.* London: Penguin Books, 1984. An exhibition catalog (Tate Gallery).

PRUD'HON, PIERRE-JOSEPH. *Du principe de l'art et de sa destination sociale.* Paris: Garnier, 1865.

QUINSAC, A. M. P., ed. *Giovanni Segantini: Luce e simbolo 1884–1899.* Milan: Skira, 2000. An exhibition catalog (Varese-Venice).

QUINTAVALLE, ARTURO CARLO. *Gli Alinari.* Firenze: Alinari, 2003.

RAPETTI, RODOLPHE. *"Ce mode neuf de voir": neoimpressionismo e simbolismo in Francia,* in *L'età del Divisionismo.* Milan: Electa, 1990.

RATCLIFF, CARTER. *John Singer Sargent.* Oxford: Phaidon, 1983.

RAVENEL, JEAN. "L'Epoque," *Le Salon de 1865,* May 4, 1865. In *Manet and His Critics,* by G.H. Hamilton. New Haven and London: Yale University Press, 1954.

REDON, ODILON. *À soi même: Journal 1867–1915, Notes sur la vie, l'art et les artistes.* Paris: Conti, 1961.

REWALD, JOHN. *The History of Impressionism,* rev. ed. New York: 1973.

RIMBAUD, ARTHUR. *Lettres du voyant (lettres à Paul Démeny et Georges Izambard),* 13. May 15, 1871. Commentary by George Schaeffer. Paris: Minard, 1975.

RODIN, AUGUSTE. *L'art: Entretiens réunis par Paul Gsell* (Paris 1911), facsimile edition. Paris: Grasset, 1986.

RUSKIN, JOHN. *The Pre-Raphaelites,* in *The Works of John Ruskin* (39 vols.), XII, 339–93. Edited by E.T. Cock, A. Wedderburn, and G. Allen. London: 1903–12.

SABARSKY, S., ed. *Gustav Klimt.* Firenze: Artificio, 1991. An exhibition catalog.

SCHURE, EDOUARD. *Les Grands Initiés: esquisse de l'Histoire secrète des religions* (1889). Paris: Perrin, 1949.

188

SISI, CARLO. *Umbertini in toga*, "*Artista.*" Firenze: Le Lettere, 1993, 174–81.

SPALLETTI, ETTORE. *Giovanni Dupré*. Milan: Electa, 2002.

STURGES, H., ed.. *Jules Breton and the French Rural Tradition*. New York: The Art Publ., 1982. An exhibition catalog.

*Thomas Eakins: Un réaliste américain, 1844–1916.* Paris: Réunion des musées nationaux, 2002. An exhibition catalog (Philadelphia-Paris-New York).

VARNEDOE, K., ed. *Northern Light and Symbolism in Scandinavian Painting.* New York: 1992. An exhibition catalog (Washington-Brooklyn-Minneapolis).

VENTURI, LIONELLO. *Les archives de l'impressionnisme Lettres de Renoir, Monet, Pissaro, Sisley et autres. Mémoires de Paul Durand-Ruel. Documents*, Durand-Ruel, Paris and New York: 1939.

VIAZZI, PIO. *Per il Simbolismo*, "*L'Arte all'Esposizione di Torino del 1898.*" Turin: 1898.

VILLARI, PASQUALE. *La pittura moderna in Italia e in Francia*, "Nuova Antologia." Florence: 1869.

VOLPI, MARISA. *Il maestro della betulla*. Firenze: Vallecchi, 1986.

VON HILDEBRANDT, ADOLF. *Das Problem der Formin der BildendenKunst*, Strasbourg 1913.

WEISBERG, G. P., ed. *The Realist Tradition: French Painting and Drawing 1830–1900.* Chicago: Congress Printing Co., 1980–82. An exhibition catalog (Cleveland-New York-St. Louis-Glasgow).

WEISBERG, GABRIEL P. *Beyond Impressionism: The Naturalist Impulse.* New York: Abrams, 1992.

*William Bouguereau 1825–1905.* Paris: Réunion des musées nationaux, 1984. An exhibition catalog (Paris-Montréal-Hartford).

WOOD, CHRISTOPHER. *Olympian Dreamers: Victorian Classical Painters 1860–1914.* London: Constable, 1983.

WORRINGER, WILHELM. *Abstraktion und Einfühlung* (1908), Italian version *Astrazione e empatia*. Turin: Einaudi, 1975.

ZOLA, ÉMILE. *Écrits sur l'art.* Edited by J.P. Leduc-Adine. Paris: 1991.

——. *L'oeuvre.* Paris: 1886.

——. *Une nouvelle manière en peinture: Édouard Manet*, "Revue du XIXème siècle." January 1, 1867.

# Index

Note: Page numbers in *italics* indicate works of art.

192